FOR JULES

Intended Consequences: Rwandan Children Born of Rape

Photographs and
Interviews by
Jonathan Torgovnik

Introduction by
Marie Consolée Mukagendo

aperture

Preface

I first traveled to Rwanda in February of 2006 on assignment for *Newsweek* magazine with then health editor, Geoffrey Cowley, to work on a story about HIV/AIDS, on the twenty-fifth anniversary of the disease's identification. While there, we met Odette, a woman who had been brutally raped during the Rwandan genocide and contracted HIV/AIDS as a result of those encounters. It was the most powerful and sad interview I have ever experienced. Odette described how her entire family had been killed and recounted the abuse she experienced, in detail. She also told us that she had become pregnant as a result of the multiple rapes she endured in the genocide and bore a baby boy. Her horrific story led me to return to Rwanda to embark on a personal mission to document the stories of women like Odette and to share them with the international community.

I learned from local nongovernmental organizations that an estimated twenty thousand children were born from rapes committed during the genocide. Over the last three years, I have returned to Rwanda several times, uncovering more details of the heinous crimes committed against the mothers of these children.

All thirty interviews I conducted took place in the private space of the women's homes. Even though I knew what their stories might contain, it was impossible to prepare myself for what I was going to hear. Most of the women had not revealed their stories to their children and communities; yet with each interview, the women told me the most intimate details of their suffering and the daily challenges they continue to face as a direct result of the brutality. They knew why I was there, and they wanted to tell their stories to the world.

It is hard for me to understand how a mother can say, "I do not love my child." In one of the interviews, the mother put her hand on me and said, "I know what you are asking me. I understand your question very well. I know it is terrible saying this as a mother, but this is what I feel now. Maybe one day it will change." On the other hand, several mothers told me that their children are their hope, that without them they would not feel the will to survive. All of the women I photographed and interviewed demonstrated that they cared for their children and that they had accepted the responsibility of motherhood despite the violent circumstances in which their children were conceived and, in many cases, despite knowing that the fathers of their children were responsible for killing their families.

The mothers in this book have lived through the most severe torture any human can endure, and in the aftermath they continue to struggle against multiple levels of trauma. I admire their resilience and courage. They are undoubtedly the strongest human beings I have ever encountered.

The level of brutality exercised by the Hutu militiamen is beyond comprehension—how could neighbors, teachers, priests, and friends become killers and rapists overnight and for no apparent reason? Although they are healing, Rwanda's wounds are still very open and fresh. More than half of the women I met are HIV positive. When I asked them how they viewed their future and the future of their children, a question with which I closed all of the interviews, they would often look at me and say, "I don't even know what's going to happen to me tomorrow." When I pushed further and asked what future they would envision if they had the means, nearly every mother talked about education for her children and how vital it is that these children, in particular, acquire the skills to provide for themselves should their mothers not survive.

I was deeply moved by this repeated appeal and affected by the incredible challenges these women and children face daily. For the first time in my career, I felt compelled to do something beyond documenting stories. Inspired to act, Jules Shell, a non-profit professional and author, and I cofounded a non-profit organization, Foundation Rwanda, to improve the lives of children born of rape committed during the genocide. Foundation Rwanda provides funding for secondary school education for these children and links their mothers to existing psychological and medical services. It also helps raise awareness about the consequences of genocide and sexual violence through photography and new media. This book is an extension of my work there, providing a space for these mothers' voices to be heard.

This book is not only about the women and children of Rwanda. Many of the same Hutu militiamen who killed, raped, and maimed in Rwanda, escaped to Congo and neighboring countries. These militiamen are continuing the cycle of violence and raping young girls and women on a massive scale in Congo today. It is astonishing that the world is not taking more action in this region.

Many of the women featured in this book took more than a decade to start the healing process and tell their stories. For some, these interviews were the very first time they spoke about what had happened to them. Unfortunately, victims of sexual violence in Congo, Darfur, and around the world are facing challenges similar to the women in Rwanda. My greatest hope is that, in reading these stories and seeing the images of the women and children in this book, people will be inspired to act and work toward ensuring that similar acts of violence never happen again and that these families can have a brighter future.

Jonathan Torgovnik

The Struggles of Rwandan Women Raising Children Born of Rape

Odette is twenty-eight, and in the eyes of her community, she doesn't exist. Even though she survived the harrowing genocide as a victim of rape and has a child as a result, she remains ostracized from her family and the community because of the stigma associated with a child born of rape. Thousands of other women share her fate. In her powerful testimony, given to photographer Jonathan Torgovnik, Odette made an appeal to the world not to forget the suffering of the women of Rwanda like her:

> *We have families that are broken and torn up. We have people who were dehumanized and treated like animals. I want the world to ensure that everybody's human rights are protected. But above all, I want the world to ensure that rape and acts of sexual violence never happen to anyone. They not only affect the individual victim, but also the children that are born of sexual violence.*

Fifteen years later, Rwandan women who have survived the genocide and systematic rape are still facing unimaginable suffering in absolute silence. To reveal the rapes they endured during the genocide would bring shame upon them and their children and families even now. As their children have grown into adolescents, they are calling upon the world to acknowledge them as they struggle to secure their lives and education.

Between April and June of 1994, over eight hundred thousand Tutsis and moderate Hutus were killed in the space of one hundred days in the small central African country of Rwanda. The genocide was sparked by the death of the Rwandan president, Juvenal Habyarimana, a Hutu, whose plane was shot down above Kigali airport on April 6, 1994. The Hutus began a massive slaughter of the Tutsis. Hundreds of thousands more were raped, tortured, and beaten. The international community failed to stop this genocide, and a period of instability continued in the country and in the refugee camps located in neighboring countries for nearly three years afterward.

During the genocide and post-genocide period, sexual violence, including torture and exploitation, was used as a weapon of war mainly against Tutsi women by the Hutu militia groups known as the Interahamwe. Often the Tutsi men of the community were killed first. Afterward, the women were forced to witness the torture and execution of their families. A long series of torturous rapes followed. In addition to a systematic attempt to wipe out the Tutsi ethnic group, these rapes were intended to put the women through untold agony and effectively destroy their hopes for a bright future. Indeed, most of the women continue to suffer from the aftermath of the genocide through nightmares, physical injuries, and mental-health issues. Thus, a generation of women has had their physical, emotional, and moral well-being altered irreparably.

While there is little information available on the real numbers of rape victims at the national level, a study in 2000 by Human Rights Watch estimated up to five hundred thousand women were raped systematically during the genocide. In Rwanda, abortion is illegal, but many women used more primitive methods to abort their pregnancies or traveled to neighboring Zaire (Congo) in order to

obtain an abortion because they were unable to cope with the prospect of raising a child fathered by a militiaman. Many other women, however, had children in the aftermath of genocide and are now raising them alone.

The National Population Office of Rwanda estimated the number of children born of forced impregnation to be between two and five thousand. However, according to information provided by victim groups, the number may actually range between ten and twenty-five thousand children. Rwanda is a heavily patriarchal society; so children are identified with the lineage of their fathers. This means that most members of society perceive the children of wartime rape as belonging to the enemy. They are often referred to as "les enfants mauvais souvenir" (children of bad memories) or "enfants indésirés" (children of hate) and others are named "little killers" by their own mothers and by the community. As a consequence, often as soon as the mothers reveal the truth of their rape, they face rejection by their families and lose any support from the community, which harbors deep emotional scars from the genocide. So many of the women were girls during the genocide, and acknowledging the rapes, publicly or privately, can dash their future hopes of marriage. Josette, a mother to eleven–year-old Thomas, explains, "My uncle didn't welcome me into his house. He asked me who was responsible for my pregnancy. I said it must be the militias since many of them had raped me. He said I shouldn't enter his house carrying a baby of the Hutus and chased me away. I left, but I didn't know where to go." These mothers and their children are simply not accepted into the community and struggle for support.

Children born of rape in Rwanda are included in the group labeled "vulnerable children," which makes them eligible for certain aid as long as they can prove they are orphans or that one of their parents is a survivor of the genocide. However, these policies often only apply to a child born before or during the genocide, not after the genocide. When the child is simply conceived during violence and, as a result, does not have a father, the government may not classify him or her as "vulnerable." In order to qualify for aid, the mothers would have to reveal their stories of rape, something that, in most cases, they have yet to speak about openly or share with their children. This confession would certainly have serious repercussions within the community. In addition, even when women do reveal that they were victims of rape, they may find the aid withheld because of lingering prejudices of the administering aid workers. Because of these complicated factors, the children of the genocide may not receive the benefits or interventions they desperately need and that the government provides for other vulnerable children.

To date there has been no systematic effort to identify the children of rape or to evaluate their needs and the needs of their mothers specifically. Although there are programs and international support for genocide survivors and orphans, this special group of sexual-violence victims continues to fall through the cracks because of the stigma of their status and unwillingness to talk. Odette explains that the mothers "have health problems. So many diseases related to rape are not easily talked about. They don't talk to just anyone, and many are dying because they keep quiet about their past and

their health." The real challenge in reaching this group of mothers and children is to establish protective measures and a system for identifying and tracking their progress confidentially so as not to stigmatize them further. The primary concern must be ensuring the rights of the children and mothers and giving them hope for a better future. For now, as the mothers continue to suffer in silence and receive little or limited support from the community or the government, they face their difficulties alone, fearing what the future holds for them and their children.

Thirty-six percent of all families in Rwanda are headed by women, according to a survey conducted in 2001 by the Rwandan Ministry of Health and the National Population Office. The victims of genocide and post-genocide sexual violence face severe economic constraints. In some cases, women who have survived multiple rapes during the genocide are forced to turn to prostitution as a means of support. According to the World Bank, ninety-seven percent of Rwandan women provide for themselves and their families through subsistence agriculture. Having suffered physical handicaps as a result of the violence, many mothers are simply unable to feed their families adequately in this manner. In her recent testimony, Josette describes that her economic situation is bleak after the genocide and after having given birth to her son: "Two years after I gave birth, I didn't have ways of supporting myself and my child. So I went into prostitution and unfortunately I became pregnant again and I gave birth to another child, but this time not as a result of rape, but of prostitution because I was looking for money to support my kid." With little or no support, women find it very hard to raise the children on their own in addition to maintaining their own mental and physical health.

These social and financial realities are further exacerbated by the HIV/AIDS pandemic. Although not all cases of HIV/AIDS among rape survivors can be traced to the sexual violence committed against them, the mass rapes during 1994 contributed significantly to the spread of the virus. According to UNICEF, seventy percent of the women who survived rape during the genocide were infected with HIV. Human Rights Watch estimates that most children born of rape in Rwanda will have lost their mother to HIV/AIDS before they turn fifteen. AIDS remains one of the leading causes of women's deaths.

Access to life-prolonging antiretroviral (ARV) therapy continues to be limited for many of the rape victims. Many rape survivors cannot afford health care, and the health-care system does not guarantee women and children access to health services for which they are eligible. The inadequacy of resources combined with the excessively high cost of antiretroviral therapy makes the situation dire.

The HIV and AIDS pandemic only compounds the personal struggles of the mothers in the continuing aftermath of the genocide. They are already extremely vulnerable within their community because of their status, but as their health deteriorates, they become too weak to care for themselves. In many cases, the children have to drop out of school, care for their mothers, and attend to the household. This widespread practice will most certainly affect the future of Rwanda as a generation goes without basic schooling.

Rwandan students are required to begin school at the age of seven. Both primary and secondary school are six years. The government, through the Ministry of Education, has implemented a policy of fee-free primary education. Orphans and children of rape represent a large portion of the school population, but the government only routinely waives fees for secondary school for orphans, not for children of rape, leaving much of that population without access to basic secondary education.

Children born of rape come from very poor households that struggle not only to pay for fees but also for uniforms and basic supplies. To ease the financial burden, the government decreed that school uniforms are not required, but this policy has not been adopted in all districts. In her testimony, Bernadette, another survivor with a child born of rape, reveals, "Whenever I think about his future, I don't know, and that is my biggest problem. Sometimes he sits here for a whole school term because I can't afford to get pens and books. If there is anything that tortures me, it is the tomorrow of my son."

Even when they manage to send their children to secondary schools, many mothers of children of rape quickly run out of money and cannot maintain their children's attendance. In addition, because their mothers are often ill themselves and suffering from HIV and AIDS, the children are forced to leave school and care for them. These children often have to work at small jobs, which generate little income, to provide for their mothers and other siblings.

In the future, the government plans to expand the mandate of free education to include not only the first six years of primary school, but an additional three years of post-primary education so that all children can receive a basic education. However, the children of the genocide are reaching the age of secondary school now and cannot afford to wait.

At the secondary level, mothers of children of rape are eligible to apply for assistance from the Rwandan government through the Ministry of Local Affairs, which pays for fees, or through the Genocide Survivors Fund, which pays for tuition and boarding fees, as well as other expenses, but this process requires the burden of proof and necessitates revealing their raped status. As long as the mothers remain shrouded in silence through fear of ostracizing themselves and their children from their families and the community, these programs will not provide a workable solution for children of rape. In order to help them, programs need to take a different approach, one that respects their confidentiality through the application process to prevent stigmatization.

The new non-governmental organization, Foundation Rwanda, established by Jonathan Torgovnik and Jules Shell addresses the specific needs of these children and their mothers. Although it is still relatively new and expanding in Rwanda, this organization shows real promise to offer much-needed opportunities to the children just as they are beginning to reach the age for secondary school.

The women raped during the genocide and the children born of this conflict need attention at the

national and international level in order to address their needs fully. They deserve special attention and protection because they are at risk of ongoing human rights violations, in particular, violations of their right to survive and lead a healthy life. Social and cultural values continue to marginalize them from their communities and their extended families. As these children of genocide grow toward adolescence, their mothers face almost insurmountable difficulties planning a future for their families. Lack of access to government programs and the stigmatized status of these women and children continue to plague efforts to ensure a successful future for this group. Thus, the country is at risk of leaving behind a generation of vulnerable women and children. Fifteen years after the genocide in Rwanda, it remains ever more imperative that the international community work to find ways to reach out effectively to these victims of the violence.

Marie Consolée Mukagendo

Rwandan-born, Marie Consolée Mukagendo has worked with the United Nations Children's Fund for over five years. She specializes in issues related to children's rights, including children in armed conflict, and is based in Maputo, Mozambique.

Josette
with her
son,
Thomas

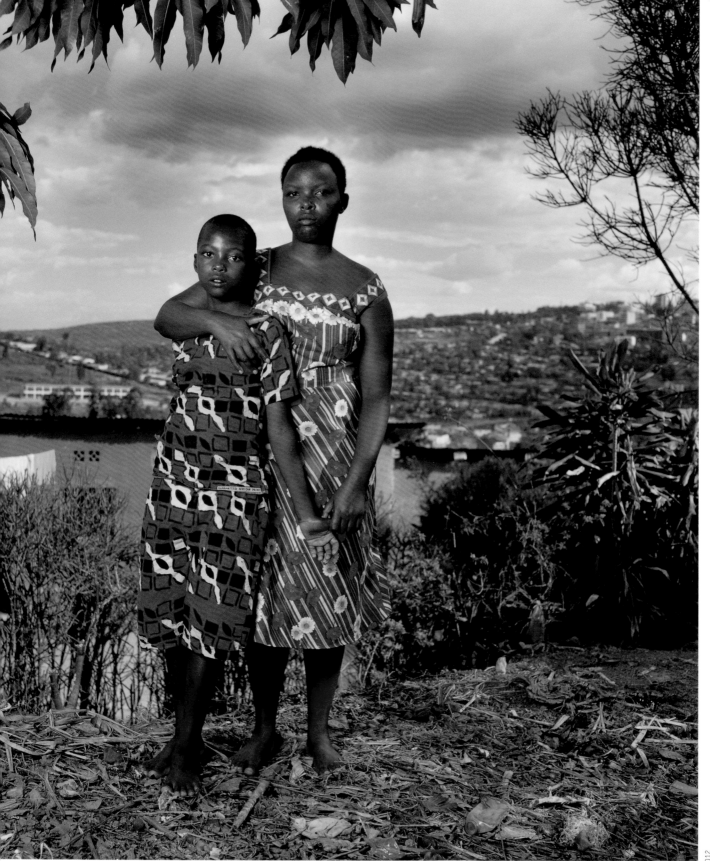

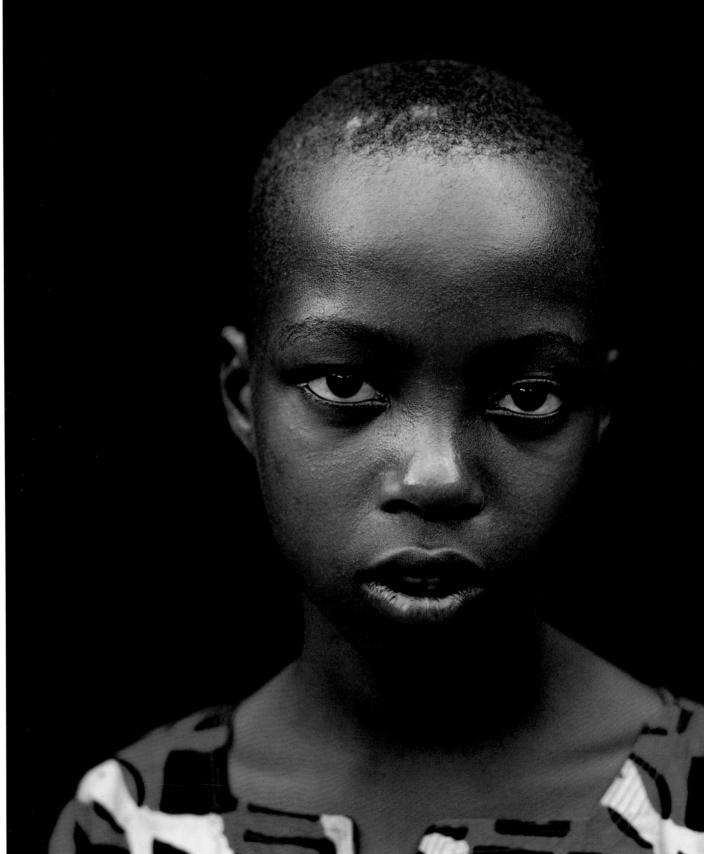

He said
I shouldn't
enter his
house carrying
a baby of
the Hutus
and chased
me away.

> They said they were going to rape us, but they used the word *marry*. They said they were going to marry us until we stopped breathing.

The militias came in the evening and locked us in a house. Then they said they were going to rape us, but they used the word *marry*. They said they were going to marry us until we stopped breathing. That night, my sister told me to get ready because she had already been raped. I had never known what sex was like. The militias went away in the morning and came back in the evening with clothes and machetes stained with blood. They told us to wash the clothes and machetes—that was going to be our job because they had other jobs to accomplish. They kept doing that: coming with blood-stained clothes, we would wash the clothes, they would rape us at night, and then the next day, they would go out to kill. That was the pattern of our lives.

Every morning they hit us ten times. After hitting us, we got a different man. Eventually my sister said it was too much, that we needed to commit suicide. There was a river close by that my sister heard people talking about. We went to look for it so we could throw ourselves into the river and die instead of living with torture. But when we got to the river, there were many dead bodies floating in it, and we feared going there.

My sister was pregnant at this point. I also realized that I was pregnant. I was so weak that I couldn't even walk. I had too much pain in my private parts, but that did not stop them from continuously raping me. Eventually they cut my sister, and three days later, she died. When I realized she had been killed, I knew I would also be killed. By the time they killed her, her kid was five days old. The baby was also killed.

My uncle didn't welcome me into his house. He asked me who was responsible for my pregnancy. I said if I am pregnant, then it must be the militias since many of them had raped me. He said I shouldn't enter his house carrying a baby of the Hutus and chased me away. I left, but I didn't know where to go. Later, my uncle told me that I could only enter his house if I agreed to throw away the child. Because of how I was living—the conditions were very difficult—I complied. We left the child in the forest, but as we were going to get into the taxi, I didn't feel comfortable. I went to find my child and put him on my breasts again. My uncle said that if I was taking the child, I shouldn't come back.

I must be honest with you; I never loved this child. Whenever I remember what his father did to me, I used to feel the only revenge would be to kill his son. But I never did that. I forced myself to like him, but he is unlikable. The boy is too stubborn and bad. He behaves like a street child. It's not because he knows that I don't love him; it is that blood in him.

Stella
with her son,
Claude

I don't think
about Rwanda often.
I think about
my son.
He is like
a tree without
branches.

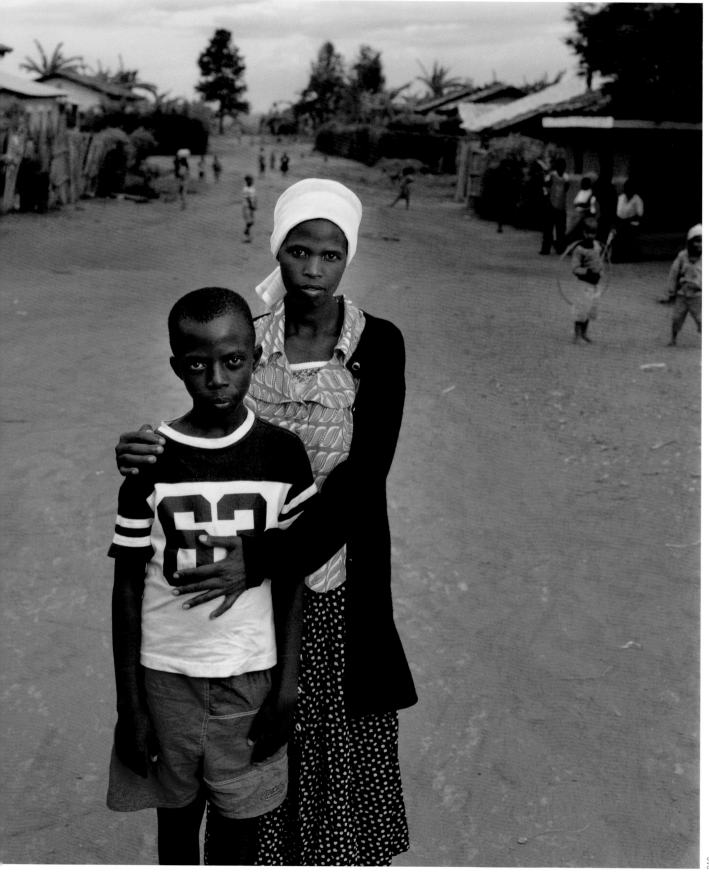

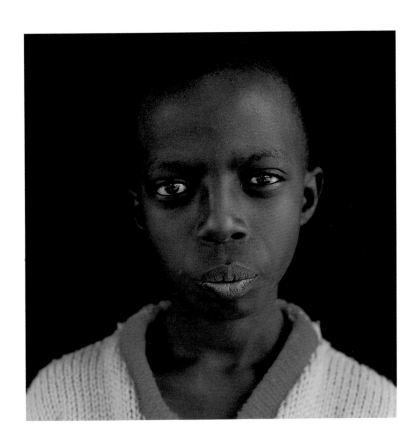

Sometimes I forget where I am. Today we may be talking and, all of a sudden, I think I am in the forests in the Congo. Sometimes I see myself and around me, men are running, chasing me or raping me. Then, I realize I am in a normal setting. I have these hallucinations and nightmares. I have never overcome them.

It was a surprise if a night passed and no man raped me.

The militias took us to the forest. They were very mean and started raping us one after the other. Afterward, they thought we had died and they left us there. Once they were gone, a kind Hutu lady nearby who saw what was happening came over to see if we were still alive. She took us to her house and gave us porridge. But the militias saw her and asked her why she was helping the cockroaches. Overcome by fear because they threatened to attack her, she told us to go back to where we came from. When night came, we slept in the bush. Every day, every night, a different man had sex with me forcefully. It was a surprise if a night passed and no man raped me.

My son was born on July 7, 1995. I'll never forget that day. I wished that he would die immediately after birth. I was surprised when he didn't because I didn't have any milk in my breasts to give him. My kid was almost a skeleton. But that man, that rapist was with me, and despite these problems, he kept raping me again and again.

My problem is that boy, my son. I don't think about Rwanda often. I think about my son. He is like a tree without branches. I am alone with him. I don't have any surviving relatives apart from my old mother. He is my life. He is the only life I have. I love him. If I didn't have him, I don't know what I would be. I ask myself, suppose I die now, what would happen to him? I would really be happy to have my life as it originally was before the war. Perhaps then, my son would have a future.

I ask you to tell the world that genocide happened in Rwanda, that we went through torture like no other person has gone through. Even the legacy of genocide is too much to live with. The international community has a debt to pay because they didn't come to our rescue. They should now come to support us in the legacy of genocide.

Justine with
her daughter,
Alice

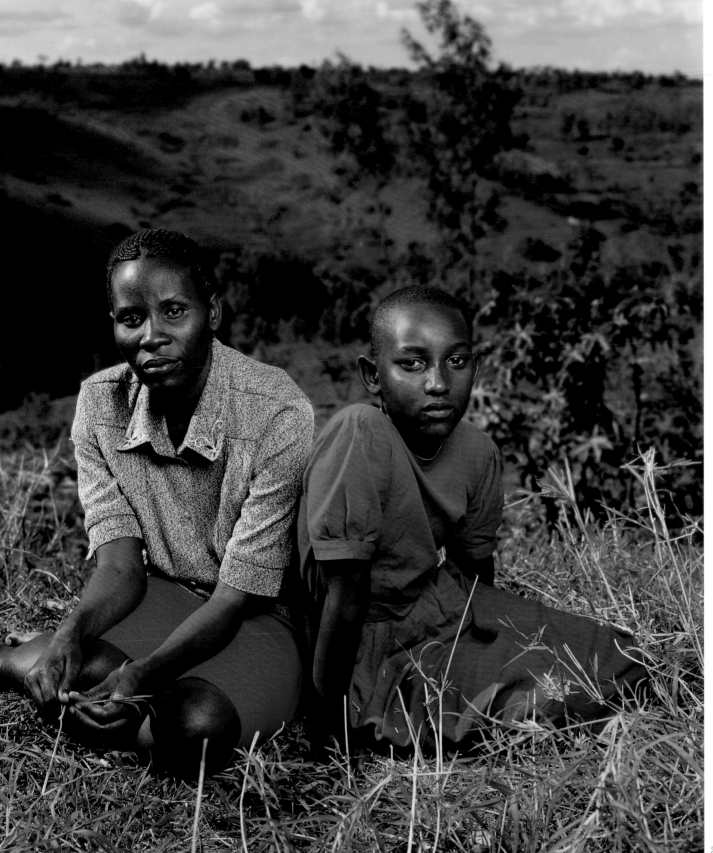

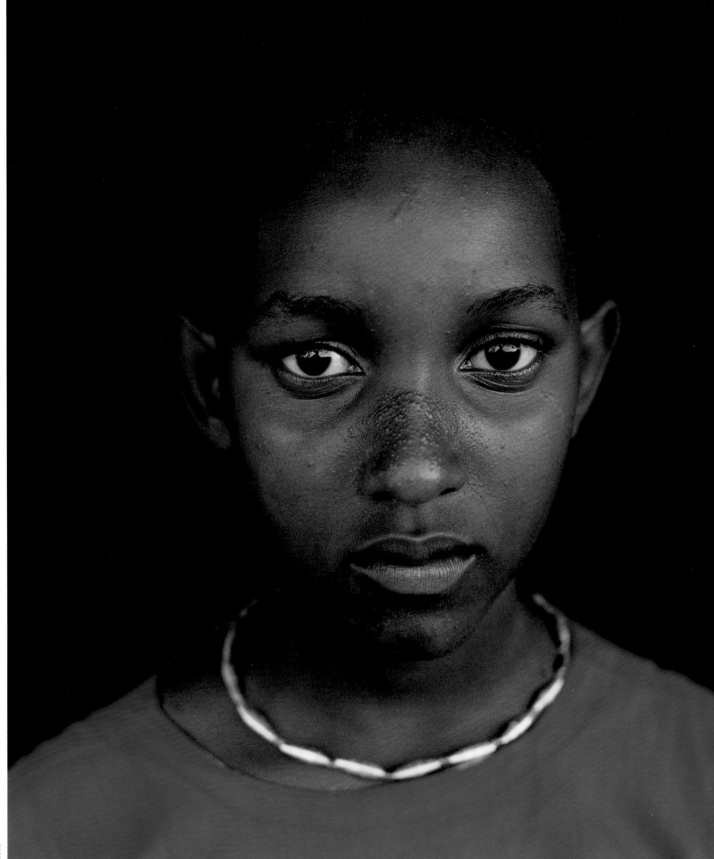

ALICE

We went to a church nearby because we thought that it would be safe. All of my family were killed in that church except me.

We went to a church nearby because we thought that it would be safe. All of my family were killed in that church except me. In 1959, when our people took refuge in churches, they were not attacked. Our parents thought it would follow the same pattern.

We stayed there for two weeks. On April 9, the militias took me and raped me. We were hiding in one room in the church, and the militias collected us and took us to a banana plantation where they raped me. One took me as a sex object for three days. For three days, I was his "wife," so to speak, and when I came back after the third day, they went to steal food and property from our neighbors. I ran away to come back to the church. When I returned, I found my family dead. I was confused and stranded, but the RPF soldiers found me there and rescued me. My father and mother and all my brothers and sisters were killed. About five thousand people had taken refuge there, but less than one hundred were rescued.

At the time, I didn't have many wounds on my body. Compared with other people, I was okay. I took on the voluntary service of cleaning and washing others, so the hospital here took an interest in me and gave me a job. I stayed okay until I delivered the baby I was carrying. I don't have many problems, but my sisters left behind children. They are orphans and only have me to look after them. But I am not strong enough or in a position to look after them. Right now, we do not have a house. This is a hospital house that we rent. If I could get shelter, I would put all these orphans together and look after them.

Bernadette
with her
son, Faustin

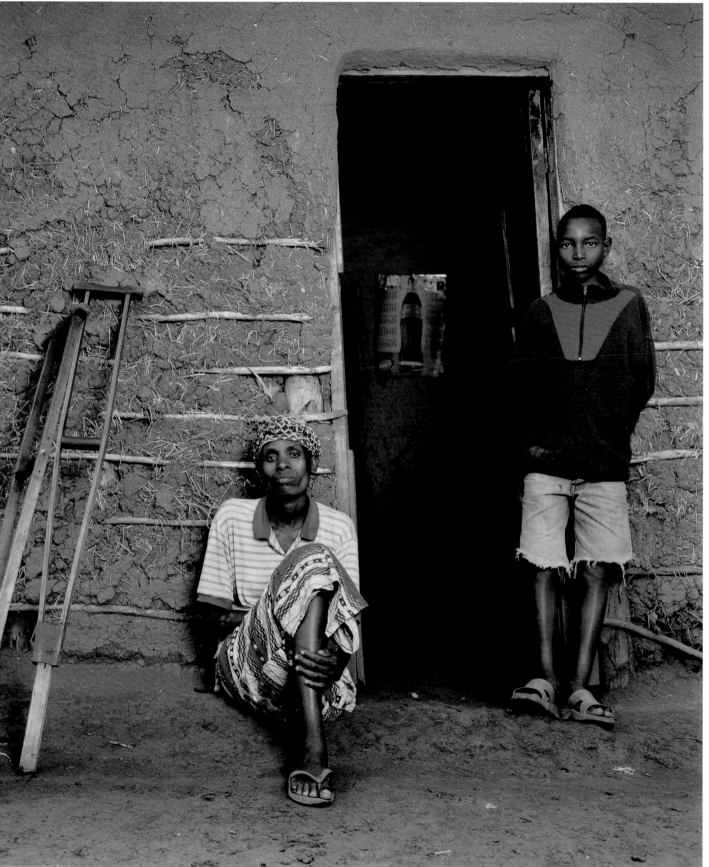

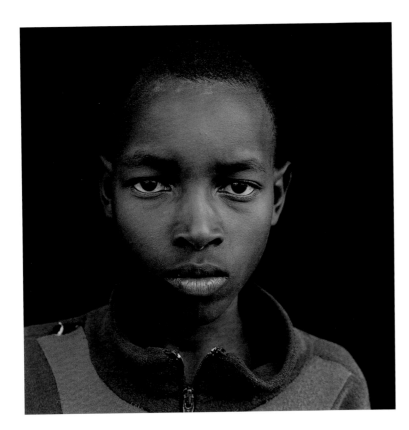

My mother negotiated with a militia member to try and save us. We gave him part of our eucalyptus plantation to save my brother, Turgen. We didn't know that they would kill women. Three days later, he came back and said that he no longer wanted the land. He said, "I want your daughter; I want this girl." My mother said no, that the land was enough. Then he came back again with other militiamen. Eventually they took me to the forest, and he told them to gather around. He raped me and said that now I had no choice but to have a permanent relationship with him.

> **If there is anything that tortures me, it is the tomorrow of my son.**

He told the other militiamen to reduce my height because I had always been arrogant; so they got clubs and hit my legs. They didn't cut my leg off, but they hit it until it was all broken. I couldn't move; I was shaking all over. Later, I went to a refugee camp for Tutsis. But little did I know that this man had made me pregnant. I had the problem of the pregnancy and the problem of the leg, which was now beginning to swell. There was a lot of puss in it, but they hadn't cut it off yet.

I knew that nobody would be happy with the child, but I prepared myself. I was excited about it. Today, if you want trouble with me, then show me that you hate my child. I am a mother, yes, but I am not a mother like I ought to have been a mother. Maybe God chose that this is my life. I've accepted it. Although, I think if it wasn't for the genocide, I would have been a better mother.

My family didn't show me that they didn't like my child. In Rwandese, a child is an angel, is innocent. You can't take the sins of the father and blame them on the child. My family accepted this child, but I am talking about my family, not the family of the father.

My son is twelve years old, and I think he knows, though we have never sat down and squarely talked about it. Once he came crying and yelling that someone told him, "You're the son of a militiaman. Your father is in prison." The philosophy I use for my life is to laugh; so I laughed and after laughing told him, "Why should that worry you? Why should that make you cry?" If he has brains, he should know by the way that I laughed. I confirmed to him that he is the son of a militiaman.

Whenever I think about his future, I don't know, and that is my biggest problem. Sometimes he sits here for a whole school term because I have failed to get pens and books. If there is anything that tortures me, it is the tomorrow of my son.

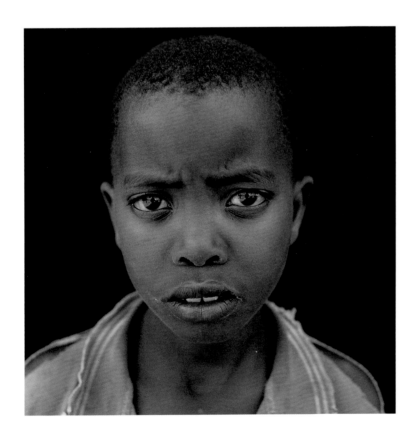

The genocide started when I was fifteen. All the Tutsis from this area ran up the hill where the strong men from the area were resisting. We kept repelling them until April 18, when the soldiers from the presidential guard overpowered us. That day they killed many people. My two brothers were killed, my sister died, my father died, and my mother died.

When I awoke the next morning, I heard voices. My heart told me that it would be my father and mother; so I ran to see who was talking. It wasn't my parents, but people I knew, my neighbors. The militias held them captive. One militiaman asked if we had money to give them. When we gave them money, they left us alone and told us to take this road. Little did we know then that they were sending us directly into a roadblock of merciless militias.

At that roadblock, one of the militias knew my aunty. He asked me if I was related to her. When I said yes, he said he would take me to her. My aunt was very happy; she thanked him and gave him a goat for securing me. But later he came back and said he wanted me to go with him. My aunt begged him not to take me, but he said, "I take her or I kill her right here."

He started raping me from that night on for two weeks until we heard that the RPF were near the village. The militias became scared. He told me that they were going to kill us in the evening, but if I trusted him, he would save me. I didn't have a choice. He took me to a place where he had relatives, and I stayed there. When he heard that the RPF were going to take over the government, he decided to go into exile. We went to Tanzania and there, when he realized that I was pregnant, he declared that I was his wife.

I had never had sex until I was raped during the genocide. I never loved that man at all. I always feared him. Even now, when I hear people say they enjoy sex, I don't know what it means to enjoy sex. For me, sex has been a torture and I associate it with torture. As we stayed for a second year in Tanzania, he insisted that he wed me in a church. I had no alternative. When we got back to Rwanda, I went to my church and told them what happened to me and that I wanted a divorce. At first they refused. I got annoyed and wrote a letter to the chief of the big parish and told him my story. He understood me, and the church allowed me to divorce. Now I am free. I feel satisfied and have hope and faith in God and in the survivor organizations that support us. They encourage us to live positively. Whatever I do, I strive to see that my parents' killers are not going to laugh at me. Instead, they are going to see me progressing every day and keeping alive.

Valentine
with
her daughters,
Amelie
and Inez

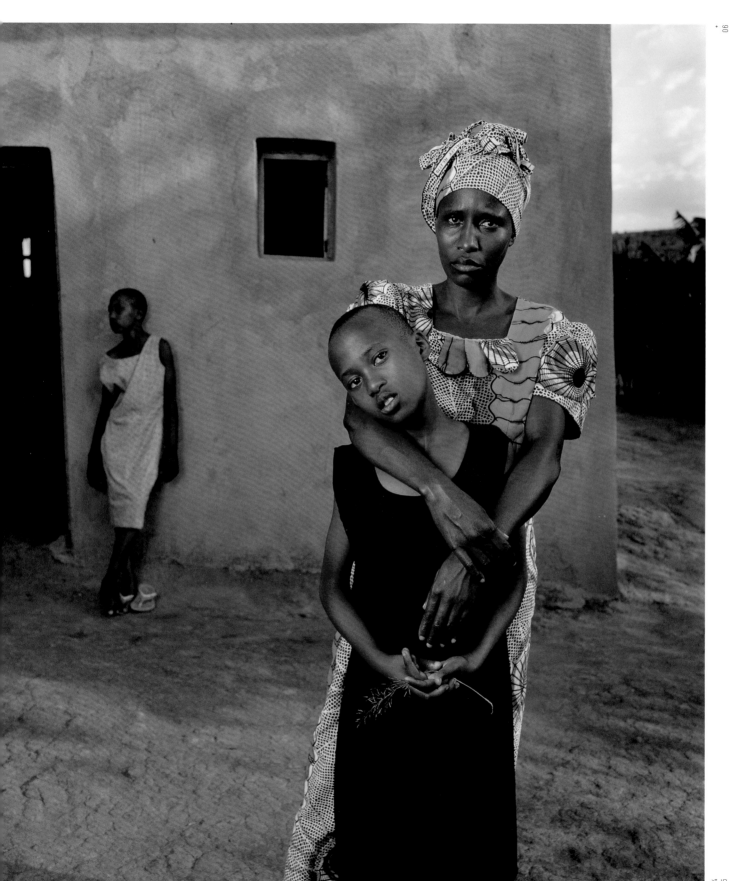

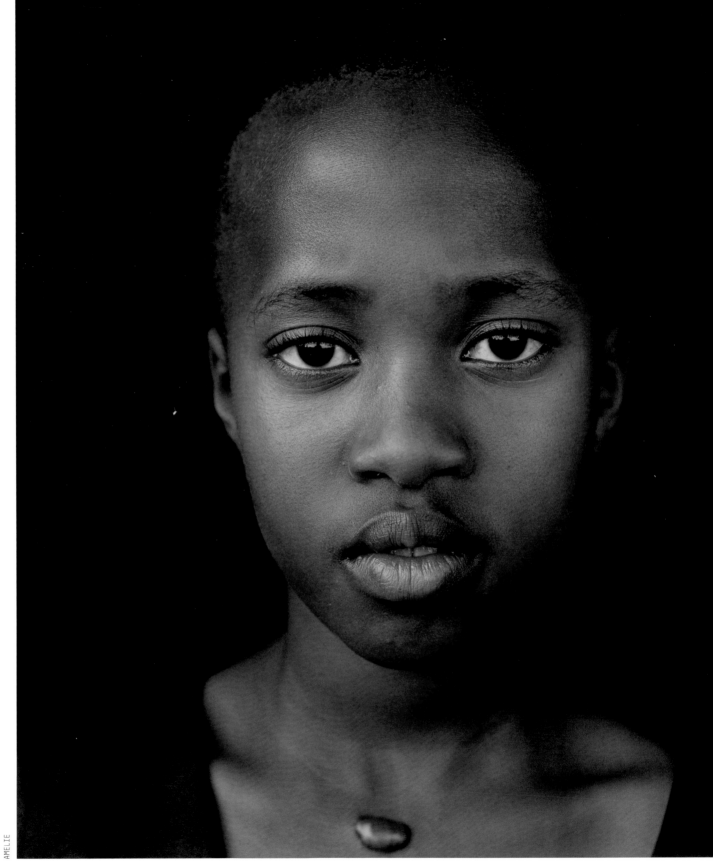

AMELIE

That fateful day, April 9, is when they attacked my husband's house because they considered him to be a sympathizer with the RPF. We had just ended our honeymoon. We had been married for three months, and I was two months pregnant, carrying a little girl.

The head of the militias was ruthless and put a spear in my leg to force my legs apart. I was raped every night, and during the day, they locked me in. A man, who had been a friend of my husband's, pretended to be kind, saying that he would take me to his house, that they had wreaked enough havoc on me. He asked his wife to let me sleep on the bed because I was pregnant and had gone through difficult things. She allowed it, but whenever she left the house, he came and raped me.

When I was in a refugee camp in Congo, I gave birth to my daughter. Fortunately, she was alive. I stayed there and was raped by that man and other men as they wished. Shortly afterward, I became pregnant again. One day, I boarded a truck that was bringing people back to Rwanda. When we arrived, I learned the news of my family: they had all been killed. I had two sisters and three brothers—they all died. I am the only survivor in my family. My mother and father and five grown children died. I am the only survivor, but I have my two children.

It took me a long time to be able to sit and talk like we are sitting here now. I went to the Association of Widows of Genocide, where I received counselling and support. They encouraged me to talk.

I love my first daughter more because I gave birth to her as a result of love. Her father was my husband. The second girl is a result of unwanted circumstance. I never loved her father. My love is divided, but slowly, I am beginning to appreciate that the younger daughter is innocent. Before, when she was a baby, I left her crying. When it came to feeding, I fed the older one more than the younger one, until people in the neighborhood reminded me that was not the proper thing to do. I love her only now that I am beginning to appreciate that she is my daughter too. My cousin is also a lone survivor. We gather courage together and talk about our experiences during the genocide, but we have not revealed everything to the young girl—she thinks she is like her sister.

> My love is divided, but slowly, I am beginning to appreciate that the younger daughter is innocent.

Isabelle
with her son,
Jean-Paul

Sometimes I
look at my
situation and
compare myself
with people
who have their
families
around them,
and I regret that
I didn't die
in the genocide.

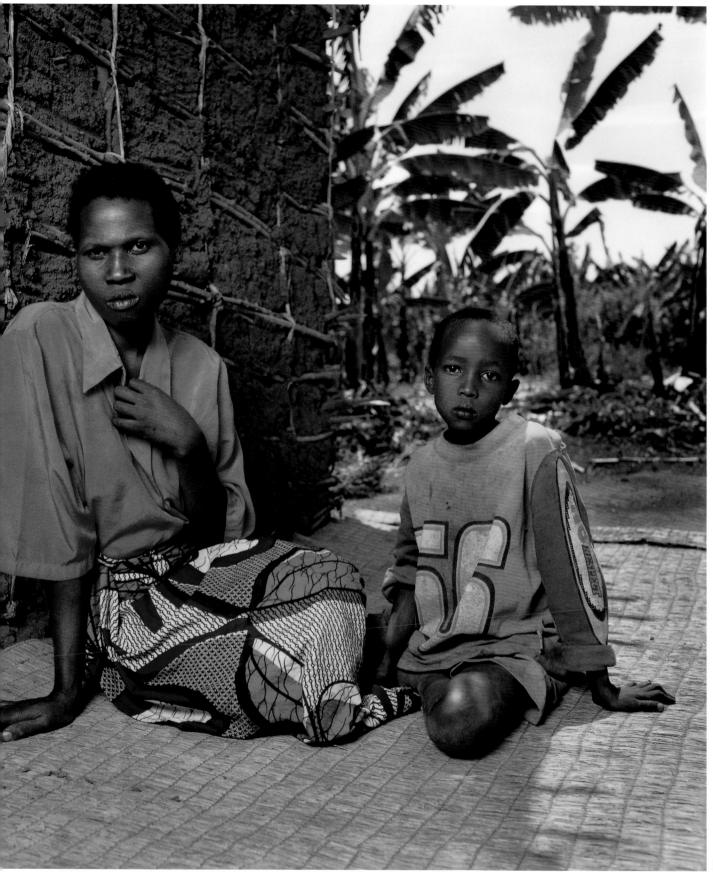

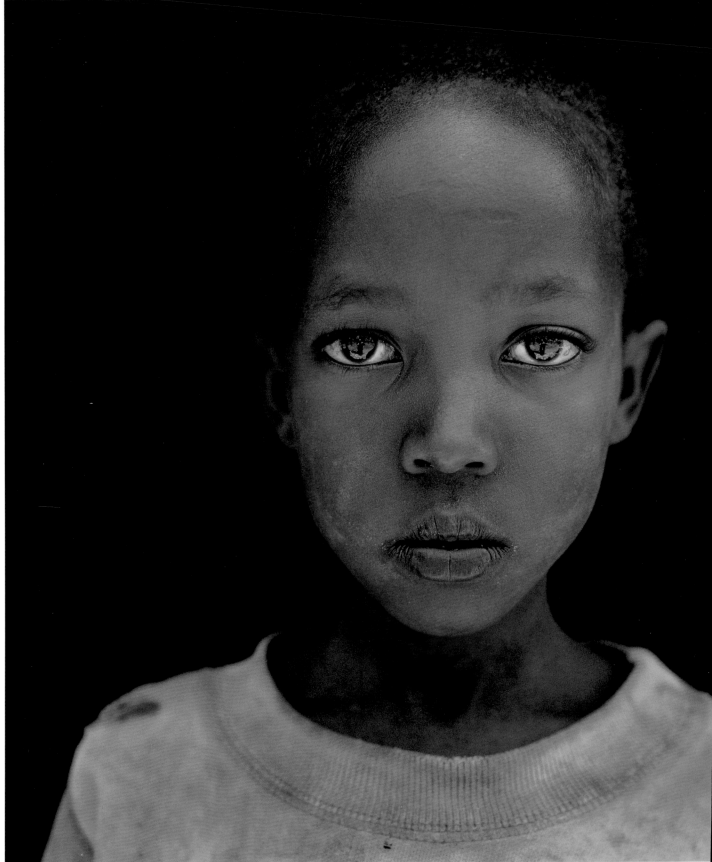

It all started on April 6 in the evening when they told us that the president had died and my mother said we should run away from the house. I ran, but I didn't know where I was going. I didn't even know what had happened, apart from hearing that the president had died. The next day they told us that they had started killing people in the neighborhood, but I hadn't seen anyone dead. The third day is when they killed my three brothers; then I knew it was real. A group of militias attacked our home and took me. In the evening, they took me to a place where they raped me, one after the other. I can't tell you how many there were; I can't describe the experience. What I know is that later I realized that I was pregnant from that rape. I'd never had sex before; that was the first time.

My first thought was that I should have an abortion, but I didn't know where to go for such services. After giving birth, I thought of killing the baby because I was bitter and didn't know who the father was. It was painful, but eventually I decided not to kill him. I feel trauma every time I look at this boy because I don't know who his father is and I don't know how I am going to live with a boy who has no family. I am physically handicapped because of the beatings that I endured and I can't carry anything. I can't work. All I can do is sit down. It was not until now that I can say it is good that I didn't kill that boy because he fetches water for me.

Now I have accepted that he is my son, and I will do whatever I can in my position as a mother to raise him. But I fail in my duty as a mother because of poverty. I fail to buy him soap, so he can't wash his clothes. Sometimes he doesn't have enough to eat. But it is because of my poverty not because he is the son of rapists. I am not interested in a family. I am not interested in love. Anything that comes to me is a surprise, not something I planned. I don't see any future for me. Sometimes I look at my situation and compare myself with people who have their families around them, and I regret that I didn't die in the genocide. I wonder why the genocide didn't take my life.

Sylvina
with
her daughter,
Marianne

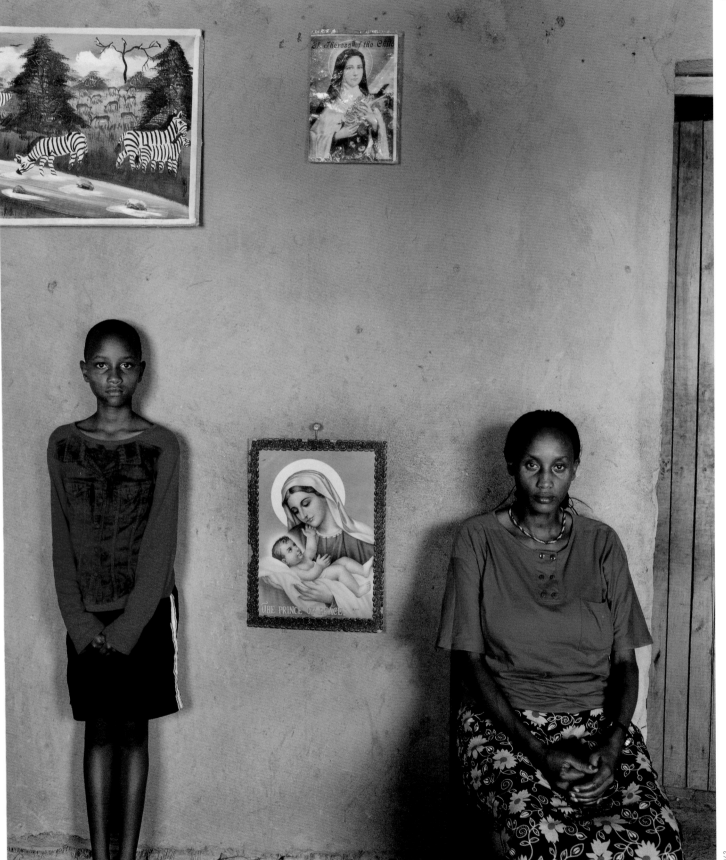

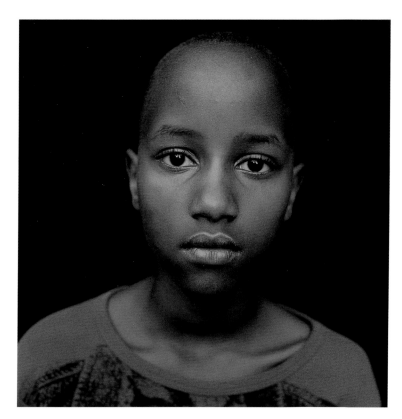

MARIANNE

My orphans and my daughter are my hope.

I cannot really tell you how many men came to rape me; they were many. All I know is that four months later, I was pregnant. I felt so bad about it, I tried committing suicide twice. I kept asking myself how I was going to raise a child whose father I didn't know. But deep down I said to myself, "You don't know why you stayed alive when all your family members died. There must be a reason." So I stopped attempting to commit suicide and gathered courage. The good news is that when my daughter was born, she looked like me and that was my source of happiness.

The genocide affected my family in particular because we were tortured more than words can tell. My parents were beaten, my mother was cut by machetes, and when it comes to me, I live with HIV, which is a legacy of genocide. The militia raped us brutally. There were between six and seven men, and all of them raped me. I don't want to think about it again. We begged them to kill us, but they refused. Instead, we had to travel with them to roadblocks. They would make us sit there as they killed. After killing, they would come back to rape us. Even though they were doing all this to us, they knew we hadn't eaten or had anything to drink. And they smelled, always in dirty jackets, they lie on me. One day, it's one bastard smelling, the next day another with a different smell. It was terrible.

I have many children that I look after. My brothers and sisters have all been killed, but six of their children survived the genocide. I am their everything— their mother, their father, their grandfather. They don't want to hear that I am HIV positive, but it is reality that they have to live with. I am.

I have never told anyone that Marianne is my daughter too. But, even so, everybody knows I'm her mother, and I'm happy. My orphans and my daughter are my hope. It's better than being called Mama-nobody; I am Mama-somebody. That keeps me going.

Marianne is my life. Since I know that she is alive and she is mine, I don't regret the past because I will have her as long as I can be on this earth. The only thing that gives me trouble is what will happen when I die? What will happen to her?

I wonder why I was chosen to survive. All of these children I care for have no other surviving relatives. And I am not sure of my tomorrow because I am living with the HIV virus.

Winnie with her daughter, Athanse

I wanted to
find a
place to
disappear
into the
water
instead
of going
through that
torture.

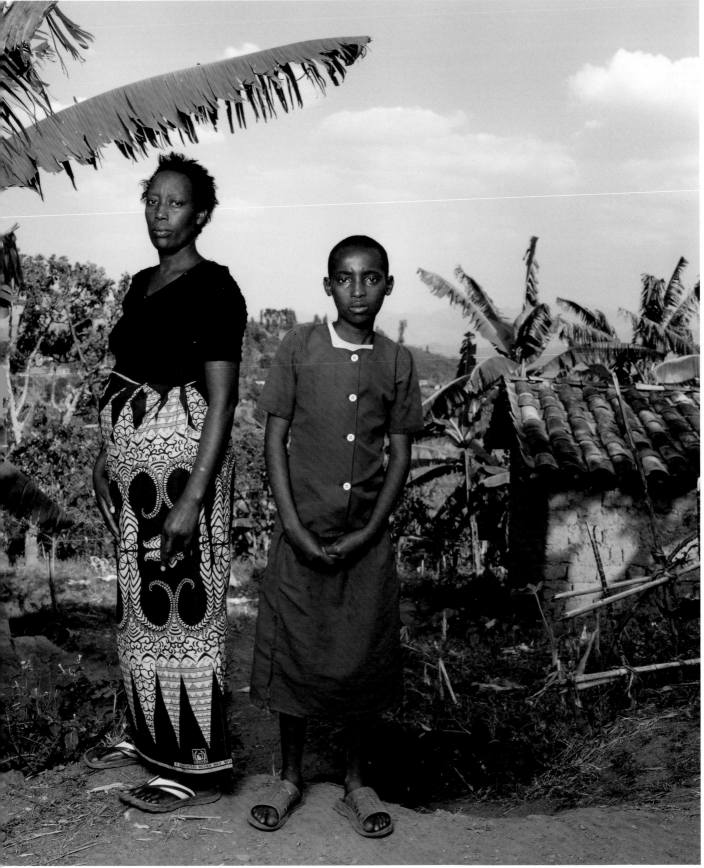

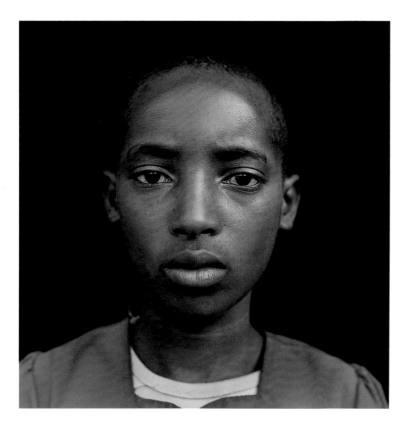

ATHANSE

I've now come to accept that we can live together with Hutus. Maybe it was not their fault, but the result of bad leadership. But when I think of going back to the village where it all happened, I can't imagine going there again. I've never gone back there. Whenever I think about that place, I hate Hutus.

On April 7,1994, my fiancé was killed. The man who killed him actually told me he came to protect me. He brought me to his house and kept me there. I thought he wanted to save me, but on the third night, he started raping me. Each day, he would lock me in the house while he went to kill. And, he would return with food that he ordered me to cook for him. Sometimes he would give the key to other militiamen. When the door would open, I would think it was him returning, only to see a different militiaman. He would rape me, finish, lock me in again, leave, and then give the key to another.

One day, exhausted by that routine, I risked my life. I broke the small window in the bedroom and jumped out of the house. I fled to the jungle near Lake Kivu and I planned to commit suicide there. I wanted to find a place to disappear into the water instead of going through that torture. But they came looking for me. The man who kept me before was in the group, and when the other militias wanted to kill me, he prevented it, saying I had disappeared from him and he would take me back to be his "wife." And so he did, but he was very hostile afterward. He came with groups of men. They raped me one after the other until I couldn't close my legs. After one of those nights, a final man appeared. He was drunk and high on opium. He forced himself on me, and when I tried to resist, he overpowered me and drove four nails into my body. He raped me so hard that he crushed one of my nerves. This damage is something I still live with even now.

When I realized I was pregnant, I was very depressed. I was in a refugee camp in Congo, and I did not want to have the child of a man I did not know in a place that I did not know. So I returned to Rwanda, to my village, in search of surviving relatives—someone to help me give birth or advise me how to raise a child. When I got there, I found out that my father had been burned and all my family had been killed, apart from two of my sisters and an uncle. I went through difficulties giving birth because of health complications. Some of my nerves and veins were damaged from the brutal rapes. But despite this, I gave birth to a good girl.

Later I got married with the blessing of my uncle. My husband had no shirt, no trousers; he was a peasant. I, too, had nothing, but we decided to start a life together. He accepted me and took my daughter as his own and gave her his family name. Of course, the neighbors remind him that she's a child of a militiaman. Sometimes he comes home disappointed, but we haven't told our daughter. Even when she asks me, I tell her this is her father. I love her so much, even more so because she is the result of suffering.

Olivia
with her son,
Marco

I had a
premonition
that I might
survive if I picked
one child
and ran away.
I looked at
all three of my
children,
and they all
looked so
nice to me that
I couldn't pick
just one.
But I also knew
that I couldn't
run with
all three.

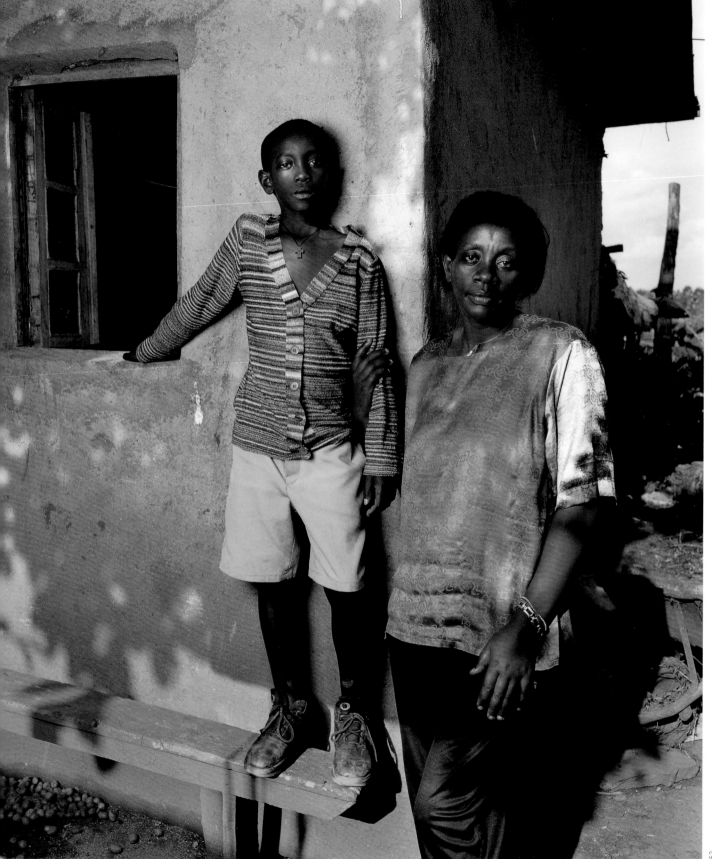

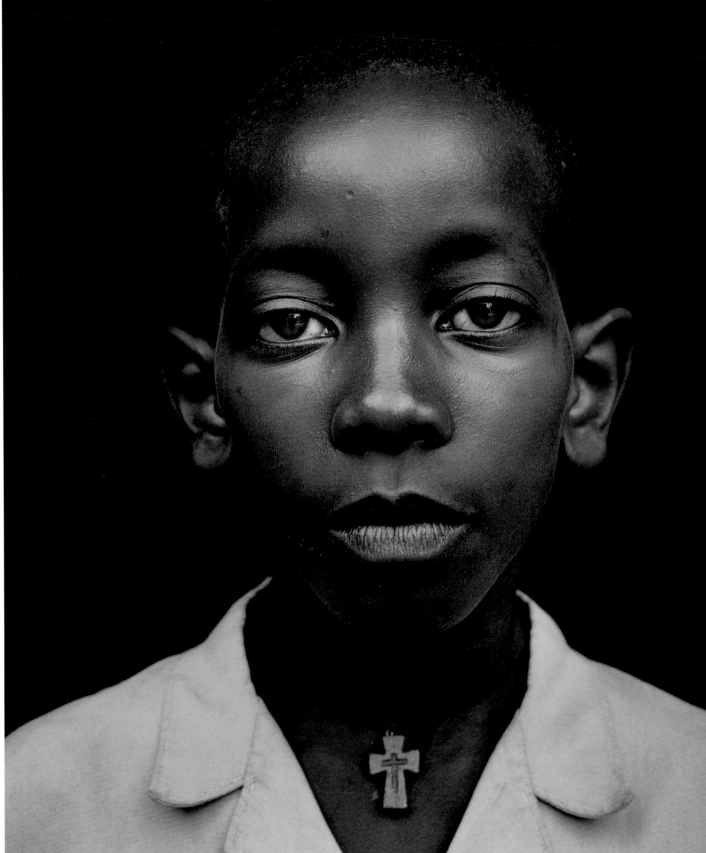

MARCO

About ten thousand people had fled to the church compound at the time. After a week, militias started attacking us. It was a terrible experience. They entered with machetes, with axes, with grenades and guns. Because there were so many people in the church, we were all in one place when they entered. They started cutting into the crowd. When they killed someone, they put the body off to the side; when others went down, they stacked them on top of the dead bodies. I don't think I can fully explain it. It was all noise, crying, and the killing did not stop. After killing people for about eight hours, they said they were tired, that they needed something to help them regain their energy. So they picked girls who were still alive and raped them.

Since the dead bodies were not removed, we had to sleep in the church next to them, even when they began to rot. On the third day, they did not kill but spent the entire day just raping women from different corners of the church. I am a victim of that day; they raped me with all of my children watching. I can only remember the first five men. After that I started losing my understanding. Even after I was unconscious they kept raping me. To be honest, every woman in that church at that time was raped.

I had a premonition that I might survive if I picked one child and ran away. I looked at all three of my children, and they all looked so nice to me that I couldn't pick one. But I also knew that I couldn't run with all three. Eventually, my heart told me to pick the first born, so I ran toward the church door with him. Many other people were running too, and I fell. I put my body over my son's to protect him. Meanwhile, people were falling on top of me, about four layers deep. The militias started cutting those on top into pieces. They cut and killed the first layer, the second layer, the third layer. I realized I was next.

As they were cutting people, blood was falling on us. I confess that I was so thirsty that when the blood ran into my mouth, I drank it. The taste was a mixture of salt and blood. When they came to my layer, the militiamen said, "I think this one is already dead." I pretended to be so. He removed my watch and then my shirt. I waited and then woke up around 3:00 a.m. I didn't know where I was, but then I remembered the church and the dead bodies. I moved slowly, stepping on dead and wounded people, until I got so disoriented. My son was still alive, but I learned later that my other two children were killed after I left them behind in the church.

All survivors have issues, but survivors who went through what I went through have bigger challenges. I am expecting death soon, and when I die who is going to look after my children, who will be their safety net?

Josephine
with her
daughter,
Sylvie

Learn to be
patient just
like I have
been patient
in the trying
moments of
this world.

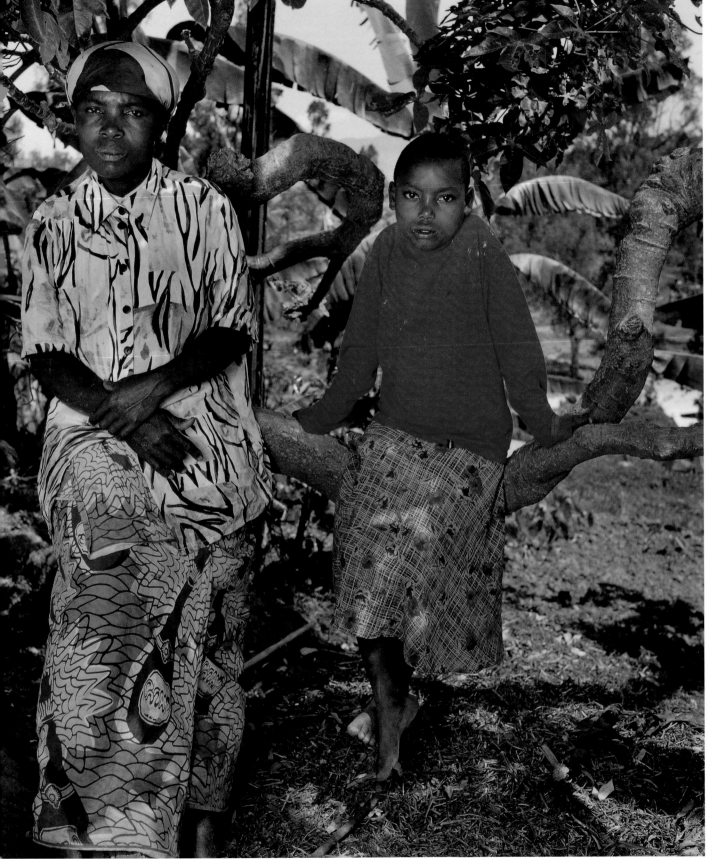

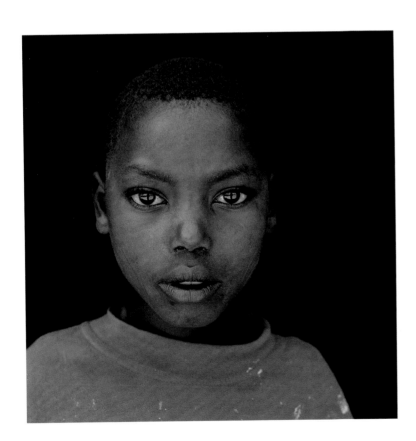

I got married when I was sixteen years old to a Tutsi man. By the time genocide started, we had six children. My husband told me I should take the children and hide in my birthplace. Because I'm Hutu, we thought that maybe I would not be targeted there.

On the way, we came to a very strong checkpoint. One of the militiamen there recognized me. She said, "This one is ours (Hutu), but her children are wrong." They said that they would either kill me with my children or I could give them my children to be killed and be set free. I wanted to be killed with my children. They killed my two boys while I was watching. Then, they told me to flee with the girl, that they just didn't want to look at the boys. Another militiaman got up and said, "Why don't we kill the girl too?" He threw his machete at her. It hit her leg, but as luck would have it, another militiaman then said, "Let me go and kill the girl." He took her, but he never killed her.

When the neighbors at my birthplace saw my daughter alive, they were angry. They organized to kill her, but not with a machete this time. Instead, they put beans in her nose—four beans in each side of her nose so that they would rot there and expand her nose to look more Hutu.

When the militias knew that I was around, they came saying they wanted to see the woman who married a Tutsi. They raped me and told me that I should be there for them to have sex whenever they want, that I was no longer anyone's wife, but a sex object as punishment for marrying a Tutsi. As a result of those rapes, I got pregnant and later I gave birth to that girl.

Because I reported these people in Gachacha, my family does not accept me. They said I should have kept quiet, but I couldn't keep quiet. They killed people in broad daylight when I was watching, when everybody else was watching. I am one of them (Hutu), but I'm not embarrassed to say that the Hutus are beasts.

My neighbors are not friendly. They attack my house everyday. They say I'm stupid, that the Tutsi bewitched me. They ask how I could report what the Hutus did as if I were a Tutsi myself, how I could do this in addition to sleeping with the Tutsis and giving birth to their children. Despite this, I don't regret having married a Tutsi. It is agony and trauma to remember how my children were killed, how my husband was killed. But I think this is what gives me the courage to stand in Gachacha every day.

I think God gave me the gift of being tolerant. The world should learn to respect all people when they consider what I went through, my being led to slaughter as if I were an animal just because I married into a certain ethnic group. God created each one of us differently, but we should learn to live together and to respect each other. Just in case I don't live, I want my children to remain with these words: Be friendly. Love one another. Learn to be patient just like I have been patient in the trying moments of this world.

Brigitte
with her
children,
Emmanuelle,
Ambroise,
and
Rosette

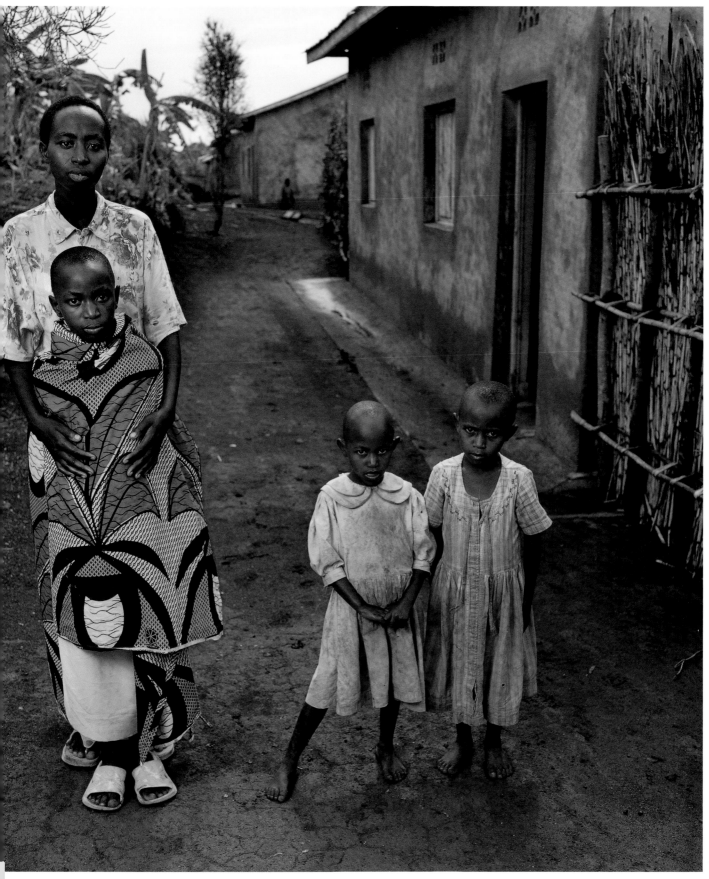

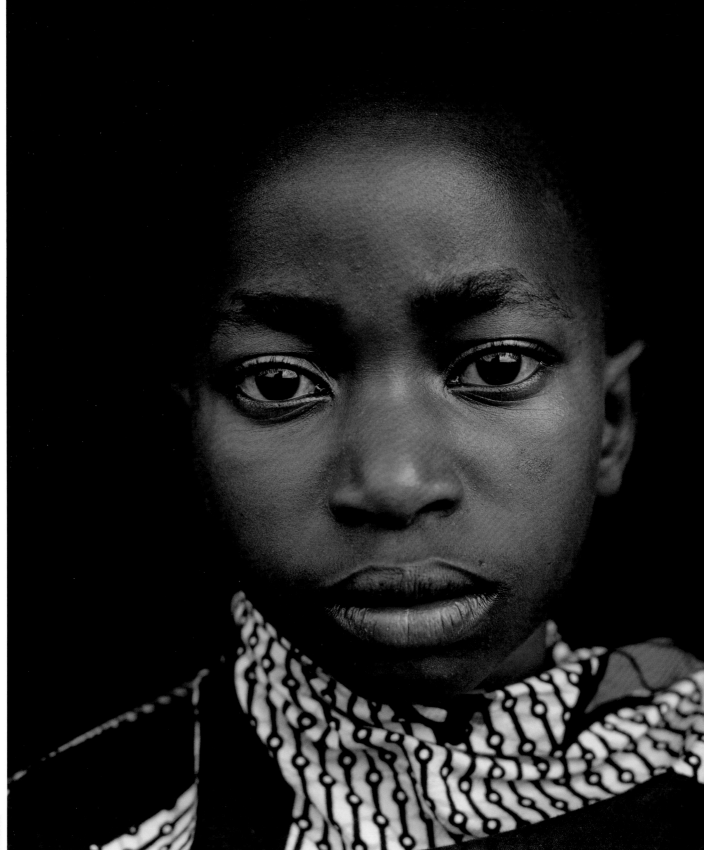

When the genocide started, I was engaged. My fiancé was among the people killed in the first three days, and I saw his body after he was killed with a machete. After that, I was raped by many men that I didn't love. The results are these children. I never fell in love again, I never enjoyed sex, I never enjoyed being a mother or having children, but I have accepted it.

The leader of the militia put guards around me in the cassava plantation and would only allow me in his house when he wanted sex. After sex, he would throw me out at night. I ate raw cassava, and when I felt thirsty, I went to a banana plant and squeezed its stem for water. I felt so bitter—I was fed up with life and felt like I needed to die. So I made a decision and took a risk. I ran to the local leader to declare that I was still alive. I expected them to kill me like they killed my mother and to bury me where they buried her. Instead, the leader took me to his house and raped me for fifteen days.

I am suffering now because of no other crime than having been born a Tutsi.

If you saw me before 1994, you wouldn't believe I am the same person. I used to be a beautiful girl. I used to be loved. I used to have fun at home. It is now all lost. It is now all a nightmare. I feel I don't have a bit of interest in life.

Even now, the world does not know about this. Even as I talk to you, I don't think you understand as I want you to. But I am happy that at least you will go and tell your people that the girls and women in Rwanda went through untold suffering. Before the genocide, we had a very good life. Now there is nothing in life I find interesting. I am suffering now because of no other crime than having been born a Tutsi, and I am paying a price for the sins that I never committed.

Most of the women that I know who were raped have AIDS. Imagine not being sure of tomorrow, afraid that you could die at any time, not because you made love and had fun, but because someone came and brutally forced himself on you and infected you with HIV.

Annet with her son, Peter

When I
hid in the
jungle,
I lived near
a small
bear in the bush.
It never
harmed me.
But when
I fled the jungle,
militiamen
cut me with
machetes.

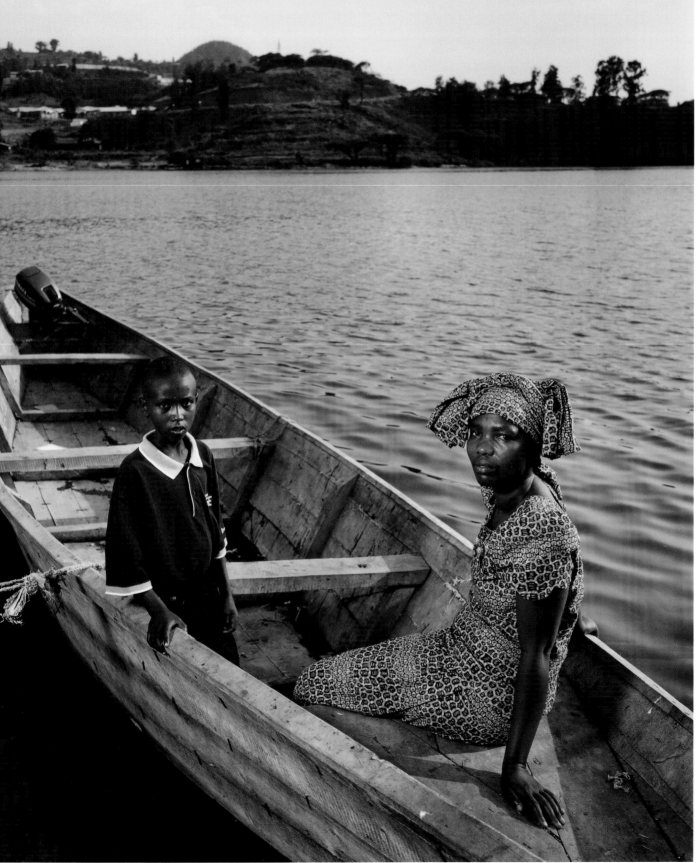

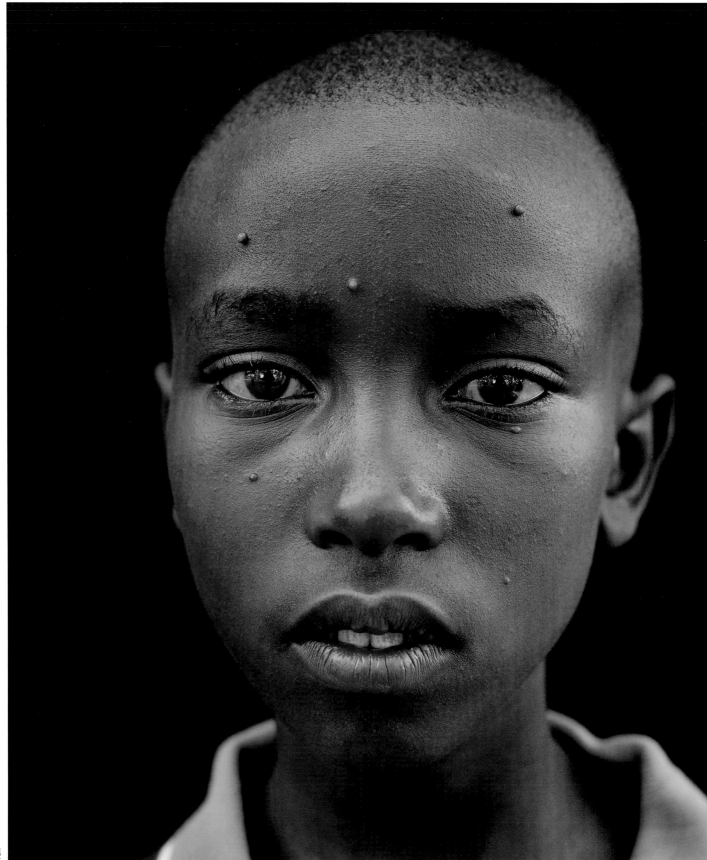

The
effects
of
the
genocide
are
very fresh
on us.

I look at the people who killed our families not necessarily as enemies, but as people who should be forgiven because they didn't know what they were doing. It is beyond comprehension. Even animals cannot behave like the militias behaved. When I hid in the jungle, I lived near a small bear in the bush. It never harmed me. But when I fled the jungle, militiamen cut me with machetes. Now who is more understanding, the beast or the Hutu?

When it started, we hid in one of my uncle's houses because we were a large family. When the militias came, they said they were going to protect us, and they kept us there until the militias came in bigger numbers. My father was hit with clubs; I saw him being killed. My mother was carrying a baby on her back. They hit her with stones and threw her into Lake Kivu with the baby. My elder brother tried to run away from them, but they cut off both his legs before killing him. They hit my other brother with sharp metal. It went deep into his head, and when they pulled it out he started to fall. He was holding my hand when another militiaman cut it off and he fell to his death. My elder sister was terribly raped there. After raping her, they put pieces of wood and sharp metal inside her vagina before spearing her through the neck. They cut us all over our bodies with machetes.

I fled to the jungle, but I could hardly move and I was naked. Maggots started coming out of the wounds. I was very weak, but I eventually removed clothes from the dead bodies around me and slowly walked to the hospital. I begged the militias there to kill me. They refused, sending me away because I smelled. They dug a mass grave and threw us into it. They thought I was dead, but at night, I realized I was alive and dug my way out of the dead bodies.

I ran back to our former home and hid there. One of our neighbors realized I was there, and he raped me at night. He raped me for three days, and I knew I didn't want to continue like that. So I went to talk with one of the local leaders who my father had given a cow to in the past. When he saw me, he called one of his sons and told him to take care of me. The son took me into his house and raped me. I was raped many times. Honestly, I don't understand why the Hutus did this. One of the people who cut me with a machete was a boy who stayed in our home. For years we shared the same food. My father had given a cow to one of the people who ultimately killed him. I don't understand how they turned overnight.

I was still a virgin at the time of the genocide. I didn't know what it felt like to be pregnant, but when I realized I was, I became depressed. I had suffered enough. But when I saw my son for the first time, I felt I had been given another brother. Through all that I went through, he is a gift; he's my consolation.

The effects of the genocide are very fresh on us. We have children born as a result of this violence. These children are everyone's responsibility. It is my wish that they will get to go to school because if you go to school, you have a better life, and if you have a better life, you don't get involved in bad things.

Beata
with her
daughter,
Bertide

When you
despair,
you die sooner.
When you
look for courage,
you go on,
and that's the
choice I made.

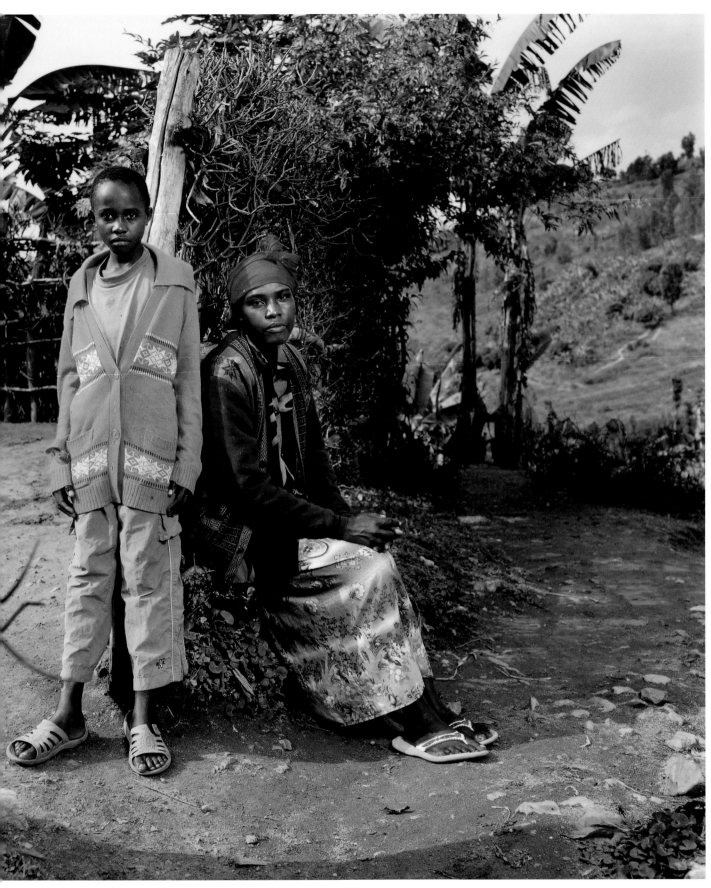

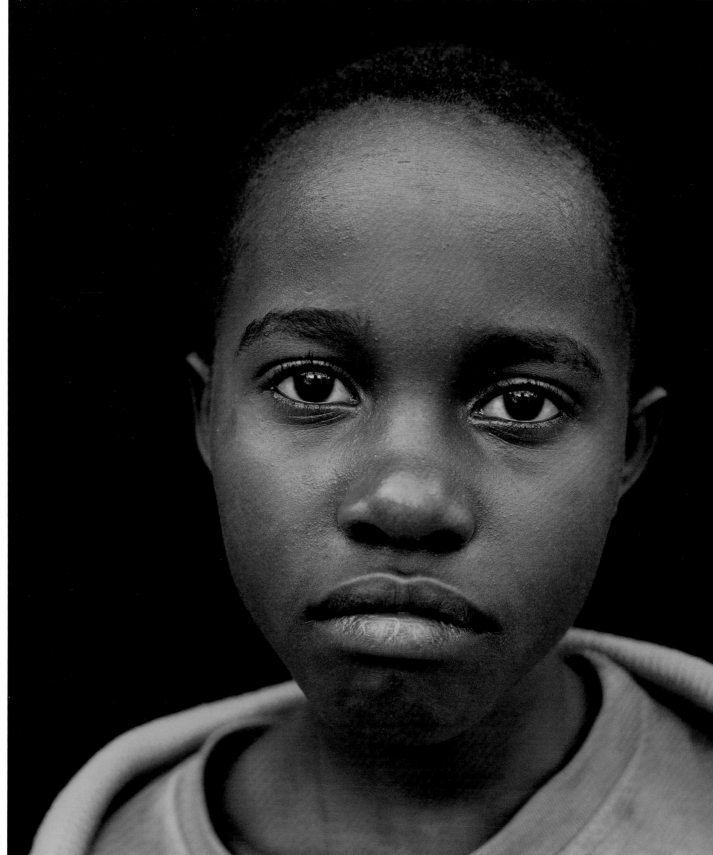

BERTIDE

When the genocide started, my husband and I were together. The militias were killing men first so my husband and other men decided to go by boat across Lake Kivu to Congo. He left me with his jacket, and everybody knew about this jacket. When the militias came looking for him, they found me with the jacket. They said I was the wife of a traitor and raped me along with my mother and sister.

I was hiding with a lot of people in a house when the militias tore the roof off. People started running for their lives. I also ran, but someone hit me and my baby fell off my back. I continued running for my life without realizing. By the time I noticed, I was far away. I turned back, but didn't find her. Later, I saw her dead body.

After I was reunited with my husband in Congo, he asked me if I was pregnant. I denied it, but after four months, it became obvious, and he realized someone else was the father. I didn't have the will to tell him what had happened. He thought I had cheated on him. When we returned to Kibuye, I gave birth, but he didn't care about the child at all. He said he would be glad if she died. But the child lived despite being malnourished, with no food or milk. He later realized that I had been raped and when he knew the child was a militiaman's, he said he could never take care of her. He proposed we kill her so that I could remain with him on good terms. I couldn't accept that. One time he saw the baby lying on the ground and rode over her with his bicycle. Fortunately, she survived. Another time he came in drunk at night and slammed the baby against the wall; blood started oozing from her nose. At that moment, even if he hadn't told me to go, I would have left for the sake of my daughter's life.

I haven't told my daughter what happened; she thinks my husband is her father. She asks, "Why is it that my father does not care? He doesn't pay my school fees; he doesn't buy me dresses. Why?" I tell her, "I'm your mother and your father." If I don't love her, who will? I love her because I have no choice. That's why I call her "God's child." I just surrender her to God and I get my strength from prayers. Otherwise, how would I survive? When I started taking ARVs for AIDS, it gave me more courage and the will to live. When you despair, you die sooner. When you look for courage, you go on, and that's the choice I made. To be honest, I don't think about the future, but I don't take any day that passes for granted. I thank God for it.

This is the first time after genocide that I have really opened up and talked about my story. I think keeping quiet breaks me more. Now I realize that the more I talk about it, the more I feel relieved. Suffering is not death. You can suffer, but push on.

Marie with her
daughter,
Mary,
and her cousin,
Jacqueline

Every step
of that hill,
every tree,
every stone,
every house,
reminds
me of 1994.
I don't want
to go there.

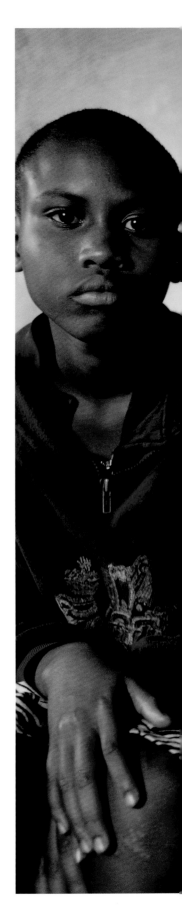

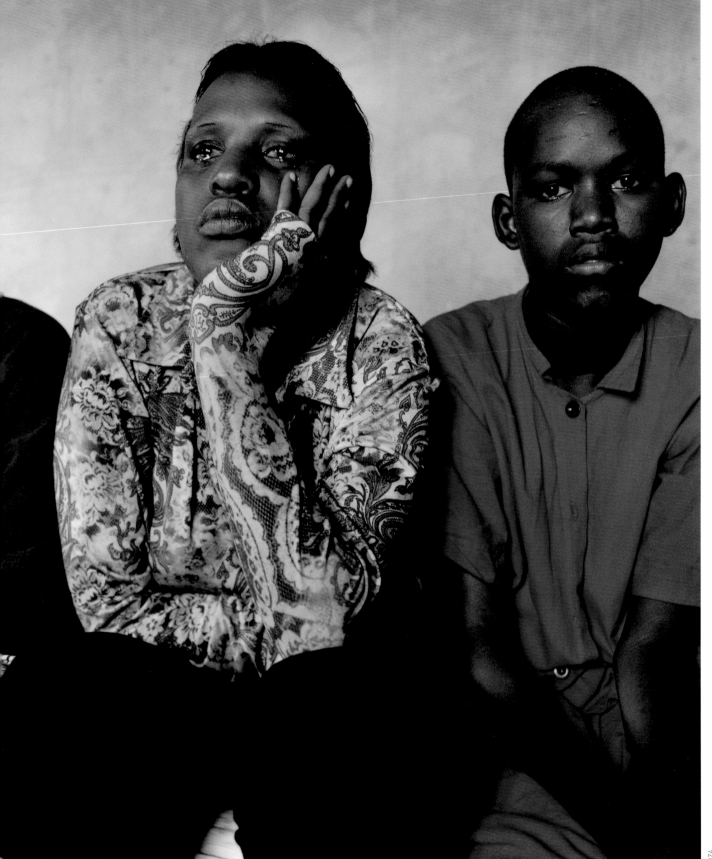

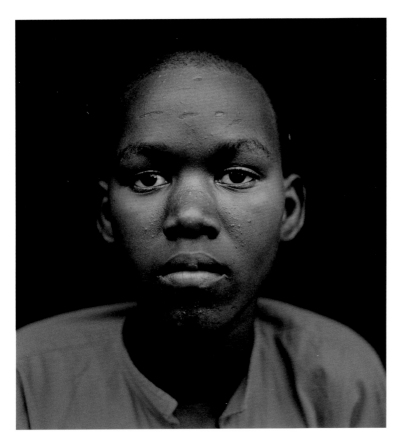

When I heard the bullets, I ran and hid under the bed in the bedroom. They had killed my aunt and uncle, but they hadn't killed their baby, Jacqueline. When I came out from under the bed, it was one of the most shocking moments in my life. They had raped my aunty, and there was blood flowing out of her private parts. Even though she had been killed, they put the baby on her breast. The whole sitting room was full of blood and dead bodies except for the little kid who was alive, but sucking the breasts of her dead mother.

We were attacked by a gang of Hutu men. I started to scream and to shout and to make noise. One of them hit me hard in the chest so I couldn't make any more noise. They negotiated among themselves which one of them would take me home. And one of them raped me. After the rape, I couldn't speak. He raped me over and over for about an hour, and when he was done, he left me there unconscious.

I stayed at a roadblock for a week. While there, I saw them kill people, I saw them rape women, I saw them throw people in pits. Despite what they were doing, they were not afraid of the consequences. They might have been doing this just to torture me. There were over ten men, and they took me in and raped me. One would come in, and when he would leave, another one would come and go. I couldn't count how many there were. After the last man raped me, I told him I was thirsty and asked if he could give me some water. He said yes and brought a glass. Once I drank it, I realized it was blood. The man said, "Drink your brother's blood and go." That was the end.

After a month and a half, I was told I was pregnant. When my father was told the news, he was bitter. He advocated that I have an abortion, but my aunt, who was a nun, said that they shouldn't do an abortion, that for God to let this thing happen to me at fourteen years old, there had to be a purpose.

After the war, I reunited with my father, and he constantly reminded me that this kid is bad, her family is bad. Her family killed my relatives; there is no reason whatsoever for me to love this girl. When I see her, she reminds me of the rape. The first rape and the second rape and all the rapes that followed, I relate them to her.

I can't say that I love her, but I can't say that I hate her either. She lives with my aunt now, and I sometimes miss her. When I am alone in the house, I sit on my bed and think about how I have a kid. But when she comes and asks me for something that I can't provide her, then she thinks I hate her. She can't understand that I do not have what she wants me to give her. Whenever I go to where she lives—where I went through the horror—every step of that hill, every tree, every stone, every house, reminds me of 1994. I don't want to go there.

Yvette
with
her son,
Isaac

When I gave
birth, he
was so
beautiful
that I developed
love
immediately.
I said to
myself,
"I can't kill him;
I am going
to love him."

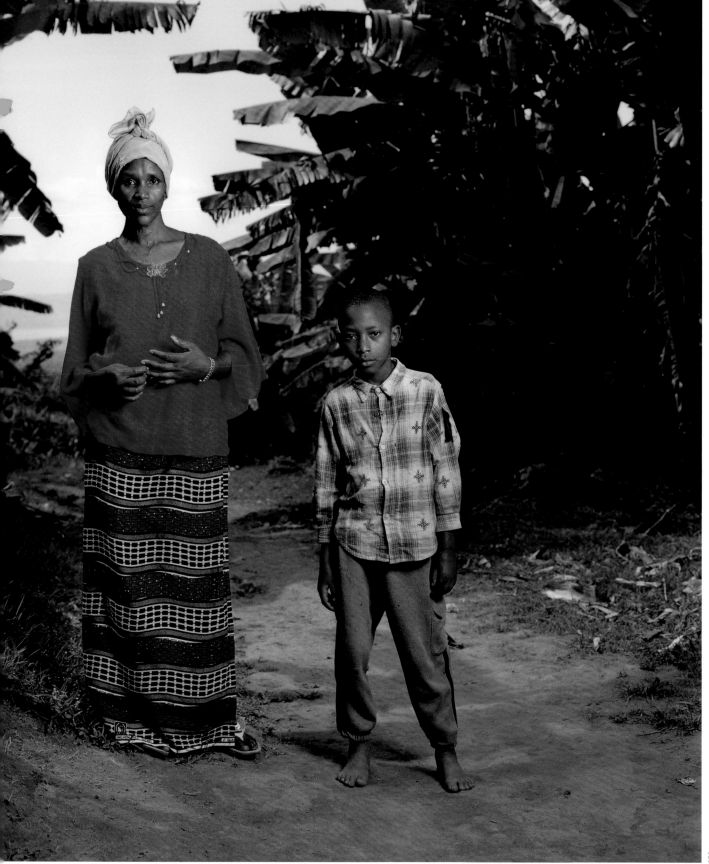

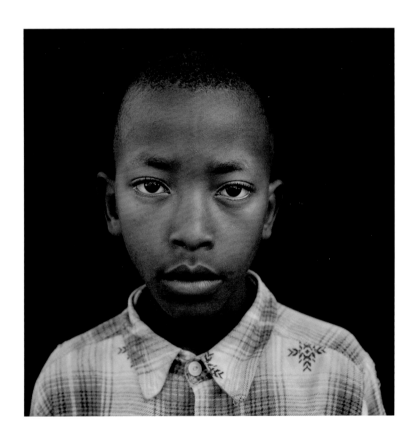

We were forced into marriage, forced into being mothers, but we accepted our children and loved them. There is nothing bad existing in the world that we did not go through. Pray for us so that we may die a peaceful death. Tell the world that if we die, we are leaving behind these children, these children who were born when the world was looking away and never came to our rescue. The world should take on these children and look after them.

Shortly before my wedding, the genocide started. I carried my youngest brother on my back and moved in the direction of the forest. We were about six girls, and the militiamen were many. On the fourth day, they came and found us. They asked how many of us were still virgins; almost all of us were. They wanted virgins on this side and nonvirgins on the other. They ordered me to take my brother off my back. They got hold of him, squeezed his ribs, and said they didn't need to use a machete or a bullet on that one. They threw him in the forest, and as he was crying, they ordered us to remove our clothes. They started raping us. The one who started with me left me and went to another one. And the other one came to me. In turns, they did that for six hours. We were left there as if we were dead.

After around six months, I thought I was probably pregnant. This is when I started wishing to die. I even thought of committing suicide. But I feared suicide and thought instead that I should give birth to that kid and kill it. But when I gave birth, he was so beautiful that I developed love immediately. I said to myself, "I can't kill him; I am going to love him."

My family thought I had died. When we were reunited, it was like they were seeing a person resurrected. They were happy, extremely happy. My brother, too, didn't die. He was taken to an orphanage and stayed there until I found him when I came back.

What I've gone through has prepared me for anything. I pray that if I am to die, let me die after seeing my son living a good life. My wish is that he studies and is successful, but that is a wish because I can't make it happen for him. I have nothing, and I don't see myself facilitating his studies. The government fund for survivors will not take him on because he is not a survivor.

If God allows me some time to see him grow, I will tell my son two things: first to always be careful in this world, and second to protect himself and not to go into sex at all. I would add that he should love people. Because when you love people, you avoid problems; when you hate people, you create problems.

Catherine
with her son,
Eugene

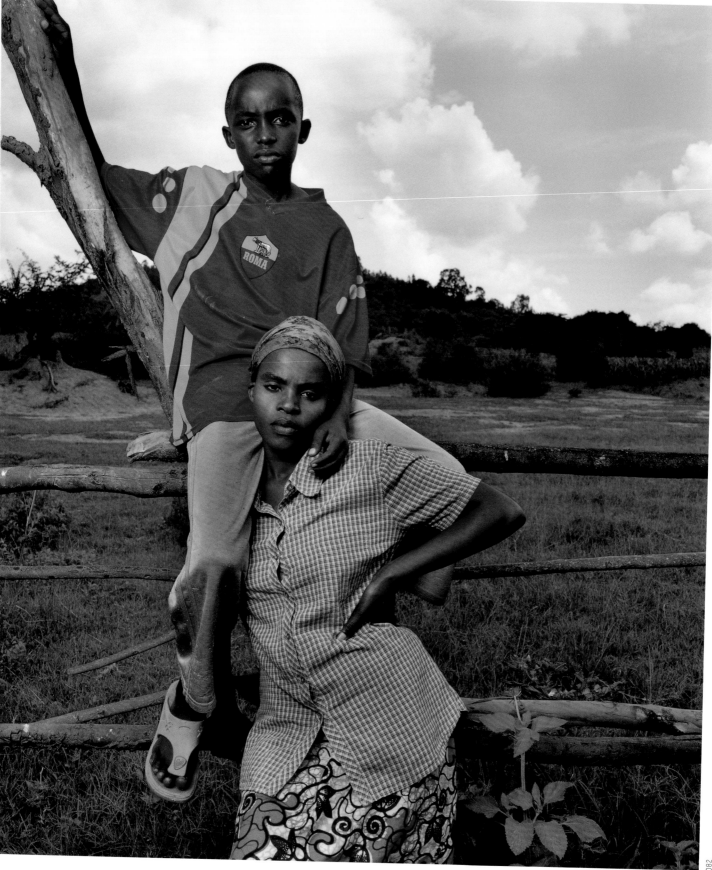

Aline with her daughter, Jackie

Whenever my daughter sees me, her voice disappears, and she's unable to speak.

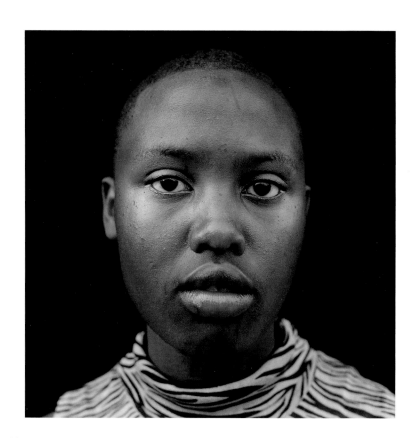

My parents and twelve brothers died in the church, a Catholic church. My brother who survived the church was killed as he ran away from it. My husband and I fled to a tea plantation with four of our children. When he left to check what was happening at home, the militias captured him and took him to the primary school where our children studied. The headmaster of the school shot him—two bullets and he died.

We didn't have anything to eat, so I decided to go to the road. Immediately the militias saw me. There was a rich man there named Simone. He proposed that all the Hutu militia peasants make a mockery of me. They gathered by the road in broad daylight so that Simone could enjoy seeing these laborers rape me, one after the other, while my children watched. By the third day with them, I wasn't human anymore; I was like wood. One of them said, "You Tutsi women are not pleasing us; you are not interested in sex. Let's find medicine to make your vagina wet." They got a bottle of beer and broke it. They mixed water with mud and put it inside me. I began to bleed, and so they said, "Now you're wet," and they started raping me again. After four days, they thought I was dead. But slowly I started walking with my children through the bush. We saw many people coming from Kigali toward the border of Congo, and as we walked with them, I lost my children. They got mixed up in the crowd, and I couldn't find them.

After this, a man captured and tortured me. When militias came to kill me, he said, "Don't kill this one here. I'll make sure she dies from agony." He brought a cup, urinated in it, and gave it to me to drink. I drank it. The next day, he brought food, but mixed it with stones and urine. He kept doing this for many days. He said, "You are my toilet." Whenever he needed to urinate, he told me to open my legs and he urinated into my vagina. Even after we traveled to a refugee camp in Congo, he kept me with him to torture and rape whenever he wanted.

At some point I started moving toward the Rwandan boarder. I came to a place where they cleaned me, and I found out I was pregnant. Every evening I stood by the lake so I could commit suicide. I don't know what stopped me, but something held me back. After giving birth, I felt so annoyed because I wished the baby had died. The nurse convinced me, and slowly I started feeding it, but I never loved it. The children of my love, I didn't have anymore, yet I was suffering with one whose family killed my family.

When I tested positive for HIV in 2001, I became a real crazy person. I moved out of the house and went to live in the bush. I was surprised to learn that some of my children were alive in an orphanage. When I finally saw them, it made me happy. But I had no house, no job, no food. I was just a lunatic moving from here to there. They were not excited to see me; they didn't seem to recognize me. This is all an effect of genocide. They know I'm their mother, and I love them as my children, but we are not very close.

Victoria
with her son,
Charles,
and her
daughter,
Laurence

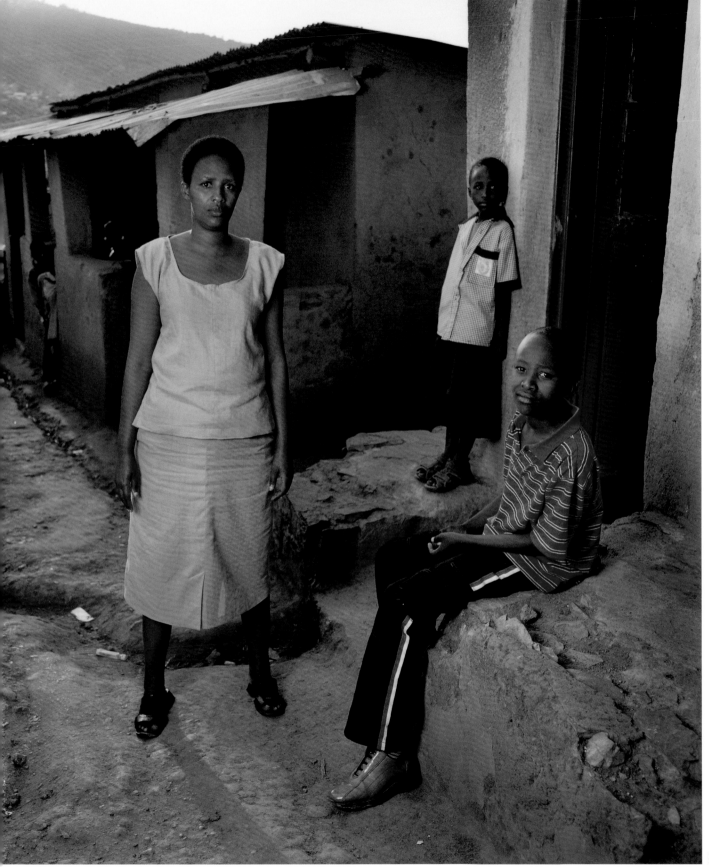

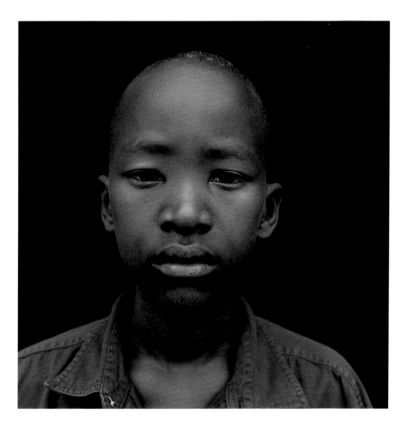

From the day I realized I was pregnant to the day I gave birth, I cried and asked myself, "Will I ever love this child?" One thing that kept me going was a feeling that, in the end, this rapist was not going to be my husband. In time, I would run away from him.

The evening when the militia began attacking people's homes, I was living with my aunty, who was married to a Hutu. We didn't have much trouble that day, but my aunt's husband said that since I was new in the village and people were beginning to suspect me of being a spy, it would be better if I hid in another house. They took me to the home of an intelligence officer who was working for the office of the president, thinking I would be safe there. Instead of keeping me safe, he asked his wife to go on holiday, and when she went away, he raped me.

Life at his place was not easy. When the RPF was closing in on Kigali, he had to run. He told me we would go together, but it was obvious they would notice I was Tutsi at any checkpoint. So he advised me to cover my face and make my nose a bit wider, so I could pass as a Hutu. Whenever they checked me, they said, "This is a snake." But he would say, "You see my identity card. I work with the office of the president. How could I have married a snake? She just looks like them, but she's not one."

In the meantime, I heard the news that all my family had been killed. At that time, I thought, "Why should I even hide myself? I should be seen as I am so they can kill me quickly." And I was becoming trouble for him. He was not going to be able to keep pleading all the time. Because we were with many soldiers, he thought of a plan to give me a military uniform so that people wouldn't recognize me immediately. One time, when I failed to move, they said, "Which soldier is this who is being so lazy?" Looking at my face, they realized I was not a solider, that I was not even a Hutu. They wanted to kill me, but he fought them. One of them shot him, and they exchanged fire. Then, they considered him a rebel and arrested him because he had shot another soldier.

There was no love between us. He forced himself on me and had a brutal attitude. I don't think I'll forgive him. He was a beast, but my survival was because of him. Other militiamen raped girls and then killed them. But with the memory of my family and the way I lost my virginity, I regret that I didn't die. I had a mother. I had a father. I had a grandmother. I had four brothers. I had four sisters. I survived alone. I don't like Hutus, but I don't hate them. What would I do by hating them? Would it resurrect my family? My kids ask me, "Mommy, you don't have an aunty, you don't have an uncle, you don't have a father, you don't have a mother. Why?" I tell them about the genocide in Rwanda and that my relatives were all killed and that it was their father who saved me. If my son grows up and I'm still alive, I'll change that image, but for now, I prefer the distortion.

I don't like Hutus, but I don't hate them. What would I do by hating them? Would it resurrect my family?

Esperance
with her son,
Jean-Louis

When he throws
a stone, they
say he has the
behavior of a
militiaman.
Whenever they
look at him,
they say his
people killed my
family.

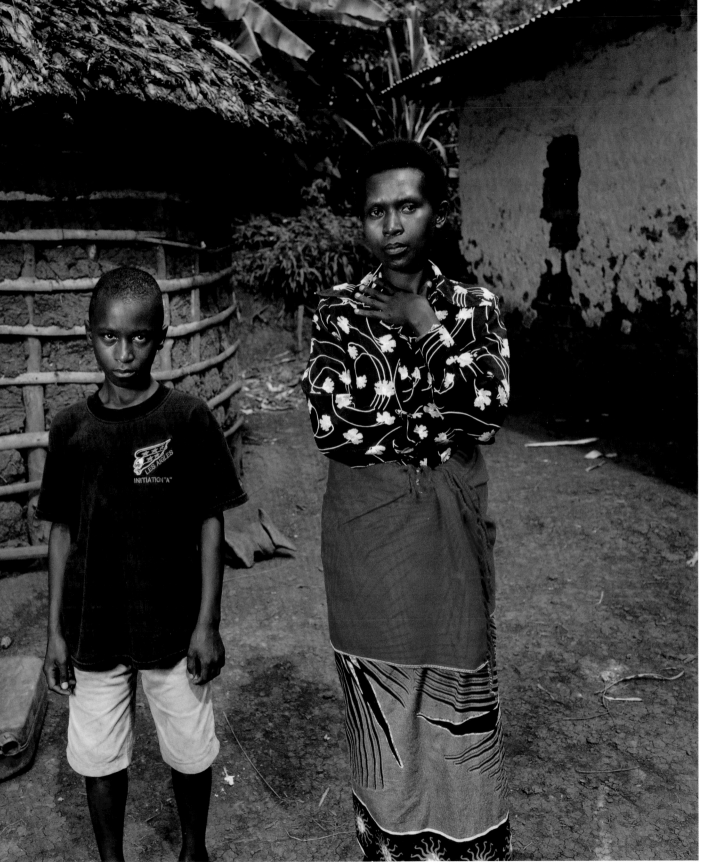

Odette
with
her son,
Martin

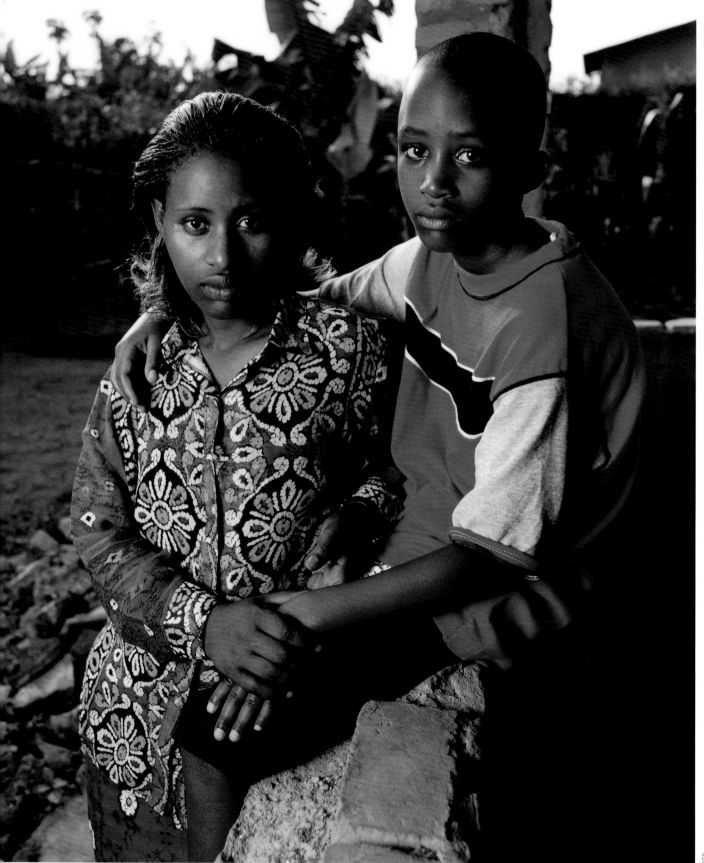

I don't think I'm a mother. I don't think I'm a girl. I'm something in between.

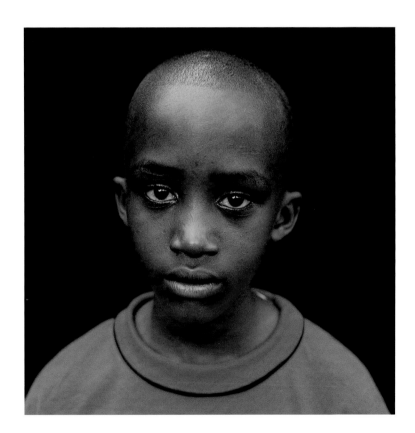

When the militiaman was going to rape me, I begged him kindly, saying, "I'm still a student. I'm still young. Wait. When I finish school, I will be your wife, but please don't rape me." Then he told me, "You don't have time to go to school, so forget about being anyone's wife. Even if you are lucky enough to survive, you will just be a maid in my house."

Before my father died, he told me that I shouldn't get pregnant before marriage. I imagined my brother asking me, "Why are you pregnant? Who got you pregnant?" While I was pregnant with a child of rape, I thought of my father's wish that after four years of secondary school, I should go to a convent and become a nun. I tried to abort the baby, but I didn't know how to do it. I also thought it was a sin against God, so I decided to keep my pregnancy.

I started loving my son when I went back to school and I began studying psychology. That's when I knew that this child of mine needed a lot of attention and that he's innocent. I tried to remove the hatred from me and turn it into love.

My job now involves helping widows and orphans. One thing that I find in common with all of them, and is true for me in particular, is a loss of dignity. They also have health problems. So many diseases related to rape are not easily talked about. They don't talk to just anyone, and many are dying because they keep quiet about their past and their health. The challenge is to get to the point of addressing this. If it wasn't for the counseling I received, I don't think I would have talked about my experience at all.

I don't think I'm a mother. I don't think I'm a girl. I'm something in between. Something I don't know. Because a mother must have a home. I don't have a home. A girl doesn't have a child. I have a child. I have a photograph of my mother that I look at when I'm lonely. She's the one who brought me into this world. Whenever I feel traumatized, I look at her picture. Whenever I feel lonely, I look at her, and I feel like I have a parent even though she's not here anymore.

We have families that are broken and torn up. We have people who were dehumanized and treated like animals. I want the world to ensure that everybody's human rights are protected. But above all, I want the world to ensure that rape and acts of sexual violence never happen to anyone. They not only affect the individual victim, but also the children that are born of sexual violence.

Uwera
with her
son,
Francoise

That was
when
I realized
it was war,
it was
genocide.
I was
now an
orphan.

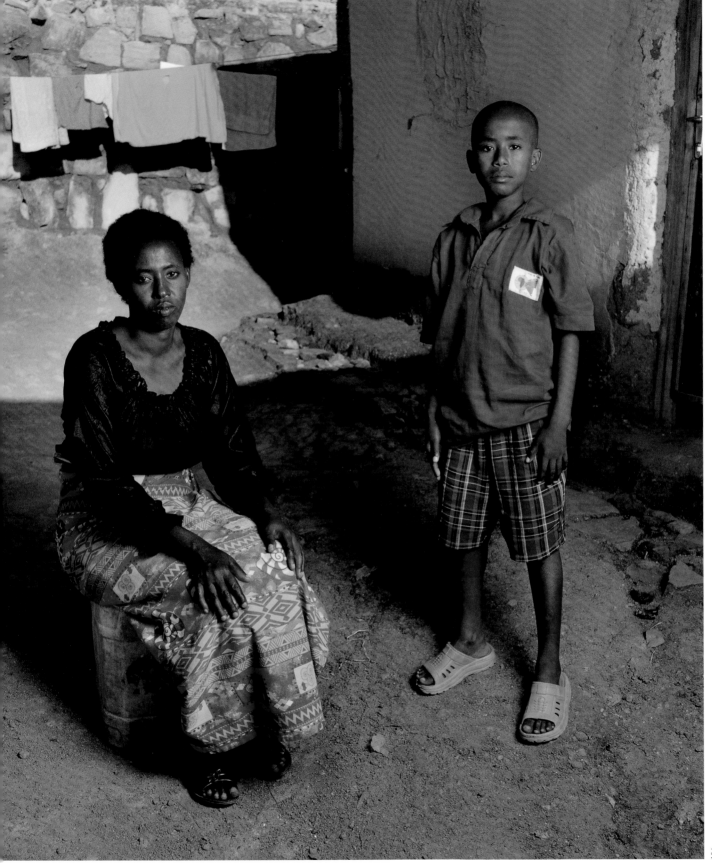

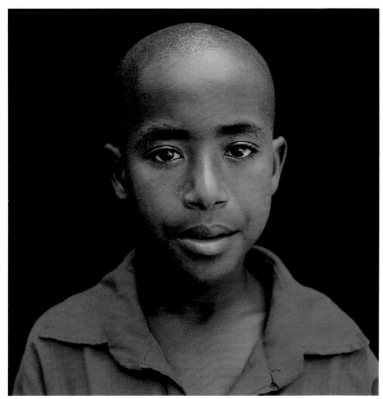

When I talk of the genocide, I don't have enough words to express it.

When I talk of the genocide, I don't have enough words to express it. I can only say it robbed me of my parents, my immediate family, my childhood, and everything that I had regarded so dear in my life. It resulted in my being raped when I was fourteen. And, as if that was not bad enough, the rape left me pregnant. I had a baby with nobody to tell, with nobody to help care for it, with nobody—just alone, struggling by myself.

What they did to my mother, I don't want to remember. They raped her. When I saw this, it was unbearable for me. That was when I realized it was war, it was genocide. I was now an orphan. When I left the church where we took refuge, my mother was already dead and my grandmother was already dead. My uncle and my brother and sister had been killed. I said to myself, "If I'm going to die, let me run and die outside instead of dying where everybody else is." So I ran, and they ran after me. They got me and hit me in the head with a club, a big trunk of wood with nails driven into it. If I didn't have hair, you would see the scar. I fell unconscious. They thought they had killed me and left me there.

Later, when I realized I was pregnant, I was annoyed. But at that time in my life, the pregnancy was a small problem compared to what I had gone through. The real problem was that I didn't have an aunty, I didn't have an uncle. I didn't have any surviving relatives. I knew it was just me, but I was prepared to face it head-on. I was very bitter to be a mother at a time when I wasn't ready, when I wasn't with the father. But I was also happy I had no one else. Since no one survived in my family, I thought God must have a plan for me to live with someone. So I said to myself, "Well, let me nurse this kid. This is the blood of my family." And, who knows, it might be my only family on this Earth. I have mixed feelings: bitterness and happiness.

Beatrice
and her
sons,
Antoine
and
Geoffrey

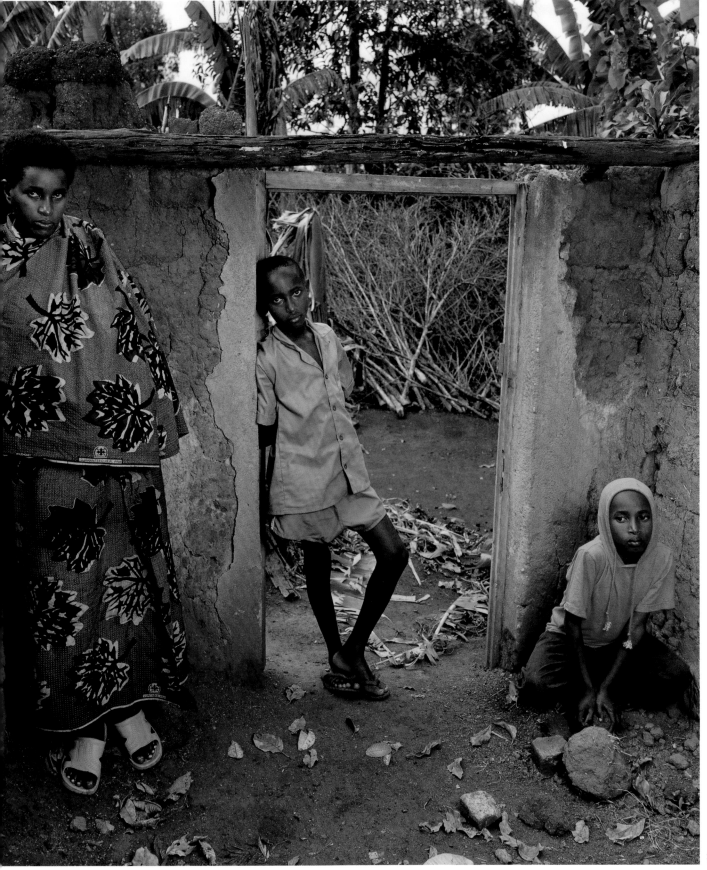

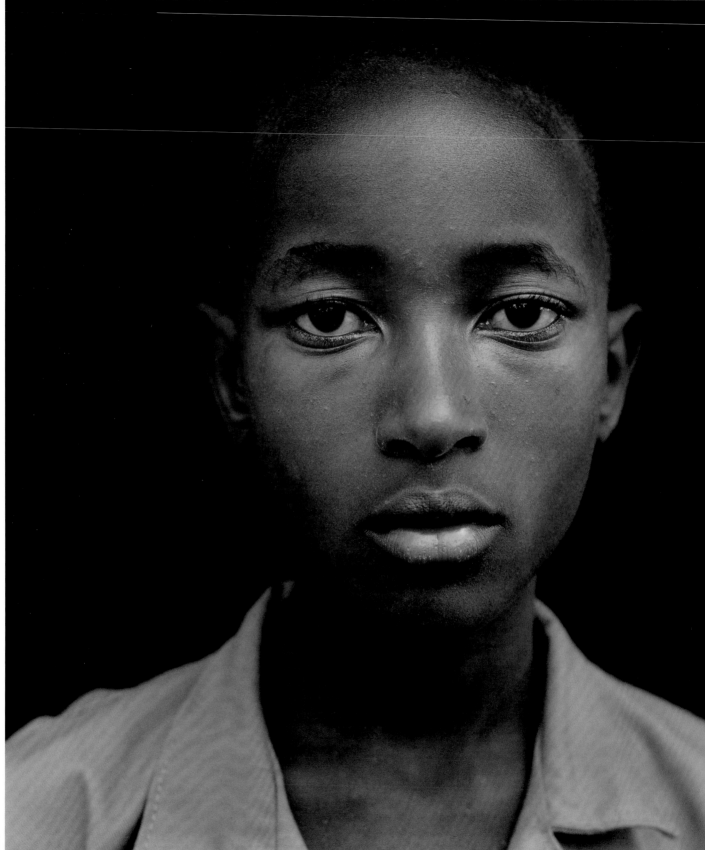

ANTOINE

I'm not happy being a mother—I have two children as a result of rape. These children have distorted my life. The experience of rape has thwarted my ambitions. My children don't have a family and their future is not clear. I don't know where they belong. They don't know where they belong. All they see is me, but I am not able to sustain myself. I don't see a bright future for them because they don't have a family. They don't have a father. They don't have an address. They don't belong anywhere. They are not recognized by the community.

The genocide started when I was seventeen. We ran from our home, my parents and most of my brothers and sisters went in one direction, and I went in another direction. They didn't survive. I survived; I hid in the forest for a night and then decided to go to one of my uncle's homes to hide. I stayed there for only one day before the militias came and took me. They claimed they were going to take me to their home as a house girl. One of them did, but when we reached his house, he told me he had "married" me, that I was now his "wife." He raped me every night and kept me captive. Because of the way I look, I couldn't go out of the house. Hutus were all around, and they would recognize me immediately. I got pregnant, and the result is that young boy, Antoine.

This militiaman kept me until the RPF forces were advancing, and he forced me to go with him because he was running away. We were running together. We went to a place called Chacongora and then to exile in Burundi and then to Tanzania. In the course of those days, because I was raped everyday, I got pregnant again and in 1996 had a second child, Geoffrey.

When I returned to Rwanda, I moved from one extended relative's home to another. Each of the families I went to didn't like my children. They said they would accept me if I didn't have children of a militiaman. It was very hard for me to part with my children, but eventually I took them to an orphanage. My head kept disturbing me when I didn't have them. They were not being treated well there, but I also missed them. Eventually, I decided to forgo the comforts of my family and walked here to look for accommodation and to get my children from the orphanage.

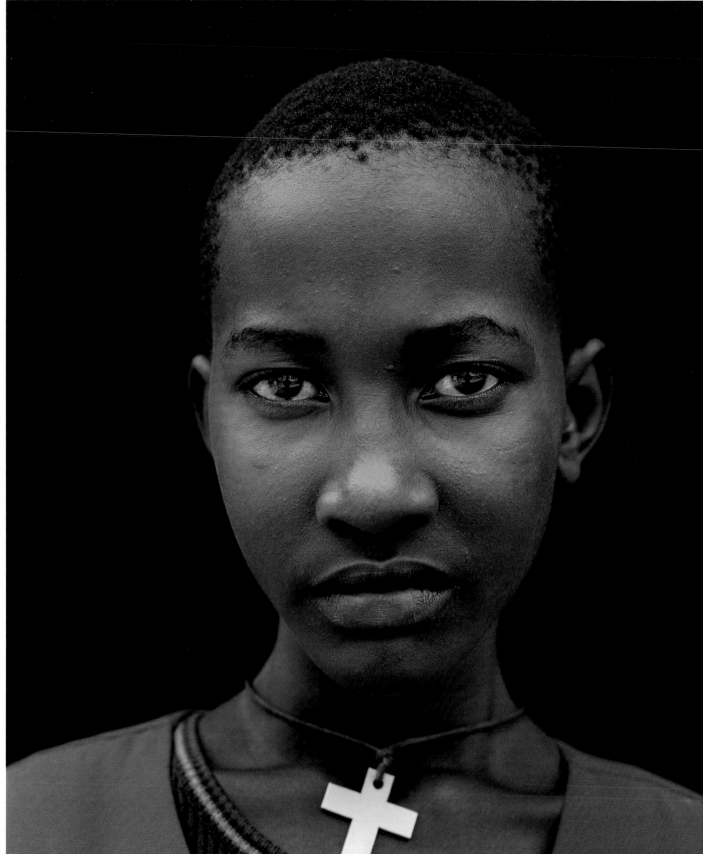

My message to my children is: Don't look at whether one is Hutu or one is Tutsi.

Before the genocide, I had a family, I had parents, I had relatives, I had brothers and sisters; we lived a happy life until the genocide came and destroyed it. Everybody was killed, apart from me.

On April 6, the president was killed, and Tutsis around our village were targeted by Hutu militias that were very organized, like they had prepared this for many years. My family fled to the nearby church. A priest told me I should hide in the head priest's house. When I entered the house, he called his friend and said this was an opportunity for them to "enjoy a Tutsi girl." And so they raped me, both of them raped me three times each in the house of the chief priest. Later one mocked me, "I wanted to love you, but you were too proud. Now I have enjoyed you when I didn't even want you." He called in other militias, and they almost killed me. Outside the parish, my upper teeth were removed with clubs.

They had dug holes in the forest. There, they hit me with clubs and machetes and threw me among the dead bodies. They thought I was dead. I don't know how I survived, but in the night, I managed to walk slowly through the dead bodies and then quietly through the bushes. But I was discovered along the way by many militiamen, and they all raped me. I don't know how many there were, but each time I was "saved" by someone, he would rape me and then lead me to another bush where I would be raped again. And so that's how I moved. It was a long distance, and I was raped by many men. The final man who raped me kept me captive in his house for several days. He would go out to kill during the day and come back at night to do whatever he wanted to do to me. Fortunately, one day when he went out to kill, he never came back.

When I found out I was pregnant, I thought that I would kill the child as soon as it was born. But when she arrived, she looked like my family, and I realized she was part of me. I started to love her. Now, I love my daughter so much; actually our relationship is more like sisters. I got married to a man and told him the whole truth about my daughter. I thought he would protect me, but four years down the road, he seemed to change his opinion about her. We are separated now. I think I would rather be alone and have my daughter with me. If I had the means, I would send her to secondary school because that is the only inheritance she will have.

At first, I would get disoriented whenever I saw a Hutu in public; it was as if I looked at an animal. Even in church I would feel traumatized, sometimes to the point of being hospitalized with a severe headache. But slowly, after getting therapy, I have accepted them. I don't encourage my children to advance ethnic ideologies. My message to my children is: Don't look at whether one is Hutu or one is Tutsi. That's not what is important.

> I don't know how many there were, but each time I was "saved" by someone, he would rape me and then lead me to another bush where I would be raped again. And so that's how I moved.

Philomena with
her daughter, Juliette

I don't love
this child.
Whenever I
look at this
child, the
memories
of rape return.
Whenever
I look at her,
I imagine
those men
holding
my legs open.

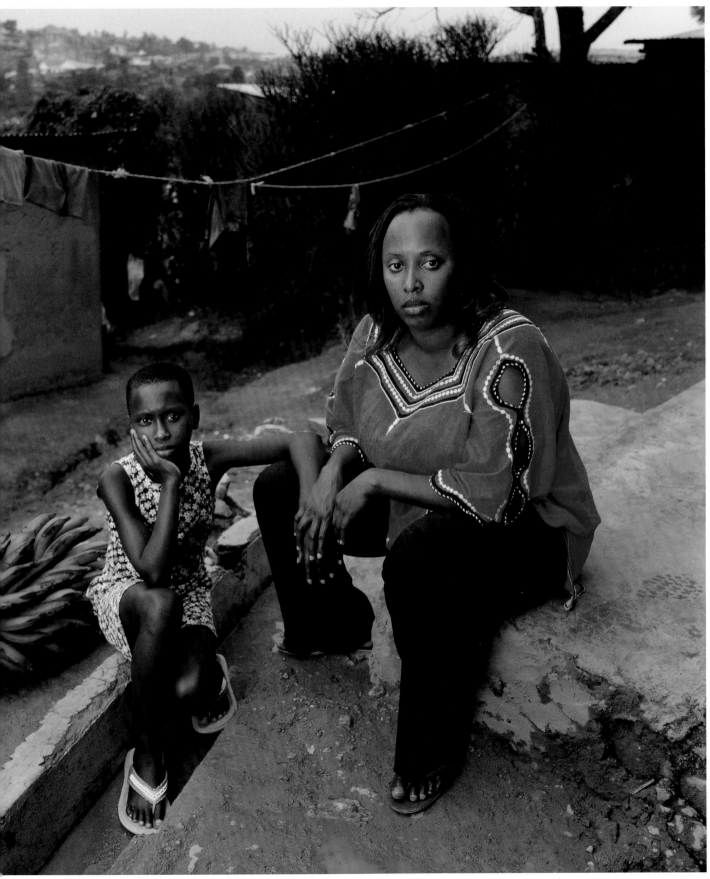

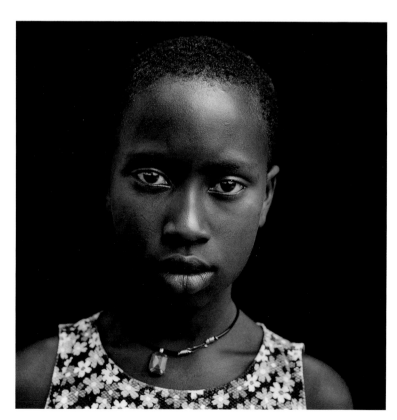

When the genocide started, I was thirteen and in the first grade of secondary school. We had a small bar, and my father was having a drink with friends, when all of a sudden, there was a big blast. People were wondering, is it thunder? Is it rain? A gun? We later heard the news that the president of Rwanda's plane had crashed and both he and the president of Burundi were dead. We kept the radio on, tuning into Radio Rwanda, and all we could hear was classical music, slow songs, as if it were a mourning period.

We stayed inside for some days until the militia came. They killed my father, and I knew they were going to kill my brother too. They had my mother and sister in the sitting room. They said, "We are going to have sex with you." I said "Can you please wait? After the war, I will be your wife. You can take your time." One of them said, "Who said you will still be alive when the war ends?" I kept pleading that I was a virgin. So he said, "If you are such a coward, let me show you something about it." They removed all of my mother's clothes and raped her. I looked away, but he said, "No, look here and be prepared because I want you to see how it is done. And then after this, we will come to you." They closed the door and raped my mother, one man after another. Then they raped my elder sister. Then they raped me.

Later, they took me to one of their militia headquarters, where I stayed for two months. Our life, our routine was eighty percent sex and twenty percent cooking food. We stayed on the ground floor, while the guns and weapons were upstairs. After their meetings, if a man wanted sex, he came to us. Whoever he wanted that day, he would have.

When we heard there was no more fighting, I said to myself, "Let's go and try to get home." My elder sister was there, but my mother was in Gitarama. When she returned, she said I looked pregnant. At that time, we were free to abort a child of a militiaman. But my mother said, "No, I am Christian. I can't allow you to kill. Just bear with it. It will be your child, and you will love it later."

Today, I have a big challenge: I am a mother but feel unwilling to be a mother. I don't love this child. Whenever I look at this child, the memories of rape return. Whenever I look at her, I imagine those men holding my legs open. I understand that she is innocent, and I try to love her, but I fail. I don't love her like a mother ought to love her child. I don't see a future for her. I have asked God to forgive me. Maybe, with time, I will love this daughter of mine. But for now, no. Sometimes, I regret not aborting; other times, because she is the only daughter I am going to have in my life, I don't regret it. For a long time, I really hated God. I asked myself, why did people die? Why did my family die? Why this extreme violence? Why am I HIV positive? Where was God? Why did he let it happen?

We kept the radio on, tuning into Radio Rwanda, and all we could hear was classical music, slow songs, as if it were a mourning period.

Anne-Marie
with her daughter,
Celestine

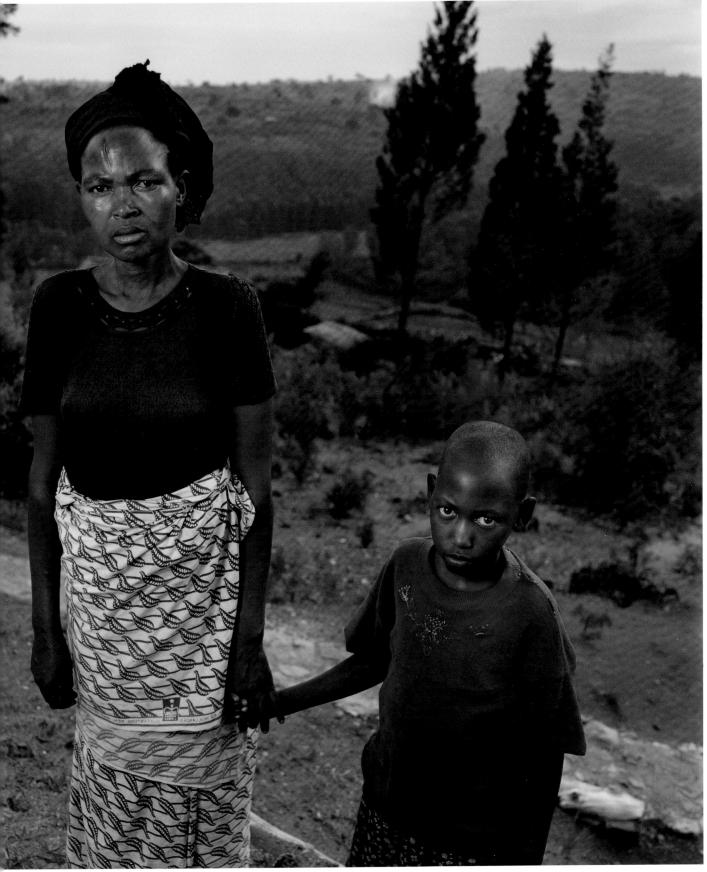

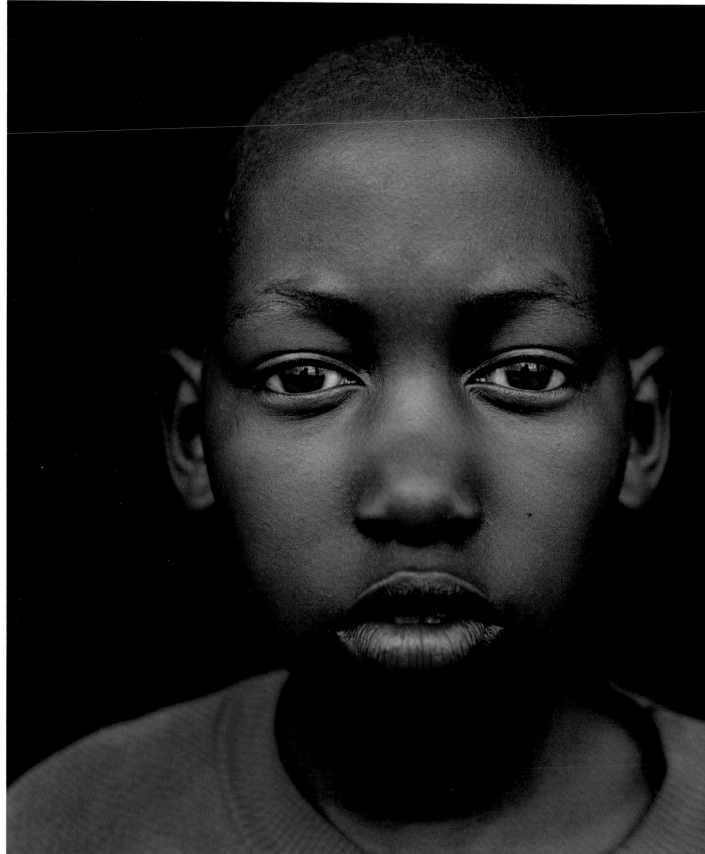

People from different villages were being collected to take refuge at a camp for internally displaced people. We stayed at the camp for three days. We started sensing trouble when soldiers came and began rounding people up. But they didn't say anything until around noon when they told all the men to go to one side and all the women to go to the other side. When the men went to the other side, they started shooting them. I ran toward a place north of where we were.

A local leader called a meeting, saying, "People should go back to where they came from . . . girls and women can go back to their places of origin." I started walking back, but little did I know that I was going to meet serious trouble. I went to a house to ask for water. They sent me away. As I was reaching the end of the road, I met the owner of the home. He looked at me with a lot of bitterness and cut me in the face with his machete. I ran, but was feeling weak. I reached a place I thought would protect me for the day because I didn't want to walk in the daytime. You could hear people being killed with machetes, being hit with clubs, or being speared.

I went to a Catholic Church. There was a group of militiamen there, but one of them who knew me advised me not to hide there because I had a wound that would easily identify me as Tutsi. He told me to hide in the houses near a place called Rango. He sent two young men to kill me there. They hit me with machetes and clubs, saying I shouldn't die in the house because my blood would cause bad omens. They took me to the forest and raped me there.

After they raped me, they called to another two boys; one of them said, "This woman is sweet, you also need to enjoy her." After that, they said, "This Tutsi woman is not getting satisfied. Let's get a corn stem and sharpen it to the shape of a penis; that will satisfy her." So they went to cut that piece and they put my legs apart and then they started pounding that stem of corn into my private parts. After that night, I couldn't walk.

When the leader of the militia saw me, he said, "These people must be killed because we killed all the others. If we leave them, they are going to report us when things don't work out. Or they will be a bad omen." And one of them asked, "Now, how do we kill thirty people? There are too many." Another man offered to take us to his land where he had already dug a grave. He said, "Let us take them and kill them there. And then when they rot, they will be fertilizer for my farm. I will plant banana plantations afterward, and they'll be fertile."

Delphine
with
her
daughter,
Sophie

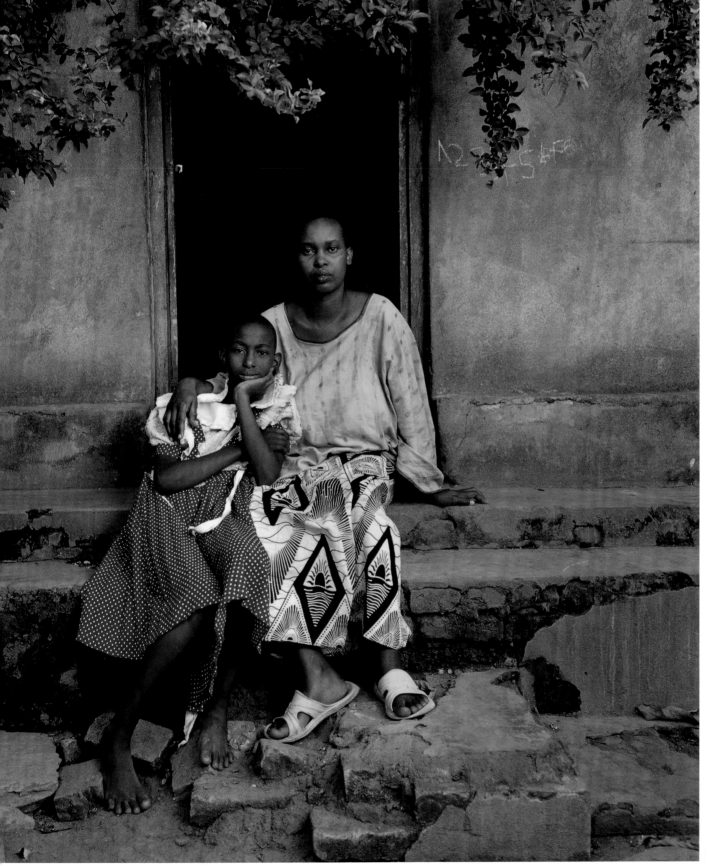

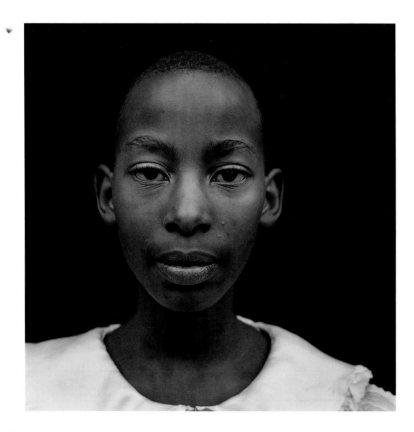

At a roadblock, a militiaman said, "We must kill this one. She can't go beyond this point." I was just seventeen years old. It didn't make any sense. Why me? Why not everybody else? I argued with them: "Why kill me and not the people that I'm traveling with?" They said, "We are killing you because you are a Tutsi." As I prepared myself for death, one of the young militiaman came and said, "No, don't kill this beautiful girl. I'll take her for a 'wife.'"

That's how my ordeal of rape started. He took me to their headquarters at a school. In the bush nearby, he made me lie down and raped me. I started bleeding, but that was not the worst thing for me—the worst was the shame that he did it with everybody around me watching. He would come during the day, evening, and at night—for three days, he raped me.

They say we are leftovers of the militia's sexual appetite. And whenever I think about it, I hate myself. I don't want to talk about it.

When I realized I was pregnant, my thoughts went back to those nights, to the torture that the militiaman exposed me to. I never accepted that I was pregnant. Thinking of giving birth to a child of that man, who never showed me even a slight bit of love, only brutality, I decided I was going to have an abortion. But when I did give birth, surprisingly, I didn't feel any bitterness. I was surprised that I was happy about the child.

But as she was growing, when just like other kids, she would do something stubborn or naughty, I couldn't see it like that. I saw it as something that the father left behind deliberately to keep torturing me because she was supposed to be as bad as the father anyway. But really, I love her. I'm happy being a mother. For the first six years, I didn't think I would even be able to get close to a man. It is degrading for me to pass by and have people say, "Oh, you see that girl. That girl was raped." You feel you don't have value. I avoid thinking about it. They say we are leftovers of the militia's sexual appetite. And whenever I think about it, I hate myself. I don't want to talk about it.

My daughter is now in her last year in primary school. She's doing well, but I'm not sure whether she will go to secondary school—not that she won't pass, but I don't think I will have the money to send her. Unless something happens, I think she's going to stop there. I also struggle to get food, to pay rent for this house. And I remember how it was at home before the genocide— we were from family that was fairly well off. So that is the problem.

Chantal with her
daughter, Lucie

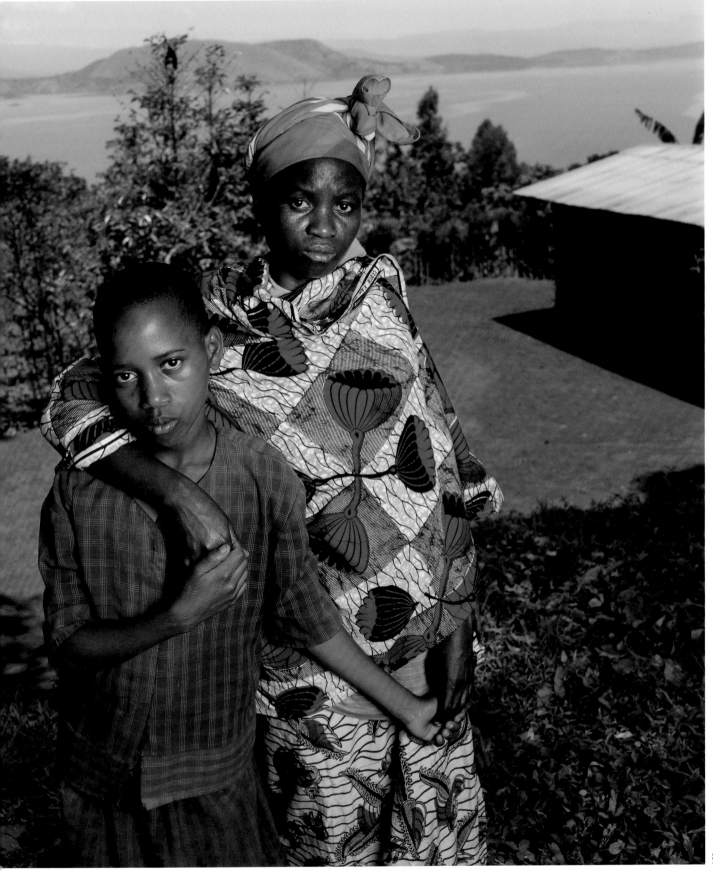

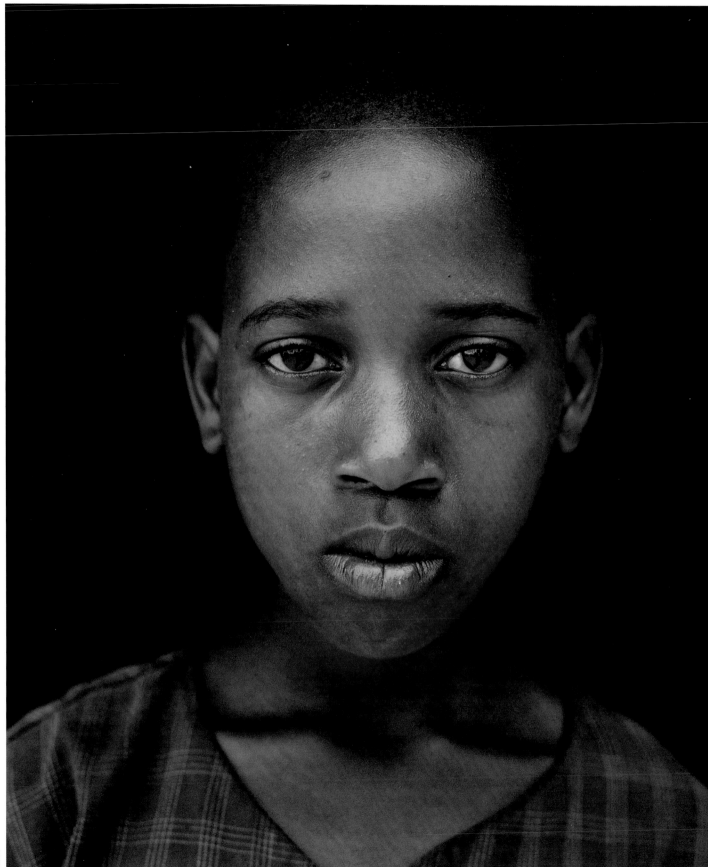

I frequently fall sick. I am alone and don't have anyone to visit me, no one to take me to the hospital. That's problem one. Problem two is when my daughter wants something and I can't give it to her; that's the biggest challenge. I can't explain the feeling of failing to supply my daughter with what she wants.

The militias came with whistles and spears. One of the militiamen found me and took me to his place. He told me that he was going to protect me because he knew my father, but when we got to his place, he didn't put me in his house because he was married. There was a small house for his cousin, who was also a militiaman and had gone to kill people, so he put me in that house.

Mummy, every kid has a father, why don't I have a father?

At night he came and raped me. His wife was there, but he never bothered about her. In the morning, he put a spear to me and said, "You shouldn't move. If you move, you will be killed." He told me that from that day on, I was his second official wife. I stayed in that man's house as a wife. He went to kill; then he came back and raped me. He went to kill; he came back. I was there for about four months. I never loved him. He was married with four children. I was still a virgin.

If he asks for forgiveness publicly and he tells everybody what he did to me, I'm willing to forgive him. There is this pamphlet that has gone around telling us that we must forgive people who did bad things to us and reconcile to create unity for the country.

I raised this child by myself, the hard way. I have not told her, but one time she came from school and said, "Mummy, every kid has a father, why don't I have a father?" I almost told her the whole story but instead said, "Your father is in exile." Then she asked, "Why is my father in exile?" I told her that he was in a militia, and she didn't believe me.

In group counselling, we are divided into groups and share our experiences. This has helped me because I forget about myself when I am with others. I was raped by one man. There are women who tell me they were raped by ten, others by five, others don't even know the number. When I hear that, I realize that my problem is small compared to others—it keeps me going.

Marguerite
with
her
son,
Joseph

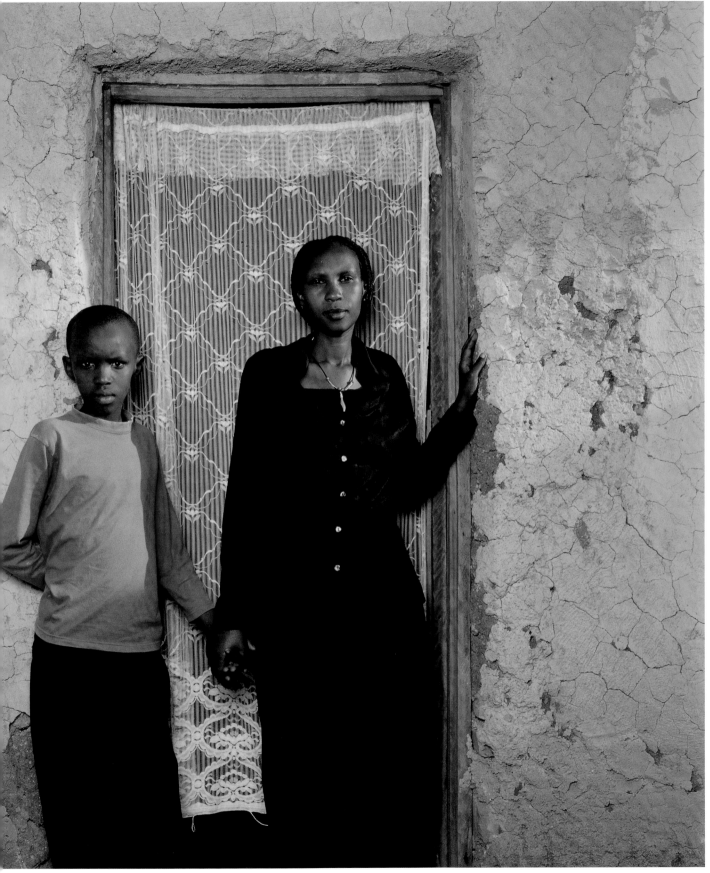

> My family doesn't love them— not even the first son. Although the father was not a militiaman, they know that I was raped, so they don't like either of these children who they call bastards.

We stayed in our homes for days, but there was unrest in the whole neighborhood. On the fifth day, soldiers came early in the morning and told us to get out. They took us by the road. When I saw that they were hitting people with machetes and clubs, I got up and ran. When I ran, they ran after me, but I was fast. I was strong. I ran, and they couldn't catch me. I kept running until I reached a high place, and then I fell down into a very deep ditch. My back was broken. They thought that was enough to kill me, but I hadn't died. I stayed in that ditch for two days, unable to move. No one passed by, so I crawled until I got to a road. I decided to go to my house, thinking that, if anything, I would die in my own house. There I found my neighbors; one had taken my son and hidden him. We heard that RPF soldiers were rescuing people near the stadium, and we decided to go when everybody was asleep. We went to the RPF place, but it was a battlefront again.

Militias started shooting and killing. Three of us could not run, so they raped us. One held me by the hand, another by the leg, and another raped. After that, they switched and another one held my hands and another one raped. Three of them raped me.

When I realized I was pregnant, I wasn't shocked. I already had one child from a rape long ago. I needed a second child, but not from a rape. Honestly, I love this boy so much. I don't know why, but I love him. Because of this love, I protect him. I don't want him to know the circumstances under which he was born. Even his brother does not know that they are not full brothers. They think they have the same father and that he died in the genocide. Nobody knows.

My family doesn't love them—not even the first son. Although the father was not a militiaman, they know that I was raped, so they don't like either of these children who they call bastards. My consolation is that I love my children. There's a church community that is very supportive. I found alternatives to my family. Faith in God has given me peace of mind, and it keeps me going because I'm hopeful that things may be better. My survival, I think, was not an accident. There is a reason why I survived. I will always encourage my children to laugh, to laugh among themselves, to laugh with other people and God, and to be patient in every situation. When you are patient and accept any situation, it prepares you for the future. Lastly, I tell them always that everything good is in the future. They should work toward getting to the future.

Henriette
with her daughter,
Noemi

When the
militias
came attacking,
they came
shouting my
name,
"Henriette,
Henriette."

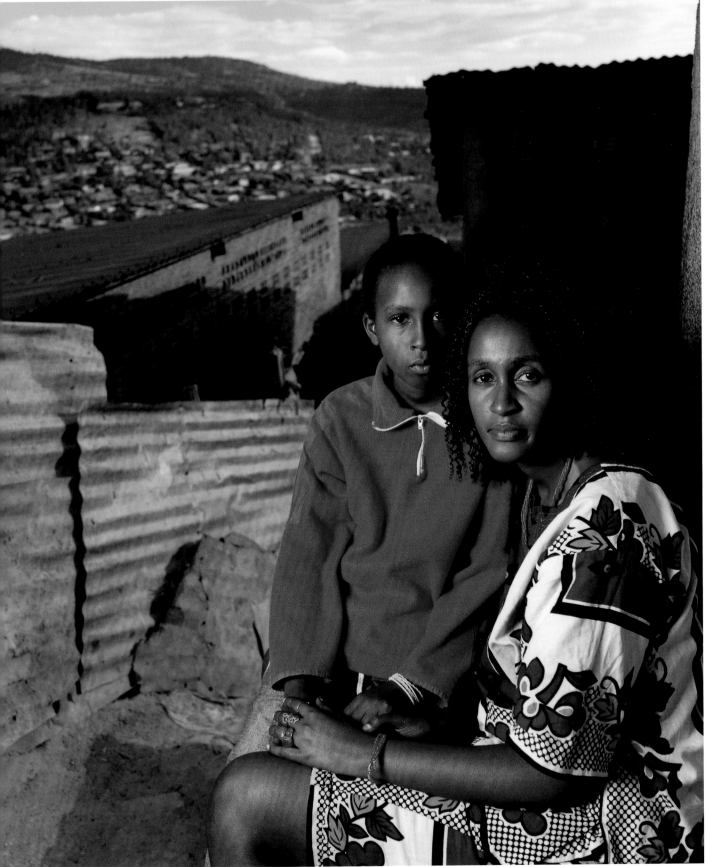

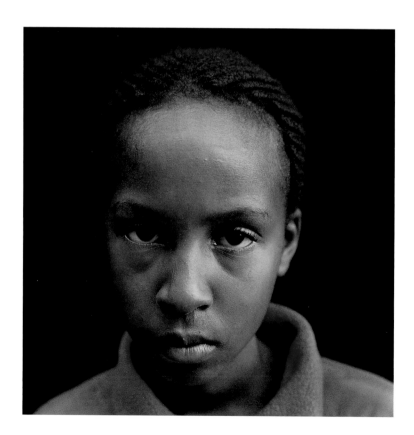

NOEMI

I became a mother when I wasn't ready to be a mother. There is nothing that can make me happy now. My life has been destroyed. I am not interested in living, but I live for those two children. For them, somehow I live.

A Hutu priest, who had worked with my uncle, came to tell my aunt that my uncle had been killed. But that was not all. He also came to warn my aunty that militias were organizing to take me from that home for a wife. He was very concerned so he came as soon as possible to warn my aunt and to bring the news that my uncle and other Tutsi priests in the parish had been killed. My aunty was now convinced that we needed to move. But it was too late, roadblocks had been erected everywhere; killings had started at every corner.

When the militias came attacking, they came shouting my name, "Henriette, Henriette." Even before the genocide, when we went to church and passed by the training center, those boys, who were now militias, said: "Some day, we will have you." When I heard them shouting my name, I waited until the last minute, but I knew I was going to die.

They came and took those who were fifteen or sixteen years old into the bush nearby, and for a whole day they raped us. From one to the other, exchanging and switching, the whole day until six in the evening when they brought us back to the church where we had taken refuge. They killed men first, young men, but whenever they came to us, they said, "Don't kill them, they will be our 'wives.' Don't kill them."

Each one of us had wounds, some more serious than others. I couldn't even walk, and while sitting there, I heard militias killing people. People making noise, people shouting, we heard them cutting people with machetes. We could hear the noise of machetes in the road and people saying, "Forgive us, forgive us." We were scared but at the same time determined not to move. Let come what may, but we will not move out of this convent.

I hated myself. My father had died. My mother had died. My aunty had died. My uncle who was paying my school fees had died. Deep within me, I was thinking that since my other family members had died, there was no reason to stay—I just wanted to die. I insisted, "Leave me alone. Let me go where I will be seen so they will kill me soon and save me from the agony."

A chronology of key events:

1300s / Tutsis migrate into what is now Rwanda, which was already inhabited by the Twa and Hutu peoples.

1600s / Tutsi king, Ruganzu Ndori, subdues central Rwanda and outlying Hutu areas.

Late 1800s / Tutsi king, Kigeri Rwabugiri, establishes a unified state with a centralized military structure.

1858 / British explorer Hanning Speke is the first European to visit the area.

1890 / Rwanda becomes part of German East Africa.

1916 / Belgian forces occupy Rwanda.

1923 / Belgium granted League of Nations mandate to govern Ruanda-Urundi, which it ruled indirectly through Tutsi kings.

1946 / Ruanda-Urundi becomes UN trust territory governed by Belgium.

Independence

1957 / Hutus issue manifesto calling for a change in Rwanda's power structure to give them a voice commensurate with their numbers; Hutu political parties formed.

1959 / Tutsi king, Kigeri V, together with tens of thousands of Tutsis, forced into exile in Uganda following inter-ethnic violence.

1961 / Rwanda proclaimed a republic.

1962 / Rwanda becomes independent with a Hutu, Gregoire Kayibanda, as president; many Tutsis leave the country.

1963 / Some twenty thousand Tutsis killed, following an incursion by Tutsi rebels based in Burundi.

1973 / President Gregoire Kayibanda ousted in military coup led by Juvenal Habyarimana.

1978 / New constitution ratified; Habyarimana elected president.

1988 / Some fifty thousand Hutu refugees flee to Rwanda from Burundi, following ethnic violence there.

1990 / Forces of the rebel, mainly Tutsi, Rwandan Patriotic Front (RPF) invade Rwanda from Uganda.

1991 / New multi-party constitution promulgated.

Genocide

1993 / President Habyarimana signs a power-sharing agreement with the Tutsis in the Tanzanian town of Arusha, ostensibly signalling the end of civil war; UN mission sent to monitor the peace agreement.

1994 April / Habyarimana and the Burundian president are killed after their plane is shot down over Kigali; RPF launches a major offensive; extremist Hutu militia and elements of the Rwandan military begin the systematic massacre of Tutsis. Within one hundred days around eight hundred thousand Tutsis and moderate Hutus are killed; Hutu militias flee to Zaire, taking with them around two million Hutu refugees.

1994–96 / Refugee camps in Zaire fall under the control of the Hutu militias responsible for the genocide in Rwanda.

1995 / Extremist Hutu militias and Zairean government forces attack local Zairean Banyamulenge Tutsis; Zaire attempts to force refugees back into Rwanda.

1995 / UN-appointed international tribunal begins charging and sentencing a number of people responsible for the Hutu-Tutsi atrocities.

Intervention in the Democratic Republic of Congo

1996 / Rwandan troops invade and attack Hutu militia-dominated camps in Zaire in order to drive home the refugees.

1997 / Rwandan- and Ugandan-backed rebels depose President Mobutu Sese Seko of Zaire; Laurent Kabila becomes president of Zaire, which is renamed the Democratic Republic of Congo.

1998 / Rwanda switches allegiance to support rebel forces trying to depose Kabila in the wake of the Congolese president's failure to expel extremist Hutu militias.

2000 March / Rwandan President Pasteur Bizimungu, a Hutu, resigns over differences regarding the composition of a new cabinet and after accusing parliament of targeting Hutu politicians in anti-corruption investigations.

Kagame elected

2000 April / Ministers and members of parliament elect Vice President Paul Kagame as Rwanda's new president.

2001 October / Voting to elect members of traditional "gacaca" courts begins. The courts—in which ordinary Rwandans judge their peers—aim to clear the backlog of 1994 genocide cases.

2001 December / A new flag and national anthem are unveiled to try to promote national unity and reconciliation.

2002 April / Former president Pasteur Bizimungu is arrested and faces trial on charges of illegal political activity and threats to state security.

2002 July / Rwanda, the Democratic Republic of Congo sign peace deal under which Rwanda will pull troops out of the Democratic Republic of Congo and the Democratic Republic of Congo will help disarm Rwandan Hutu gunmen blamed for killing Tutsi minority in 1994 genocide.

The Democratic Republic of Congo pull-out

2002 October / Rwanda says it has pulled the last of its troops out of the Democratic Republic of Congo, four years after they went in to support Congolese rebels against the Kabila government.

2003 May / Voters back a draft constitution that bans the incitement of ethnic hatred.

2003 August / Paul Kagame wins the first presidential elections since the 1994 genocide.

2003 October / First multi-party parliamentary elections; President Kagame's Rwandan Patriotic Front wins absolute majority. EU observers say poll was marred by irregularities and fraud.

2003 December / Three former media directors found guilty of inciting Hutus to kill Tutsis during 1994 genocide and receive lengthy jail sentences.

2004 March / President Kagame rejects French report that says he ordered 1994 attack on president's plane, which sparked genocide.

2004 June / Former president Pasteur Bizimungu is sentenced to fifteen years in jail for embezzlement, inciting violence and associating with criminals.

2005 March / Main Hutu rebel group, FDLR, says it is ending its armed struggle. FDLR is one of several groups accused of creating instability in the Democratic Republic of Congo; many of its members are accused of taking part in 1994 genocide.

2005 July / Government begins the mass release of thirty-six thousand prisoners. Most of them have confessed to involvement in the 1994 genocide. It is the third phase of releases since 2003—part of an attempt to ease overcrowding.

2006 January / Rwanda's twelve provinces are replaced by a smaller number of regions with the aim of creating ethnically diverse administrative areas.

2006 November / Rwanda breaks off diplomatic ties with France after a French judge issues an international arrest warrant for President Kagame, alleging he was involved in bringing down Habyarimana's plane.

2006 December / Father Athanase Seromba becomes the first Roman Catholic priest to be convicted for involvement in the 1994 genocide. The International Criminal Tribunal sentences him to fifteen years in prison.

2007 February / Some eight thousand prisoners accused of genocide are released. Some sixty thousand suspects have been freed since 2003 to ease prison overcrowding.

2007 April / Former president Pasteur Bizimungu is released from jail three years into his fifteen-year sentence after receiving a presidential pardon.

2007 October / Inquiry launched into 1994 presidential plane crash that sparked genocide.

2007 November / Rwanda signs peace agreement with the Democratic Republic of Congo. Under the deal, the Democratic Republic of Congo will hand over those suspected of involvement in the 1994 genocide to Kigali and to the International Criminal Tribunal for Rwanda.

2008 January / French police arrest former Rwandan army officer, Marcel Bivugabagabo, who is on list of war criminals wanted for trial by the Rwandan government.

2008 February / A Spanish judge issues arrest warrants for forty Rwandan army officers, accusing them of genocide, terrorism, and crimes against humanity.

2008 April / President Paul Kagame says the Spanish judge who issued arrest warrants for Rwandan army officers can "go to hell."

2008 May / A former cabinet minister, Callixte Kalimanzira, goes on trial at the International Criminal Tribunal for Rwanda, charged with taking part in the 1994 genocide.

2008 August / Rwanda accuses France of having played an active role in the genocide of 1994, and issues a report naming more than thirty senior French officials. France says the claims are unacceptable.

Acknowledgments:

This book is dedicated to the hundreds of thousands of women who were victims of sexual violence during the Rwandan genocide, particularly to all the women and their children who were photographed and interviewed for this book. I admire your strength, honesty, and resilience and am thankful to you for instilling your trust in me by sharing your testimonies for this book.

I thank former *Newsweek* health editor, Geoffrey Cowley, for being such an inspirational friend and for sharing his wealth of knowledge while on the road working on assignments together, including the one in Africa that led me to starting this project.

Special thanks to Geoffrey Ngiruwonsaga. Without his help, sensitivity, patience, translation, and friendship this project would not have been possible. I will forever remember and cherish our long and bumpy journeys in the "bull" over more than a thousand hills of Rwanda.

I would like to thank the following individuals and organizations for believing in this project, supporting it, and becoming partners in its execution and distribution: Karen Robinson, Melissa Robinson, and Jungwon Kim at Amnesty International; Amy Yenkin, Yukiko Yamagata, Pam Chen, and Whitney Johnson at the Open Society Institute; Brian Storm and Chad A. Stevens at MediaStorm; Jules Shell at Foundation Rwanda; and my deepest gratitude to Michael Famighetti, Melissa Harris, and Lesley Martin at Aperture Foundation for making this book possible.

I would also like to thank the wonderful team at Aperture, especially Juan García de Oteyza, Diana Edkins, Annette Rosenblatt, Andrea Smith, and Matthew Pimm.

Thank you to Marie Consolée Mukagendo for her wonderful essay and contribution to this book. And to Giorgio Baravalle for his brilliant creative vision in designing this book.

This project would not have been possible without the generous support from: SanDisk, Kodak professional, Getty Images Grant for Editorial photography, The National Portrait Gallery Portrait Prize, The Arnold Newman Prize, and The Open Society Institute Documentary Photography Project Distribution Grant.

I will be forever grateful to Simon Barnett, Susan Miklas, Michelle Molloy, Beth Johnson, Jamie Wellford, Amy Periera, Paul Moakley, and Myra Kreiman at *Newsweek* magazine for their continued support and for sending me to Africa to cover a story that led me to embark on this project.

A special thanks to Audrey Jonckheer, Tanya Chuang, and Aidan Sullivan for their continued friendship and support, and for believing in this project from the very beginning.

To the following friends, colleagues, and organizations for their help and encouragement throughout the process of creating this work: Alison Morley, Cheryl Newman, Sara Solfanelli, Nancy Brady, Grazia Neri, Enrica Vigano, Peter Piot, Sondra Myers, Elisabeth Biondi, Klan Klotz, Stephen Cohen, Andreas Trampe, Angelika Hala, Sue Lapsien, David Friend, Anne Wilkes Tucker, Joan Morgenstern, Suzie Katz, Sara Terry, Rosette Adera, Yvette Rugasaguhunga, Hope Kantete, Julien Jourdes, Michael Streck, Lauren Steel, Christina Cahill, Cheryl Newman, Yael Danieli, Jeremy Goldberg, Gigi Giannuzzi, Tiziana Faraoni, Gaia Tripoli, Frederic Brenner, Gimena Arensburg, Valerie Roth-Bousquet, Nadja Masri, Tina Ahrens, Ruth Eichhorn, Venita Kaleps, Amilia Klien, David Schonauer, Jay DeFoore, Susan Meiselas, Gillian Laub, Elinor Carucci, Denise Mangen, Cara Sutherland, Patrick Phelan, Mary Blewitt, David Russell, Gabo Wilson, Geoffrey Ngiruwonsaga, Stephanie Heimann, Ziv Koren, Otis Kriegel, Laura Moix-Varma, Howard Schultz, Bill and Carrie Hannigan, Liz, Karl and Jonathan Katz, Getty Images, ADMIRA, *Stern*, *Newsweek*, the *Saturday Telegraph Magazine*, SURF - Survivors Fund, AVEGA, Canon Europe, Stern Foundation, and to Gun Roze for his masterful printing of the images in this book.

I am grateful to my parents, Virginia and Efraim, and my sister, Dana, for their endless support and unconditional love.

To Jules, for her love, patience, encouragement, and for being a wonderful source of inspiration. Thank you for all your creative advice and for your strong and sensitive force in the creation of Foundation Rwanda.

Jonathan Torgovnik's photographs have been widely exhibited and published in numerous international publications, including *Newsweek*, *Aperture*, *GEO*, *The Sunday Times Magazine*, *Stern*, and *Marie Claire*, among others. He has been a contract photographer for *Newsweek* since 2005 and is on the faculty of the International Center of Photography School in New York. He is co-founder of Foundation Rwanda (www.foundationrwanda.org), a non-profit organization that supports secondary school education for children born of rape in Rwanda.

Editor: Michael Famighetti
Design: de.MO
Production: Matthew Pimm

The staff for this book at Aperture Foundation includes: Juan García de Oteyza, *Executive Director*; Michael Culoso, *Director of Finance and Administration*; Lesley A. Martin, *Publisher, Books*; Susan Ciccotti, *Senior Text Editor*; Nima Etemadi, *Editorial Assistant*; Andrea Smith, *Director of Communications*; Kristian Orozco, *Director of Sales and Foreign Rights*; Diana Edkins, *Director of Exhibitions and Limited-Edition Photographs*; Matt Minor and Gem Salzberg, work scholars.

Intended Consequences was made possible, in part, by generous support from Henry Buhl, SanDisk, and the Consulate General of Israel, Office of Cultural Affairs, in New York. Additional support provided by Open Society Institute, Amnesty International, and Kodak.

A portion of the proceeds will be donated to Foundation Rwanda to help support the survivors of sexual violence and their children born of rape in Rwanda. For more information and to learn how you can help the women and children in this book, please visit: www.foundationrwanda.org.

The names of the women and children featured in this book have been changed to protect their identity.

Though Marie Consolée Mukagendo is a United Nations staff member, the views expressed herein are those of the author alone and do not necessarily reflect the views of the United Nations.

Timeline courtesy of British Broadcasting Corporation.

First edition
Printed in Singapore
10 9 8 7 6 5 4 3 2 1
Library of Congress Control Number: 2008939803
ISBN 978-1-59711-101-0

Aperture Foundation books are available in North America through:
D.A.P./Distributed Art Publishers
155 Sixth Avenue, 2nd Floor
New York, N.Y. 10013
Phone: (212) 627-1999
Fax: (212) 627-9484

Aperture Foundation books are distributed outside North America by:
Thames & Hudson
181A High Holborn
London WC1V 7QX
United Kingdom
Phone: + 44 20 7845 5000
Fax: + 44 20 7845 5055
Email: sales@thameshudson.co.uk

aperturefoundation
547 West 27th Street
New York, N.Y. 10001
www.aperture.org

The purpose of Aperture Foundation, a non-profit organization, is to advance photography in all its forms and to foster the exchange of ideas among audiences worldwide.

Cambridge English

Complete IELTS

Bands 5–6.5

Workbook *with Answers*

Mark Harrison

CAMBRIDGE
UNIVERSITY PRESS

CAMBRIDGE UNIVERSITY PRESS
Cambridge, New York, Melbourne, Madrid, Cape Town,
Singapore, São Paulo, Delhi, Tokyo, Mexico City

Cambridge University Press
The Edinburgh Building, Cambridge CB2 8RU, UK

www.cambridge.org
Information on this title: www.cambridge.org/9781107401976

First published 2012

Printed in China by Golden Cup Printing Co. Ltd

A catalogue record for this publication is available from the British Library

ISBN 978-0-521-17948-5 Student's Book with Answers with CD-ROM
ISBN 978-0-521-17949-2 Student's Book without Answers with CD-ROM
ISBN 978-0-521-18516-5 Teacher's Book
ISBN 978-0521-17950-8 Class Audio CDs (2)
ISBN 978-0521-17953-9 Student's Book Pack (Student's Book with Answers with CD-ROM and Class Audio CDs (2))
ISBN 978-1107-40197-6 Workbook with Answers with Audio CD
ISBN 978-1107-40196-9 Workbook without Answers with Audio CD

Contents

Unit title	Reading	Listening
1 Starting somewhere new	Reading Section 1: *Third culture kids* • True / False / Not given • Table completion	Listening Section 1: Conducting a survey • Form completion • Multiple choice
2 It's good for you!	Reading Section 2: *What do you know about the food you eat?* • Matching headings • Pick from a list	Listening Section 2: A welcome talk • Multiple choice • Labelling a map or a plan
3 Getting the message across	Reading Section 3: *Strictly English* • Yes / No / Not given • Summary completion with a box • Multiple choice	Listening Section 3: A student tutorial • Pick from a list • Matching • Short-answer questions
4 New media	Reading Section 1: *Is constant use of electronic media changing our minds?* • True / False / Not given • Note completion • Short-answer questions	Listening Section 4: A talk on blogging • Sentence completion • Flow-chart completion
5 The world in our hands	Reading Section 2: *Russia's boreal forests and wild grasses could combat climate change* • Matching information • Matching features • Summary completion	Listening Section 1: Finding out about environmental projects • Note completion • Table completion
6 Making money, spending money	Reading Section 1: *Movers and shakers* • Labelling a diagram • True / False / Not given • Flow-chart completion	Listening Section 2: A talk about vending machines • Matching • Labelling a diagram
7 Relationships	Reading Section 2: *Establishing your birthrights* • Matching headings • Matching features • Sentence completion	Listening Section 3: A student discussion about a presentation • Multiple choice • Flow-chart completion
8 Fashion and design	Reading Section 3: *Making a loss is the height of fashion* • Multiple choice • Yes / No / Not given • Matching sentence endings	Listening Section 4: A lecture on the history of jeans • Sentence completion

Writing	Vocabulary	Grammar
Writing Task 1 • Selecting important information • Planning an answer	• *Problem* or *trouble*? • *Affect* or *effect*? • *Percent* or *percentage* • Key vocabulary	Making comparisons
Writing Task 2: A task with two questions • Analysing the task • Organising ideas into paragraphs • Using linking words	• Word formation • Key vocabulary	Countable and uncountable nouns
Writing Task 1 • Summarising trends in graphs and tables	• *Teach, learn* or *study*? • *Find out* or *know*? • Study-related vocabulary • Key vocabulary	• Tenses: past simple, present perfect simple and present perfect continuous • Prepositions in time phrases and phrases describing trends
Writing Task 2: To what extent do you agree or disagree? • Answering the question • Choosing relevant information • Using linkers	• *Cause, factor* and *reason* • Internet-related vocabulary • Key vocabulary	• *However, although, even though* and *on the other hand* • Articles
Writing Task 1 • Summarising a diagram • Analysing the task • Writing in paragraphs • Ordering information • Using sequencers	• *Nature, the environment* or *the countryside*? • *Tourist* or *tourism*? • Key vocabulary	The passive
Writing Task 2: Agreeing and disagreeing • Introducing and linking ideas in paragraphs • Constructing the middle paragraphs of an essay	• Verb + *to do* / verb + *doing* • Words connected with finance • Words connected with shops and shopping • Key vocabulary	Relative pronouns and relative clauses
Writing Task 1 • Analysing similarities and differences in charts / graphs • Using reference devices	• Words related to feelings and attitudes • *Age(s)* / *aged* / *age group* • Key vocabulary	• Reference devices • Zero, first and second conditionals
Writing Task 2: Discussing two opinions • Including your own opinion • Introducing other people's opinions • Concluding paragraphs	• *Dress* (uncountable) / *dress* (*es*) (countable) / *clothes* / *cloth* • Key vocabulary	Time conjunctions: *until* / *before* / *when* / *after*

Listening Section 1

❶ Look at the second task, Question 6–10. What do all of the questions focus on? Circle A, B or C.

A how often the man does various things
B a particular aspect of life in the city
C planned changes in the city

❷ (02) Now listen and answer Questions 1–10.

Questions 1–5

Complete the form below.

*Write **NO MORE THAN TWO WORDS AND/OR A NUMBER** for each answer.*

INTERVIEW – DETAILS OF SUBJECT	
Age group:	..25-34..
Length of time living in city:	1
Previous home:	2
Occupation:	3
Area of city:	4
Postcode:	5

Questions 6–10

*Choose the correct letter, **A**, **B** or **C**.*

6 What does the man say about public transport?
 A He doesn't like using it.
 B He seldom uses it.
 C He has stopped using it.

7 What does the man say about sport in the city?
 A Some facilities are better than others.
 B He intends to do more of it in the future.
 C Someone recommended a place to him before he came.

8 What does the man say about entertainment?
 A He doesn't have much time for it.
 B There is a very wide range of it.
 C It is the best aspect of life in the city.

9 What does the man say about litter?
 A There is less of it than he had expected.
 B Not enough is done about the problem.
 C His home town has more of it.

10 What does the man say about crime in the city?
 A The police deal with it very efficiently.
 B It is something that worries him.
 C He doesn't know how much of it there is.

Vocabulary

Problem or *trouble*?

❶ Complete these questions with *problem* or *trouble*.

1 What has been the main you have had in adapting to a new country?

2 Have you had communicating with people?

3 If you have a have you got someone who will help you?

4 Have you got into because of something you didn't understand?

5 Is the language a for you?

Affect or *effect*?

❷ Complete these questions with the correct form of *affect* or *effect*.

1 Have the people you've met had an on you?

2 Does the weather how you feel?

3 Has being away from your friends and family you more than you expected?

4 What have been the main of living in a new country?

5 What you the most – the people or the place?

Percent or *percentage*

▶ Student's Book unit 1, p15

❸ Complete these sentences about emigration from a country with *percent* or *percentage*.

1 The ..p̲e̲r̲c̲e̲n̲t̲a̲g̲e̲.. of people planning to emigrate rose last year.

2 Only a small planned to live abroad permanently.

3 The planning short-term emigration was higher last year than this year.

4 There was a rise of three in the number of people planning to leave.

5 Last year, four of people said that they were thinking of emigrating.

6 This year, 73 of people emigrating did so for reasons of employment.

Key vocabulary

❹ Complete the sentences below with the words in the box. There are two words which do not fit into any of the gaps.

accustomed	adjusting	customs	seek
~~surroundings~~	values	process	matters
sense	referring	evidence	stages

Moving to a new country

- Being in unfamiliar (1) s̲u̲r̲r̲o̲u̲n̲d̲i̲n̲g̲s̲. can make you feel lonely.

- (2) to a new life is a difficult (3) You probably go through several (4) before you start to feel comfortable.

- It can be hard to understand how to deal with financial (5) because the system is so different from the one you are (6) to.

- Researchers have found (7) that certain personality types have less trouble than others in getting used to living abroad.

- If some of the (8) in your new country don't make (9) to you, it's a good idea to (10) out people from your own culture who can explain them to you.

Reading Section 1

❶ Read the title and the first three paragraphs of the article below. Who are 'Third culture kids'? Circle A, B or C.

A children whose parents keep moving from country to country

B children living in a country neither of their parents come from

C children who have just arrived in a culture that is new to them

❷ Now read the whole text and answer Questions 1–13.

THIRD CULTURE KIDS

In a world where international careers are becoming commonplace, the phenomenon of third culture kids (TCKs) – children who spend a significant portion of their developmental years in a culture outside their parents' passport culture(s) – is increasing exponentially. Not only is their number increasing, but the cultural complexity and relevance of their experience and the adult TCKs (ATCKs) they become, is also growing.

When Ruth Hill Useem, a sociologist, first coined this term in the 1950s, she spent a year researching expatriates in India. She discovered that folks who came from their home (or first) culture and moved to a host (or second) culture, had, in reality, formed a culture, or lifestyle, different from either the first or second cultures. She called this the third culture and the children who grew up in this lifestyle 'third culture kids'. At that time, most expatriate families had parents from the same culture and they often remained in one host culture while overseas.

This is no longer the case. Take, for example, Brice Royer, the founder of TCKid.com. His father is a half-French/half-Vietnamese UN peacekeeper, while his mom is Ethiopian. Brice lived in seven countries before he was eighteen including France, Mayotte, La Réunion, Ethiopia, Egypt, Canada and England. He writes, 'When people ask me "Where are you from?" I just joke around and say, "My mom says I'm from heaven."' What other answer can he give?

ATCK Elizabeth Dunbar's father, Roy, moved from Jamaica to Britain as a young boy. Her mother, Hortense, was born in Britain as the child of Jamaican immigrants who always planned to repatriate 'one day'. While Elizabeth began life in Britain, her dad's international career took the family to the United States, then to Venezuela and back to living in three different cities in the U.S. She soon realised that while racial diversity may be recognised, the hidden cultural diversity of her life remained invisible.

Despite such complexities, however, most ATCKs say their experience of growing up among different cultural worlds has given them many priceless gifts. They have seen the world and often learnt several languages. More importantly, through friendships that cross the usual racial, national or social barriers, they have also learned the very different ways people see life. This offers a great opportunity to become social and cultural bridges between worlds that traditionally would never connect. ATCK Mikel Jentzsch, author of a best-selling book in Germany, *Bloodbrothers – Our Friendship*

in Liberia, has a German passport but grew up in Niger and then Liberia. Before the Liberian civil war forced his family to leave, Mikel played daily with those who were later forced to become soldiers for that war. Through his eyes, the stories of those we would otherwise overlook come to life for the rest of us.

Understanding the TCK experience is also important for other reasons. Many ATCKs are now in positions of influence and power. Their capacity to often think 'outside the box' can offer new and creative thinking for doing business and living in our globalising world. But that same thinking can create fear for those who see the world from a more traditional world view. Neither the non-ATCKs nor the ATCKs may recognise that there may be a cultural clash going on because, by traditional measures of diversity such as race or gender, they are alike.

In addition, many people hear the benefits and challenges of the TCK profile described and wonder why they relate to it when they never lived overseas because of a parent's career. Usually, however, they have grown up cross-culturally in another way, perhaps as children of immigrants, refugees, bi-racial or bi-cultural unions, international adoptees, even children of minorities. If we see the TCK experience as a Petri dish of sorts – a place where the effects of growing up among many cultural worlds accompanied by a high degree of mobility have been studied – then we can look for what lessons may also be relevant to helping us understand issues other cross-cultural kids (CCKs) may also face. It is possible we may discover that we need to rethink our traditional ways of defining diversity and identity. For some, as for TCKs, 'culture' may be something defined by shared experience rather than shared nationality or ethnicity. In telling their stories and developing new models for our changing world, many will be able to recognise and use well the great gifts of a cross-cultural childhood and deal successfully with the challenges for their personal, communal and corporate good.

Questions 1–6

Do the following statements agree with the information given in the reading passage?

Write

TRUE *if the statement agrees with the information*

FALSE *if the statement contradicts the information*

NOT GIVEN *if there is no information on this*

1 There is a close connection between careers and the number of TCKs.

2 An increasing number of people describe themselves as TCKs.

3 Ruth Hill Useem studied children in several countries.

4 Ruth Hill Useem defined the third culture as a mixture of two parents' original cultures.

5 Brice Royer feels that he has benefited greatly from living in many different countries.

6 Elizabeth Dunbar felt that she had a culture that was different from most people's.

Questions 7–13

Complete the table below.

*Choose **NO MORE THAN THREE WORDS** from the passage for each answer.*

THIRD CULTURE KIDS – ADVANTAGES AND RESULTS		
Area	**Advantage for ATCKs**	**Possible result**
Friendships	know how different people 7	can act as bridges between worlds that are usually separate
Business	creative thinking	may cause 8 among certain people can lead to 9 despite similarities
Whole experience	knowledge of many cultural worlds and a great deal of 10	can teach us about problems faced by 11 of all kinds current ideas of what both 12 mean may be considered wrong belief that culture depends on 13

Writing Task 1

❶ Look at the chart below. Which of the descriptions, A–C, correctly matches the chart? Why are the other descriptions not appropriate?

A The chart below shows levels of emigration from Bulgaria in the 15–60 age group in 2001 and 2006.

B The chart below shows the plans of Bulgarian people aged 15–60 concerning leaving Bulgaria and living or working in another country in 2001 and 2006.

C The chart below compares reasons why Bulgarians aged 15–60 decided to leave Bulgaria in 2001 and 2006.

Emigration intentions, Bulgarians aged 15–60, 2001 & 2006

❷ Answer these questions about the chart.

1 What did most Bulgarians aged 15–60 plan to do in both years?

2 Which categories were higher in 2006 than in 2001?

3 What was the lowest category in 2001?

4 What happened in the category of people intending to live abroad permanently?

5 Which categories were higher in 2001 than in 2006?

❸ Look at this Writing task and decide which of the statements below are correct or not. Write *Yes* or *No*.

> *The chart below gives information about the level of education of Bulgarian people who wanted to go and live in another country in 2002, 2006 and 2008.*
>
> *Summarise the information by selecting and reporting the main features, and make comparisons where relevant.*

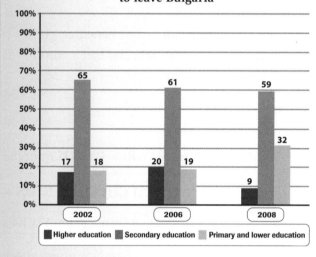

Level of education of Bulgarians planning to leave Bulgaria

1 The figure for people with higher education level fell in both 2006 and 2008.

2 One of the categories was the highest in every year.

3 Two of the categories rose in 2006.

4 One of the categories was lower in 2008 than in 2002.

5 The figure for people with primary and lower education rose each year.

6 The figure for secondary education was a lot lower in 2008 than in 2006.

❹ Now write your answer for the Writing task in Exercise 3.

Grammar

Making comparisons

❶ **This email is from Krishna, who has gone to live abroad. Complete the sentences with the comparative or superlative form of the adjective or adverb in brackets.**

Hi Neha,

Well, I've been here for a month now and things are fine. Of course, everything here is different from what I'm used to, and I'm finding some things (1)*easier*........ (easy) to deal with than others.

The course is (2) (demanding) than I expected and I'm having to work (3) (hard) than I ever have before. (4) (difficult) aspect of the course is the amount of work we have to do. Last week I had to write five essays – that's (5) (tiring) thing I've ever done! The best aspect of the course is the other students. They're (6) (friendly) people I've ever met and because of them I'm (7) (stressed) now than I was the first week of the course.

Lots of things have changed for me in comparison with my life at home. I have to travel (8) (far) to college, a lot of things are (9) (expensive) and the weather is a lot (10) (bad)! The city is (11) (big) than anywhere I've lived before and life is (12) (fast) here. I've never been (13) (busy) than I am now but this is (14) (exciting) thing I've ever done and I'm really pleased that I'm here!

I'll write to you (15) (regular) in future.

Love,

Krishna

❷ **Complete the first sentence with the comparative or superlative form of the word in brackets. Then complete the second sentence so that it has a similar meaning to the first sentence.**

1 a The town I come from is a lot*smaller*.... (small) than this one.

 b This town is*bigger*...... than the one I come from.

2 a Money is a problem because life here is (expensive) than life at home.

 b Money is a problem because life at home is than life here.

3 a I am (old) person in my class.

 b The other people in my class are than me.

4 a The transport system here is (good) than the one at home.

 b The transport system at home is than the one here.

5 a People here speak (slow) than people at home.

 b People at home speak than people here.

6 a Moving to another country is (difficult) thing you can do!

 b Nothing is than moving to another country.

Unit 2 It's good for you!

Reading Section 2

❶ Read through the article briefly. What does it mainly contain? Circle A, B or C.

A advice on healthy eating

B facts about food and drink

C criticism of the food industry

❷ Now read the text carefully and answer Questions 1–13.

WHAT DO YOU KNOW ABOUT THE FOOD YOU EAT?

A Most of us tend not to think about what we eat. Sure, we might have our favourite recipes, or worry about whether our food has been sprayed with pesticides, but the processes and discoveries that have gone into its production remain a closed book. Some, however, think differently. Why, they wonder, is frozen milk yellow? Why does your mouth burn for longer when you eat chillies than when you eat mustard? And what would happen if you threw yourself into a swimming pool full of jelly?

B It was for such people that *New Scientist* developed its 'Last Word' column, in which readers pose – and answer – questions on all manner of abstruse scientific issues, as they relate to everyday life. Many of the issues raised have simple answers. For the questions above, they would be: the riboflavin in milk begins to crystallise; it depends on your taste – the relevant chemical in mustard is more easily washed away by your saliva; and, you'd float, but don't dive in headfirst!

C Other questions allow us to explore issues that are relevant to everyone. For example, what's the difference between sell-by dates and use-by dates? You might expect the answer to involve overcautious health and safety regulation. But it's more complex than that. The shelf life of food is actually determined by its manufacturers, although lab tests and government guidelines also come into play. Food is tested periodically, at various temperatures, to check the level of bacterial spoilage over a few hours or days – the warmer it is, the more likely your prawn sandwich is to make you ill. After the lab tests, producers set a use-by date or a best-before date. Fresh shellfish need to be consumed by their use-by date (the date by which you must eat them). But tinned beans will probably last long beyond their best-before date (the date by which it's best to eat them), although they might not taste as good as they once did.

D The same research explains why even bottled mineral water, which had previously lain underground for decades, needs a best-before date. The problem isn't the water, but the bottling process: either bacteria can be introduced that multiply and, over time, contaminate the water, or unpleasant chemicals, such as antimony, leach into the water from the plastic bottles.

E Sometimes, this kind of scientific study takes us to some strange places. For example, we now know that the amount of oxygen in the air inside green peppers is higher than in red (by a whopping 1.23 percent), probably due to the different rate at which green peppers photosynthesise. The relevance of this research is that green peppers will decay faster than red if kept in sunlight: higher oxygen levels provide more resources to feed any bacteria that are present. Generally, cooler environments preserve food best – apart from tropical fruit. Banana skins, for example, have evolved to survive in warm conditions, because that is where they grow best. Anything below 13.3°C damages the membranes, releasing enzymes which lead to skin blackening. To avoid a mushy banana, keep it away from the chiller.

F It is not just fears for our health that keep food scientists busy. They are also involved in other areas. Their precision has, for example, also been applied to bottles – in particular, to the discovery that the optimum number of sharp pointy bits on a bottle cap is 21. Go on, count them. Years of trial and error led to the internationally accepted German standard DIN 6099, which ensures that almost every bottle cap is the same. This is because 21 is the ideal number when you take into account the circumference of the cap, the likelihood of its metal splitting, and the chances of it sticking in the capping machine. So, next time you open a bottle with a cap on it, pay homage to those who bothered to find out, starting with William Painter, in 1892.

G Of course, some researchers do care about the more serious stuff, driven by fear of the future and an ever-increasing population on a warming, land-impoverished planet. Sadly, *New Scientist*'s correspondents concluded that there was no one foodstuff that could feed the world on its own. However, they did come up with a menu that could feed a family of four for 365 days a year, using only eight square metres of land. Rotating crops (so that the soil didn't lose one nutrient more than any other) would be vital, as would ploughing back dead plant matter and maintaining a vegetarian diet. After that, you would need to grow crops that take up very little space and grow vertically rather than horizontally, if possible.

Questions 1–7

The reading passage has seven paragraphs, **A–G**.

*Choose the correct heading for paragraphs **A–G** from the list of headings below.*

i	Why a particular piece of information is given
ii	An unsolved problem and a solution to a problem
iii	Reasons that remain a mystery
iv	A source of information for some people
v	Development work leading to a conclusion
vi	Contrasting levels of interest in food
vii	The need to change a system
viii	Information connected with keeping certain kinds of food
ix	How certain advice is decided on
x	Ideas not put into practice

1 Paragraph A vi....
2 Paragraph B
3 Paragraph C
4 Paragraph D
5 Paragraph E
6 Paragraph F
7 Paragraph G

Questions 8–13

*Choose **TWO** letters, **A–E**.*

Questions 8–9

*Which **TWO** of the following are explained by the writer in the text?*

A why the 'Last Word' column was created

B why use-by dates are more important than sell-by dates

C how to prevent bacteria getting into bottled water

D a way in which peppers are similar to bananas

E why most bottle caps have a common feature

Questions 10–11

*Which **TWO** problems connected with food does the writer mention?*

A confusing information about the use of pesticides

B feeling pain when eating something

C sell-by dates sometimes being inaccurate

D feeling ill because of eating food after its best-before date

E the effect of sunlight on green peppers

Questions 12–13

*Which **TWO** of the following would a family of four need to do to feed itself every day of the year, according to New Scientist?*

A use more than one piece of land

B grow the same crop all the time

C put dead plants into the soil

D plant only crops that grow very quickly

E concentrate on crops that grow vertically

Listening Section 2

❶ **Look at both tasks. When is the speaker talking? Circle A, B or C.**

A at the begining of a conference

B during the planning of a conference

C at the end of a conference

❷ (03) **Now listen and answer Questions 1–10.**

Questions 1–5

*Choose the correct letter, **A, B** or **C**.*

1 The speaker says that the conference includes issues which
 A were requested by participants.
 B are seldom discussed.
 C cause disagreement.

2 The speaker says that in the past, this subject
 A caused problems in the workplace.
 B was not something companies focused on.
 C did not need to be addressed.

3 The speaker mentions a connection between health and fitness and
 A keeping employees.
 B employees' performance.
 C a company's reputation.

4 What does the speaker say about the people attending the conference?
 A Some of them may feel that there is not much they can learn.
 B All of them have attended the conference before.
 C Most of them are familiar with the speakers.

5 The speaker says that in the sessions, participants will
 A work together in pairs.
 B pretend to have various roles.
 C describe real events.

Questions 6–10

Label the map below.

*Write the correct letter, **A–H**, next to questions 6–10.*

6 Setting Up a Fitness Centre

7 Healthy Eating Schemes

8 Transport Initiatives

9 Running Sports Teams

10 Conference Coordinator's Office

Vocabulary

Word formation

❶ Complete each sentence with the correct form of the word in brackets.

1 Healthy eating is a matter of ...*education*... so that people know what to eat. (educate)

2 Yesterday she him for being too lazy to keep fit. (critic)

3 Even if exercise is , it's better than no exercise. (regular)

4 Going for a run on a day is a nice way to spend your time. (sun)

5 exercise is essential for everyone. (day)

6 Sometimes children don't want to eat healthy food because of its (appear)

7 There is a connection between being healthy and having a high level of (happy).

8 People who are can have health problems that fitter people don't have. (active)

❷ Complete the second sentence so that it has a similar meaning to the first. Use the correct form of the <u>underlined</u> word in the first sentence.

1 a The manufacturers claim that the additives don't do children any <u>harm</u>.

 b The manufacturers claim that the additives are*harmless*.... to children.

2 a There has been a <u>dramatic</u> rise in the number of obese people in this country.

 b The number of obese people in this country has risen

3 a Food producers should make the information on their products <u>simpler</u>.

 b Food producers should the information on their products.

4 a There were a lot of people <u>running</u> in the park.

 b There were a lot of in the park.

5 a I was <u>surprised</u> that I got fit so quickly.

 b It was to me that I got fit so quickly.

6 a There were some figures that people didn't <u>expect</u> in the report on the nation's health.

 b There were some figures in the report on the nation's health.

Key vocabulary

❸ Complete the sentences below, then use the words to complete this crossword.

Across

3 Farmers who grow organic vegetables have to using pesticides.

4 Farming are the ways farming is done.

5 A food is a small structure where you can buy food, for example in a market or in a street.

8 If food is grown or produced , it comes from the area nearby.

Down

1 If something is to happen, it will probably happen.

2 If something is , it is not natural.

6 goods are high-quality, expensive goods.

7 Crop are the amount of crops produced in a particular place.

Writing Task 2

1 **Read the following Writing task.**

> Write about the following topic:
>
> *Some people say that in the modern world it is very difficult for people to have a healthy lifestyle. Others, however, say that it is easy for people to be healthy and fit if they want to be.*
>
> *Discuss both these views and give your own opinion.*
>
> Give reasons for your answer and include any relevant examples from your knowledge or experience.

Below are three essay plans that candidates made for this question. Which one is the best essay plan for this question? Why is it the best one and why are the others not as good?

A

Paragraph 1: introduce the issue: healthy/ unhealthy lifestyles

Paragraph 2: why some people have unhealthy lifestyles

Paragraph 3: more reasons for unhealthy and unfit people

Paragraph 4: what people can do to be healthy and fit

Paragraph 5: conclusion: it's easy to be healthy and fit

B

Paragraph 1: introduction: why it's easy to have a healthy lifestyle

Paragraph 2: what I do to stay fit and healthy

Paragraph 3: some advice on healthy eating

Paragraph 4: conclusion: anyone can be fit and healthy if they want to be

C

Paragraph 1: introduce the subject: problem of unhealthy lifestyles

Paragraph 2: reasons why some people have unhealthy lifestyles

Paragraph 3: examples of unhealthy food and eating

Paragraph 4: why some people aren't fit

Paragraph 5: the results for people of having unhealthy lifestyles

Paragraph 6: conclusion: it's a big problem

2 **Complete the phrases below, that could be used in the Writing task, with the verbs in the box.**

cut	make	lose	take	~~have~~	stay
work	go	lead	do		

1have........ health problems
2 a healthy life
3 fit
4 you good
5 out in a gym
6 action
7 down on unhealthy foods
8 an effort
9 on a diet
10 try to weight

3 **To write a good answer, you need to use linking words and phrases. Complete the sentences below with the words and phrases in the box.**

in fact	also	as a result	~~over time~~
another	in particular	on the other hand	

1 If you exercise regularly,over time.... you will find that your general health improves.

2 People use their cars instead of walking. , they get very little exercise.

3 It is easy to buy healthy food in shops nowadays. , some of it is quite expensive.

4 Lack of exercise is one problem for some people. is the amount of junk food they eat.

5 There are gyms where people can get fit and there are ways of getting fit at home.

6 Some people think it's difficult to get fit. , it can be very easy.

7 Many people, office workers, have jobs that involve sitting in the same place all day.

4 **Now write your answer for the Writing task above.**

Grammar

Countable and uncountable nouns

❶ Complete the sentences below with the plural or uncountable form of the words in the box.

group research job way
knowledge work ~~programme~~
equipment information suggestion

1 More and more people nowadays are following fitness *programmes* .

2 It is easy to find on how to stay fit and healthy.

3 People with sedentary spend all day sitting down.

4 According to , the percentage of overweight people is growing.

5 This booklet contains many useful on how to keep fit.

6 Some people prefer to exercise in and so they join fitness classes.

7 At our gym, we have all the latest fitness for people to use.

8 Scientists are always increasing their of how the body works.

9 This book suggests a number of to help you lose weight.

10 My sister is looking for at a health centre as a receptionist.

❷ Circle the correct option in each of these sentences.

1 She does (*plenty of*)/ *much* exercise and she's very fit.

2 There's a *large / great* deal of pollution in this city at this time of year.

3 It took me *a lot of / many* time to get fit again after my injury.

4 There is *plenty / a wide* range of fitness courses that you can do.

5 Bad diets cause a large *amount / number* of health problems.

6 *Few / Little* people these days think that fitness is unimportant.

7 A small *amount / number* of junk food isn't bad for you.

8 It doesn't take *much / many* effort to stay fit if you want to do it.

9 My grandfather is very lucky. He has *few / a few* problems with his health.

10 Even *a few / a little* exercise would be good for you.

❸ Correct the underlined nouns if necessary. Put a tick (✓) above the noun if it is correct.

1 People don't get much <u>informations</u> on what is really in certain food <u>products</u>.
<small>*information*</small> above *informations*; ✓ above *products*

2 You don't need a large amount of <u>equipments</u> to do varied exercise <u>routines</u>.

3 People are given a lot of <u>advices</u> about how to have healthy <u>lifestyles</u>.

4 Junk food does a lot of <u>damages</u> to people's <u>healths</u>.

5 A nutritionist can give people good <u>advice</u> on their eating <u>habits</u>.

6 Using the latest <u>softwares</u>, experts analyse <u>sportsmen</u> when they are training.

7 People who do office <u>work</u> need to find <u>way</u> of keeping fit.

8 People sometimes need <u>help</u> to solve <u>problem</u> with their weight.

Unit 3 Getting the message across

Listening Section 3

1 Look at all of the tasks. What are the speakers talking about? Circle A, B or C.

A a dissertation the student is planning

B a dissertation the student is writing

C a dissertation the student has completed

2 (04) Now listen and answer Questions 1–10.

Questions 1–4

Choose TWO letters, A–E.

Questions 1–2

Which TWO areas of work did Beth include in her dissertation?

A retail

B banking

C call centres

D tourism

E translation

Questions 3–4

Which TWO aspects of the dissertation were impressive, according to the tutor?

A summary of academic research

B analysis of videos

C observation of live interactions

D interviews

E analysis of data on the outcomes

Questions 5–8

Which comments do the speakers make about each section of the dissertation?

Choose FOUR answers from the box and write the correct letter, A–F, next to Questions 5–8.

Sections of Dissertation

5 Dealing with Complaints

6 Collaborating with Colleagues

7 Interacting with Managers

8 Giving Instructions

> A There is not enough evidence.
> B The conclusion is confusing.
> C It highlights a real problem.
> D It is particularly well organised.
> E There are too many examples.
> F It includes new ideas.

Questions 9–10

Answer the question below.

Write NO MORE THAN TWO WORDS for each answer.

Which TWO aspects of communication does Beth emphasise in her conclusion?

9 10

Vocabulary

▶ Student's Book unit 3, p28

❶ **Complete this paragraph about a piece of college work with the words in the box. You may need to form a plural noun for some gaps.**

evaluation	extract	weakness
finding	~~assignment~~	structure
assessment	feature	

I've just done a big **(1)** .a̲s̲s̲i̲g̲n̲m̲e̲n̲t̲. concerning language skills in various countries. To do this, I read short **(2)** from various long reports and I had to list the **(3)** of various research projects. I paid careful attention to the **(4)** of my report because it had to be well organised in clear sections. One of my **(5)** is that my work is sometimes not clear and well organised. When we've completed a piece of work, we are encouraged to do self- **(6)** to see if we find anything we can improve in our work, and then we have a system of peer **(7)** and comment on each other's work. One of the main **(8)** of my work is a comparison between the number of people who are literate and the number who can't read or write in various countries.

Teach, learn or *study*? *Find out* or *know*?

❷ **Correct the underlined verbs if necessary. Put a tick (✓) above the verb if it is correct.**

 teach

1 Could you <u>learn</u> me how to change this picture on my computer?

2 Researchers have <u>found out</u> exactly why this happens.

3 I <u>learnt</u> a lot from doing that course.

4 I haven't been able to <u>know</u> much information on this topic.

5 I handed in my work last week but I don't <u>learn</u> what mark I got.

6 We had to <u>learn</u> hard because we had to write lots of essays.

7 If I <u>study</u> hard, I'm sure I'll do well.

8 Nobody <u>taught</u> me how to do this, I <u>found out</u> for myself.

Key vocabulary

❸ **Complete the second sentences with one word so that they are similar in meaning to the first sentences.**

1 How languages are learnt is an interesting subject.
Language ..a̲c̲q̲u̲i̲s̲i̲t̲i̲o̲n̲.. is an interesting subject.

2 English isn't his first language.
He isn't a speaker of English.

3 It took me about five hours.
It took me more or five hours.

4 This kind of work isn't easy for me.
I don't this kind of work easy.

5 She doesn't belong to the Drama Club any more.
She no belongs to the Drama Club.

6 I think he's trying to lose weight.
I think he's on a

7 It's important to include statistical evidence in your work.
The of statistical evidence in your work is important.

8 The important thing is that you get a good degree.
What is that you get a good degree.

Reading Section 3

❶ Read through the article briefly and look at the second task, Questions 5–9.

In which paragraphs of the text will you find the information that you require to do this task?

............................

❷ Now read the article carefully and answer Questions 1–14.

STRICTLY ENGLISH

British newspaper columnist Simon Heffer talks about his new book, 'Strictly English: the Correct Way to Write ... and Why It Matters', aimed at native speakers

For the last couple of years I have sent a round-robin email to my colleagues at this newspaper every few weeks pointing out to them mistakes that we make in our use of the English language. Happily, these are reasonably rare. The emails have been circulated on the Internet – and are now available on the paper's website – and one of them ended up in the inbox of a publisher at Random House about this time last year. He asked me whether I would write a book not just on what constituted correct English, but also why it matters. The former is relatively easy to do, once one has armed oneself with the *Oxford English Dictionary (OED)* and some reputable grammar books by way of research materials. The latter, being a matter for debate, is less straightforward.

I suppose my own interest in language started at school. Having studied French, Latin and Greek, I saw clearly how those languages had exported words into our own. When I studied German later on, I could see even more clearly why it was the sister tongue and what an enormous impact it had had on English. I saw that words had specific meanings and that, for the avoidance of doubt, it was best to use them in the correct way. Most of all, I became fascinated by grammar, and especially by the logic that drove it and that was common to all the other languages I knew. I did not intend in those days to earn a living by writing; but I was keen to ensure that my use of English was, as far as possible, correct.

Studying English at university forced me to focus even more intently on what words actually meant: why would a writer choose that noun rather than another and why that adjective – or, in George Orwell's case, often no adjective at all. Was the ambiguity in a certain order of words deliberate or accidental? The whole question of communication is rooted in such things. For the second part of my degree I specialised in the history of the English language, studying how words had changed their meaning and how grammar had evolved. Language had become not just a tool for me, but something of a hobby.

Can English, though, ever be fixed? Of course not: if you read a passage from Chaucer you will see that the meaning of words and the framework of grammar has shifted over the centuries, and both will continue to evolve. But we have had a standard dictionary now ever since the OED was completed in 1928, and learned men, many of whom contributed to the OED, wrote grammars a century ago that settled a pattern of language that was logical and free from the danger of ambiguity.

It is to these standards that I hope *Strictly English* is looking. Our language is to a great extent settled and codified, and to a standard that people recognise and are comfortable with. All my book does is describe and commend that standard, and help people towards a capable grasp of the English tongue. We shall always need new words to describe new things; but we don't need the wrong word to describe the right thing, when the right word exists. Also, English grammar shouldn't be a matter for debate. It has a coherent and logical structure and we should stick to it.

Some groups of people – state officials, academics, lawyers, certain breeds of scientist – talk to each other in a private language. Some official documents make little sense to lay people because they have to be written in a language that combines avoidance of the politically incorrect with constant use of the contemporary jargon of the profession. Some articles written by academics in particular are almost incomprehensible to those outside their circle. This is not because the outsiders are stupid. It is because the academics feel they have to write in a certain stilted, dense way in order to be taken seriously by their peers.

Many officials seem to have lost the knack of communicating with people outside their closed world.

Some academics, however, are bilingual. If asked to write for a publication outside the circle – such as a newspaper – they can rediscover the knack of writing reasonably plain English. They do not indulge themselves in such a fashion when they write for learned journals. It is almost as though the purpose of such writing is not to be clear: that the writer is recording research in order to prove to peers or superiors that he has discovered something. It does not seem to bother such people that their style is considered ugly and barbaric by anyone of discernment. It is repetitious, long-winded, abstract and abstruse. Those who write in such a way probably will not easily be discouraged, unless what is considered acceptable within their disciplines changes.

The ideal style is one comprehensible to any intelligent person. If you make a conscious decision to communicate with a select group, so be it: but in trying to appeal to a large audience, or even a small one that you wish to be sure will understand your meaning, writing of the sort mentioned above will not do. This sort of writing used to be kept from the general public thanks to the need to find someone to publish it. The advent of the Internet means that it is now much more widespread than it used to be; and the fact that it is now so common and so accessible means that this sort of writing is having a harmful effect on the language and causing it to be corrupted.

Questions 1–4

Do the following statements agree with the views of the writer in the reading passage?

Write

YES *if the statement agrees with the views of the writer*

NO *if the statement contradicts the views of the writer*

NOT GIVEN *if it is impossible to say what the writer thinks about this*

1 The mistakes made by his colleagues are minor ones.

2 It is difficult to explain why using correct English is important.

3 English grammar has a different function from the grammar of other languages.

4 Word order may be as important as the choice of words used.

Questions 5–9

Complete the summary using the list of words, A–H, below.

The rules of English

According to the writer, the English language should not be considered something **5** , and this will always be the case. However, there have been accepted reference books for over a century that were produced by **6** people, and these have established a system for the language that enables people to express themselves in a completely clear way.

In his own book, the writer aims to describe and support the established rules of the language that are in **7** use and that people are accustomed to. He also wants his book to be **8** as a way of improving people's ability at the language. He believes that there is no reason why someone's use of vocabulary should not be correct and that grammar should not be a **9** subject. In his view, a system of grammar rules exists and people should always obey those rules.

A simple	**E** knowledgeable	
B general	**F** compulsory	
C controversial	**G** historic	
D permanent	**H** useful	

Questions 10–14

Choose the correct letter, A, B, C or D.

10 The writer says that some groups of people use a 'private language' because

 A they do not want outsiders to be able to understand them.

 B they want to show their superiority over other groups.

 C they want to impress other members of their group.

 D they do not want to use the same language as other groups.

11 According to the writer, some academics are capable of

 A making sense to people outside their group.

 B writing very clearly for learned journals.

 C changing the way they communicate within their own group.

 D explaining other people's work to the general public.

12 When discussing the writing of academics about their research, the writer emphasises

 A his own lack of knowledge of the academic world.

 B his desire to understand what they describe.

 C his sympathy for some of the academics.

 D his dislike for the style used in their writing.

13 The writer says that the kind of language used by academics in journals

 A is becoming more widely understood by non-academics.

 B is attracting a lot of criticism from other academics.

 C will only change if they are forced to change it.

 D appeals only to highly intelligent people.

14 The writer's opinion of the Internet is that

 A it is making people more aware of the poor use of language.

 B it is encouraging standards of language use to fall.

 C it is enabling people to compare good and poor use of language.

 D it is making it harder for good writing to get published.

Grammar

Tenses

❶ Complete these statements by IELTS candidates, using the past simple, present perfect or present perfect continuous forms of the verbs in the box. You may need to use a negative verb in some gaps.

have	~~get~~	find	write	put	give	be
work	look	make	study	leave		

1 I*got*........ a very good mark for my essay last week.

2 I'm very busy because my tutor me a very difficult piece of work to do.

3 I for a book on this subject for days but I one yet.

4 I this subject before, so I don't know much about it.

5 I on the student committee for two years but I it a few months ago because I enough time.

6 I on this project for three weeks and I'm making good progress.

7 I a few mistakes in the essay I yesterday.

8 I my name on the list for the college trip and I'm looking forward to it.

Prepositions

▶ Student's Book unit 3, p36

❷ Look at the graph from a communication company's report. Complete the sentences with the correct prepositions.

Mobile phone sales 2010

1 Sales of mobile phones showed a small rise*in*...... April.

2 The lowest sales were in the period March June.

3 March, sales of mobile phones fell 1,500.

4 This meant that sales fell 25% compared with the previous month.

5 a six-month period, there was a rise the number of new products launched.

6 October and December, there was an increase 60% sales of phones.

7 Sales of mobile phones rose 2,500 4,000 that period.

8 Monthly sales peaked 4,000 December.

Writing Task 1

❶ **Which of these descriptions best matches the graphs below? Circle A, B or C.**

A The graphs below give information on the number of words spoken to children in various categories of family and the size of the vocabulary of those children.

B The graphs below compare the number of words children in different categories of family can understand with the number of words they use.

C The graphs below show rises in the vocabulary levels of both young children and older people in different categories of family.

Total words spoken to child

Millions of words (y-axis: 10, 20, 30, 40, 50)
Age of child in months (x-axis: 12, 24, 36, 48)

Higher-talking families ▬ Lower-talking families ▬ Lowest-talking families ▬

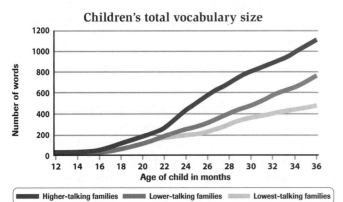

Children's total vocabulary size

Number of words (y-axis: 0, 200, 400, 600, 800, 1000, 1200)
Age of child in months (x-axis: 12, 14, 16, 18, 20, 22, 24, 26, 28, 30, 32, 34, 36)

Higher-talking families ▬ Lower-talking families ▬ Lowest-talking families ▬

❷ **Complete these sentences about the graphs with the correct information.**

1 The number of words spoken to children in families rises from about 10 million to over 30 million between the ages of 12 months and 36 months.

2 The highest number of words spoken to any children aged 48 months is approximately

........................... .

3 Children aged in the lowest-talking families hear approximately 10 million words.

4 The lowest vocabulary for any children aged 36 months is nearly words and the highest is approximately words.

5 The vocabulary of children in higher–talking families rises very steeply from the age of

........................... .

6 Children in the families reach a vocabulary of 200 words at approximately the age of 26 months.

❸ **Which of the following is the best overview of the information in the two graphs? Circle A, B or C.**

A Young children in families that talk a lot increase their vocabulary much more quickly than young children in families that don't talk so much.

B The vocabulary of young children increases rapidly even if their families do not talk to them very much.

C The increase in a young child's vocabulary is not always linked to the amount of talking their families do.

❹ **Look at this Writing task and write your answer.**

The table below gives the results of two surveys, in 1997 and 2006, in which people were asked which communication skills were essential in their jobs.

Summarise the information by selecting and reporting the main features, and make comparisons where relevant.

Which communication skills are essential in your job? (Survey 1997 & 2006)

	Percentage of people asked	
Communication: External	**1997**	**2006**
Knowledge of particular products or services	35	41
Selling a product or service	24	21
Advising or caring for customers or clients	36	39
Dealing with people	60	65
Communication: Internal (within company)		
Instructing or training people	25	30
Persuading or influencing others	16	21
Making speeches or presentations	7	11
Analysing problems together with others	20	26
Planning the activities of others	14	15
Listening carefully to colleagues	38	47

Unit 4 New media

Reading Section 1

❶ **Read through the article briefly. Then read Questions 1–6 and answer the following question.**

In which paragraphs will you find the information that you need to do this task?

❷ **Now read the text carefully and answer Questions 1–13.**

IS CONSTANT USE OF ELECTRONIC MEDIA CHANGING OUR MINDS?

The power of modern electronic media – the net, mobile phones and video games – to capture the attention of the human mind, particularly the young mind, and then distract it, has lately become a subject of concern. We are, say the worriers, losing the ability to apply ourselves properly to a single task, like reading a book in its entirety or mastering a piece of music on an instrument, with the result that our thinking is becoming shallower.

Nicholas Carr, the American science writer, has explored this theme for his new book, *The Shallows*, in which he argues that new media are not just changing our habits but our brain too. It turns out that the mature human brain is not an immutable seat of personality and intellect but a changeable thing, subject to 'neuroplasticity'. When our activities alter, so does the architecture of our brain. 'I'm

not thinking the way I used to think,' writes Carr. 'I feel it most strongly when I'm reading.' Years of internet use have, he suspects, dented his ability to read deeply, to absorb himself in books: 'My brain wasn't just drifting. It was hungry. It was demanding to be fed the way the net fed it.' He describes getting fidgety when faced with a long text: 'When we go online, we enter an environment that promotes cursory reading, hurried and distracted thinking, and superficial learning.'

Carr cites research by Gary Small, a professor of psychiatry at UCLA, who concluded that constant exposure to modern media strengthens new neural pathways while weakening older ones. Just five hours of internet use is enough to awaken previously dormant parts of the brain's pre-fontal cortex, concluded Small. For Carr, this is proof that the net can rewire the mind. He sees dangers. Deep thought, the ability to immerse oneself in an area of study, to follow a narrative, to understand an argument and develop a critique, is giving way to skimming. Young users of the Internet are good at drawing together information for a school project, for example, but that does not mean they have digested it.

But is a changing mind a more stupid one? Jake Vigdor and Helen Ladd are researchers at Duke University, North Carolina. In a study spanning five years and involving more than 100,000 children, they discovered a correlation between declining test scores in both mathematics and reading and the spread of home computers and broadband. 'The decline in scores was in the order of one or two percent but it was statistically significant,' says Vigdor. 'The drop may not be that great but one can say that the increase in computer use was certainly not positive.' The cut-off year for the study was 2005, when socialising was more primitive. Since then, social networking sites have become enormously powerful consumers of young people's time. Vigdor and Ladd concluded that the educational value of home computing was best realised when youngsters were actively supervised by parents.

This tendency to skim is compounded by the temptation of new media users to 'multi-task'. Watch a youngster on a computer and he could be Facebook-ing while burning a CD or Tweeting on his mobile phone. Modern management tends to promote multi-tasking as an expression of increased efficiency. Science, on the other hand, does not. The human brain is, it seems, not at all good at multi-tasking – unless it involves a highly developed skill like driving. David Meyer, a neuroscientist

at the University of Michigan, says: 'The bottom line is that you can't simultaneously be thinking about your tax return and reading an essay, just as you can't talk to yourself about two things at once. People may think otherwise but it's a myth. With complicated tasks, you will never, ever be able to overcome the inherent limitations in the brain.'

Paying attention is the prerequisite of memory: the sharper the attention, the sharper the memory. Cursory study born of the knowledge that information is easily available online results, say the worriers, in a failure to digest it. In addition, the brain needs rest and recovery time to consolidate thoughts. Teenagers who fill every moment with a text or Tweet are not allowing their minds necessary downtime. All rather worrying, but is it that bad?

We have been here before, of course. The Ancient Greeks lamented the replacement of the oral tradition with written text, and the explosion in book ownership resulting from the printing press was, for some, a disaster. In the 18th century, a French statesman railed against a new device that turned people into 'dispersed' individuals, isolated in 'sullen silence'. He was talking about the newspaper.

The net is supposed to consume the lives of young people, yet the only reliable studies about the time spent online, collated by the World Health Organization, suggest children spend between two and four hours in front of screens, including television screens, and not six or seven, as often suggested. Moreover, there is evidence that youngsters who use social networking sites have more rewarding offline social lives than those who do not.

A study on children and new technology in the UK included a 'study of studies' by Professor David Buckingham of the University of London's Institute of Education. He concluded: 'Broadly speaking, the evidence about the effects of new media is weak and inconclusive – and this applies to both positive and negative effects.'

Certainly the 'old' media don't seem to be doing that badly. An annual survey shows that sales of children's books this year were 4.9 per cent greater than last year, with more than 60 million sold. The damage, if any, done by excessive computer time may not be so much to do with what is being done online as what is being missed – time spent with family or playing in trees with friends.

Questions 1–6

Do the following statements agree with the information given in the reading passage?

Write

TRUE	*if the statement agrees with the information*
FALSE	*if the statement contradicts the information*
NOT GIVEN	*if there is no information on this*

1 Some people believe that modern electronic media only have a negative effect on young people.

2 Nicholas Carr's book on the subject is a bestseller.

3 Nicholas Carr believes that electronic media have affected his enjoyment of reading books.

4 Gary Small's research supports Nicholas Carr's beliefs.

5 Management beliefs on multi-tasking are proved correct by scientific research.

6 David Meyer's views on the limitations of the brain have caused controversy.

Questions 7–10

Complete the notes below.

*Choose **NO MORE THAN TWO WORDS AND/OR A NUMBER** from the passage for each answer.*

Vigdor and Ladd's research

- looked at over 7

- found that lower 8 and home computer use were linked

- indicated that the effects of greater home computer use could not be described as 9

- concluded that 10 should be involved in home computer use

Questions 11–13

Answer the questions below.

*Choose **NO MORE THAN TWO WORDS AND/OR A NUMBER** from the passage for each answer.*

11 Which invention was criticised by an 18th century French politician?

12 According to studies that can be trusted, what is the maximum amount of time per day that children spend looking at screens?

13 Which products have become more popular recently?

Listening Section 4

❶ **You will hear an expert giving a talk on blogs. Look at Questions 6–10 and answer the following question.**

Which three questions need a noun

to fill the gap?

❷ (05) **Now listen and answer Questions 1–10.**

Questions 1–5

Complete the summary below.

*Write **ONE OR TWO WORDS** for each answer.*

Blogs and the History of Blogging

A blog can perhaps be best described as a website that consists of a kind of journal that is regularly updated. Blogs cover a very wide variety of topics and many of them are personal diaries. Blogs are usually not **1** because they have interactive elements, which may lead to friendships or even **2** relationships between people.

The first 'blog' was probably created in 1994 by a student and he called it his '**3**'. Similar websites were then created and these included both links and **4** In 1999, someone changed the term used for these websites by creating the phrase '**5**', and therefore invented the term 'blog'.

Questions 6–10

Complete the flow chart below.

*Write **ONE WORD ONLY** for each answer.*

Blogging Workflow – Advice

Decide what the **6** of your posts will be

⬇

Do some reading before starting a post

⬇

As you compose the post, keep a record of **7** and links

⬇

After creating the post, add some tags to it to improve searchability

⬇

Use social networking sites to **8** a post you think is outstanding

⬇

Look at the **9** relating to the post

⬇

Don't simply say **10** to people who have responded to your post

⬇

Go on to other blogs and leave comments.

Vocabulary

Cause, factor and *reason*

❶ **Complete the sentences with *causes, reasons* or *factors*.**

1 Illegal internet downloading is one of the main of the problems faced by record companies.

2 One of the why fewer people buy newspapers these days is that they can read them online.

3 When considering which computer to get, reliability is one of the key

4 Children like computer games for a number of , for example, because the graphics are exciting.

5 The results of this problem are known but what are the ?

6 Price and number of applications are among the that determine how popular a digital product becomes.

▶ Student's Book unit 4, p42

❷ **Complete the sentences about internet use with the jumbled words in the box.**

WBOESR	CUHOT	NODDAWLO	~~TCAH~~
ETAD	SIVTI	HRCAERSE	ITGKNREOWN

- I often **(1)***chat*....... to friends on a social **(2)** site. I like to keep up to **(3)** with what everyone's doing and I check the site for messages several times a day.

- I need to **(4)** this topic and I'm going to **(5)** various documents from a number of places.

- I often **(6)** the Internet for long periods of time and **(7)** lots of different sites.

- I use internet news sites to keep in **(8)** with world events.

Key vocabulary

❸ **Complete the sentences below with the verbs in the box. Two of the verbs do not fit into any of the gaps.**

do	experiment	reveal	launch	evolve	transform
carry	attract	turn	lack	restrict	~~discourage~~

1 Parents try to ...*discourage*... their children from using computers too much.

2 Did people realise that computers would completely the way we live?

3 Some children who spend a lot of time on computers may the incentive to go out and make friends face to face.

4 Stories about the dangers of internet use attention when they appear in the media.

5 Experts a lot of research on how people use computers.

6 Statistics that some children spend many hours a day in front of screens.

7 Some parents try to the amount of time their children use the Internet.

8 Whenever companies new games consoles, children want to buy them.

9 Children like to with new gadgets to find out what they can do.

10 How will the way people use computers over the next few decades?

Writing Task 2

❶ Read this Writing task and underline the main points.

> Write about the following topic:
>
> *The use of electronic media has a negative effect on personal relationships between people.*
>
> *To what extent do you agree or disagree?*
>
> Give reasons for your answer and include any relevant examples from your knowledge or experience.

❷ What *must* your answer include? Write *Yes* or *No* in the spaces next to each choice.

A a mention of at least one kind of electronic media

B your opinion on whether the statement is true or not

C your favourite kinds of electronic media

D how the use of electronic media can affect personal relationships

E which forms of electronic media are the most expensive

F a comparison between young people and older people

G how people interact using electronic media

H a prediction about future use of electronic media

❸ Which of these notes for the above task are relevant and could be included in an answer and which are not? Write *Yes* or *No*.

A people don't speak to each other face to face

B people sometimes don't read or reply to emails and texts

C some electronic gadgets quickly become old-fashioned

D some people make lots of friends on social networking sites

E some electronic gadgets are more popular than others

F people sometimes send messages without thinking first

G people can keep in touch regularly using electronic media

H some people don't know how to use electronic media

❹ Now write your answer for the Writing task above.

Grammar

However, although, even and *on the other hand*

▶ Student's Book unit 4, p44

❶ Decide which of the following sentences about using the Internet for research is correct. Sometimes more than one choice may be correct.

1 **A** The Internet is often a good place for research, however other sources of information can be better.

 B Although the Internet is often a good place for research, other sources of information can be better.

 C The Internet is often a good place for research. Even though, other sources of information can be better.

2 **A** There's a lot of information on the Internet. On the other hand, some of it isn't accurate.

 B There's a lot of information on the Internet. Although, some of it isn't accurate.

 C There's a lot of information on the Internet. However, some of it isn't accurate.

3 **A** You can find a lot of useful information on the web, although it can take a long time to find it.

 B You can find a lot of useful information on the web, even though it can take a long time to find it.

 C You can find a lot of useful information on the web however it can take a long time to find it.

4 **A** However internet research is useful, it's not always the best kind of research.

 B Internet research is useful on the other hand it's not always the best kind of research.

 C Even though internet research is useful, it's not always the best kind of research.

Articles

❷ Choose the correct options.

1 I really want to go to *a /an* university in the U.S.

2 *A / The* music industry in Britain wants *the / a* government to stop illegal downloading.

3 I spend *a / an* hour on Facebook every morning before I go to college.

4 My sister starts *a / –* university in September.

5 Can you imagine *the / –* life without *an / the* Internet?

6 I found *a / the* brilliant website last night. I've emailed all my friends about *the / a* site.

7 Do you have *the / –* arguments with your family about who can use your home computer?

8 *The / A* first thing to do when you want to start a blog is to decide on the topic.

9 *– / The* quickest way to contact *the / –* friends is by texting them.

10 *– / The* young are always keen to try new technology.

❸ Complete the following paragraph with *a, an, the* or – (if there is no article).

It is extraordinary how quickly **(1)***the*.... Internet and email have become **(2)** enormous part of everyone's lives. Not so many years ago, people didn't have **(3)** PCs and **(4)** computers were very big objects that only existed in **(5)** big companies and organisations. When it was **(6)** new invention, only **(7)** rich could afford **(8)** PC. But now almost everyone has **(9)** home computer and they have changed **(10)** people's lives. Instead of making **(11)** phone call or writing **(12)** letter, they send **(13)** email. They use them at **(14)** work and **(15)** children use them at **(16)** school. In a very short time, they have become **(17)** most important tool in **(18)** world.

Unit 5 The world in our hands

Listening Section 1

❶ **Look at the first task, Questions 1–6.**

Which questions might need a number **only** for the answer?

❷ (06) **Now listen and answer Questions 1–10.**

Questions 1–6

Complete the notes below.

Write **NO MORE THAN TWO WORDS AND/OR A NUMBER** *for each answer.*

The Volunteer Agency

- has recruited **1** people for environmental projects

- project abroad involves doing **2** or going into the rain forest

- major project for dealing with **3** in the countryside

- project for improving conditions for **4**

- **5** projects in urban areas

- some projects do not have any **6**

Questions 7–10

Complete the table below.

Write **ONE WORD** *for each answer.*

Name of organisation	Numbers	Example volunteer activity
Wildlife Link	24,000 volunteers	getting information about **7** of wildlife
Wildlife Watch	300 **8**	doing administrative work
9 Earth	908 projects	building **10** and walls

Vocabulary

Nature, the environment or *the countryside?*
Tourist or *tourism?*

❶ Complete the sentences by putting *nature*, *environment*, *countryside*, *tourist* or *tourism* in each gap.

1 is the biggest industry in some countries.

2 If you are a 'responsible', you try to make sure that you don't do damage to the in the country you are visiting.

3 People who like enjoy getting out of cities and going to the

4 From our room we had a wonderful view over spectacular

5 Increases in can sometimes have a bad effect on places.

Key vocabulary

❷ Complete the sentences, using the nouns in the box.

plant	step	drawback	~~challenge~~
infrastructure		source	

1 Solving that environmental problem is a big *challenge* and will take a long time.

2 You have to create a proper for the supply of alternative energy supplies.

3 What kind of power should be built to supply energy?

4 Can solar energy ever be a major of electricity?

5 The high cost is a major of that kind of power.

6 After reducing emissions, the next is to use alternative energy supplies.

❸ Complete the sentences below connected with environmental issues, using words from the wordsearch.

C	L	C	H	A	N	G	E	S	S	I	E
D	E	S	A	T	O	V	A	T	I	N	M
E	L	S	B	M	T	U	R	O	N	B	I
S	A	Y	I	O	I	P	E	P	F	E	S
T	O	U	T	S	W	I	N	C	O	T	S
R	L	H	A	P	H	L	E	A	S	I	I
U	N	C	T	H	I	E	W	A	S	P	O
C	O	N	S	E	R	V	A	T	I	O	N
T	U	Y	R	R	O	E	B	A	L	K	S
I	N	T	E	E	V	L	L	S	S	I	P
O	L	R	I	N	G	S	E	M	I	D	S
N	E	N	D	A	N	G	E	R	E	D	O

1 What can be done to protect the*endangered*...... species of the world before they die out?

2 Is it possible to cut down on the use of fuels?

3 Which energy sources can replace the energy sources currently used?

4 Is it possible to stop the of rainforests?

5 Has the problem of climate been caused by human activity?

6 A lot of damage is done when greenhouse gases are released into the

7 It is becoming harder for some species to survive in their natural

8 Scientists and designers are trying to design cars with zero

9 There are wildlife programmes to protect various species.

10 There is some evidence that rising sea are happening in various parts of the world.

Reading Section 2

❶ Read through the text about Russia's boreal forests briefly and look at Questions 6–9.

In which sections of the text are the scientists on the list mentioned?

❷ Now read the text carefully and answer Questions 1–13.

Russia's boreal forests and wild grasses could combat climate change

A Scientists believe Russia's ancient forests are the country's best natural weapon against climate change, even though the stockpile of carbon beneath the ground also makes these areas vulnerable to carbon release. A recent study found that half the world's carbon is stored within land in the permafrost region, about two-thirds of which lies in Russia. Overlying former glaciers, they are a coniferous mix called the boreal forest. 'There's a lot of carbon there and it's very vulnerable,' says Josep Canadell, co-author of the study. 'If the permafrost thaws, we could be releasing ten percent more carbon a year for several centuries more than our previous models predicted. It's going to cost a lot to reduce our emissions by that much – but it will cost more in damage if we don't.'

B The study was published in *Global Biogeochemical Cycles.* Researchers found that the region contains 1,672 billion tons of organic carbon, much of it several feet underground, that 'would account for approximately 50 percent of the estimated global below-ground organic carbon'. Another paper published in *Nature* found that old forests, which make up perhaps half of the boreal forest, 'continue to accumulate carbon, contrary to the long-standing view that they are carbon-neutral'. Even though fires and insect infestations destroy entire swaths of forest and release into the atmosphere the carbon they contain, old-growth forests still take in more than these natural disturbances release, says lead author Sebastiaan Luyssaert, a biologist at the University of Antwerp in Belgium. 'This is all the more reason to protect Russia's boreal forests,' which take in 500 million tons of carbon a year, or about one-fifth of the carbon absorbed by the world's landmass, says Mr Canadell, who is executive director of the Global Carbon Project, based in Canberra.

C Jing Ming Chen, a University of Toronto geography professor who specialises in climate modelling for the boreal region, says: 'Cutting boreal trees increases the amount of carbon in the atmosphere and it takes 50 to 100 years to put that carbon back in the ground.' Luysaaert and Chen argue there's a strong case for conserving the old-growth forests. 'It's better to keep as much carbon in the forest as possible right now,' Mr Luyssaert explains. 'If we want to avoid irreversible processes like melting permafrost or changing ocean currents, we absolutely have to control our emissions in the next two or three decades. It's a case where you need to be short-sighted to be far-sighted.' 'The threats to the boreal forests don't seem significant right now,' explains Nigel Roulet, a carbon cycle specialist at McGill University in Montreal, 'but I'm convinced pressure will increase as the region gets warmer and it gets easier to operate there. Also, I expect these resources to become more valuable as others are exhausted.'

D Scientists say Russia and Kazakhstan could make a unique contribution to the fight against global warming by harvesting wild grasses that have overgrown 100,000 square miles of agricultural lands abandoned in the nineties, and using them to make ethanol – or, better yet, burn them in coal-fuelled power plants. According to Nicolas Vuichard, principal author of a paper published in *Environmental Science and Technology* of Washington, DC, using the grasses to make ethanol would sequester in the ground, over 60 years, about 10 million tons of carbon a year – one-quarter as dead root matter in the soil and the rest in producing ethanol as a substitute for petroleum-based fuels. 'That's not huge on a world scale, but it's substantial,' he says. Fossil fuels emit about eight billion tons of carbon a year, of which about two billion tons are absorbed by plants and soil.

E Renton Righelato, visiting research fellow at the University of Reading and former chairman of the World Land Trust, agrees. 'Given that it would take the world's entire supply of arable land to replace just two-thirds of our transport fuel needs,' he says, 'biofuels are not a practicable long-term solution for transportation emissions. What we need is carbon-free fuel. But in the case of abandoned croplands, using grasses as biofuels could make a contribution,' he adds. Study co-author Adam Wolf, of the Carnegie Institution for Science at Stanford University, cites a study by Elliott Campbell in *Science* magazine that showed that burning grasses in a coal-fuelled plant doubles the savings in carbon emissions compared to using the same grasses to make ethanol. 'If biofuels are going to reduce emissions, using abandoned croplands to make electricity and offset coal use is our best bet,' he says. 'Both of these countries have coal-fuelled power plants, so the process could start soon.' Thus, Russia and Kazakhstan are now in a position to become leaders in green energy, and could use the grasses to export clean electricity in addition to oil and gas, according to Mr Wolf.

Questions 1–5

The reading passage has five paragraphs, **A–E**.

Which paragraph contains the following information?

*Write the correct letter, **A–E**.*

NB You may use any letter more than once.

1 a view concerning what can and what cannot replace something

2 a mention of the amount by which carbon emissions might increase in the future

3 a reference to an established belief that researchers say is incorrect

4 evidence from one study that supports the conclusions of another study

5 how much carbon is currently located in a particular part of the world

Questions 6–9

Look at the following statements (Questions 6–9) and the list of scientists below.

*Match each statement with the correct scientist, **A–D**.*

6 More attention will be paid to the situation in the boreal forests in the future.

7 Boreal forests are able to deal with some of the damage that is done to them.

8 Earlier research may have underestimated the scale of a future problem.

9 The damage done by destroying boreal forests lasts for a very long time.

List of scientists

A Josep Canadell **C** Jing Ming Chen
B Sebastiaan Luyssaert **D** Nigel Roulet

Questions 10–13

Complete the summary below.

*Choose **NO MORE THAN TWO WORDS** from the passage for each answer.*

Wild grasses in Russia and Kazakhstan

Scientists believe that wild grasses which are currently growing on former **10** in Russia and Kazakhstan could be useful in combating environmental problems. There are two different ideas concerning how this could happen.

With the first idea, approximately ten million tons of carbon would be stored in the ground, and three-quarters of this would create **11** that could be used instead of petroleum-based fuels. The second idea is to burn the grasses in **12** power plants. Supporters of this idea say that the effect in reducing carbon emissions would be twice as great as if the first idea was carried out. The grasses would be used to produce **13** and production of this could begin in a short period of time.

Writing Task 1

1 Look at the Writing task below. Which of the following *must* you mention in your answer? Write *Yes* or *No*.

A different types of buildings

B different types of energy produced

C distances

D differences between two systems

E who uses the energy produced

F opinions on each system

G the results of each system

H stages in each system

The diagram below compares two different systems of energy production – a conventional system and one that uses natural gas as the source of power.

Summarise the information by reporting the main features, and make comparisons where relevant.

2 Complete this sample answer for the Writing task with words or figures.

The diagram compares two different ways of producing energy. The conventional system involves a thermal power plant. At the first stage, at the plant, **(1)** of the energy put into the system is not used and becomes waste heat. At the next stage, power goes from the plant through **(2)** and at this stage another **(3)** of the energy is lost. This means that only **(4)** of the power is used at the end of the process and this is used as **(5)** In the other system, natural gas is used as the source of power. Power comes from the **(6)** through a **(7)** to a gas engine. At this stage, between 10% and 30% of the energy that has been produced is lost. Of the power that is not lost, **(8)** of it is then used for **(9)** energy and 20-45% is used as electrical energy. The comparison shows that the conventional system is less energy efficient than the other system, called a **(10)** system. The overall energy efficiency of the conventional system is only 40%, meaning that only **(11)** of the power it produces can be used. In contrast, the system based on natural gas is much more efficient, as between **(12)** of the energy produced is used.

3 Now divide the sample answer into four paragraphs. One of the paragraphs is very short. Put // to indicate where a new paragraph starts. Divide it in this way:

Paragraph 1: Introduction

Paragraph 2: Description of system

Paragraph 3: Description of system

Paragraph 4: Overview

4 Look at the Writing task below. What does the diagram show? Circle A, B or C.

A stages in a process
B how something happens
C how to do something

> *The diagram below shows how heat is lost and energy wasted in a house because of air getting into and out of the house.*
> *Summarise the information by reporting the main features and make comparisons where appropriate.*
>
> **Air leaks and heat loss in houses**
>
>
>
> Air leaking out of the house ➡
> Air leaking into the house ➡

5 Now write your answer for the Writing task above.

Grammar

The passive

1 Complete these sentences about a local recycling scheme with the correct passive phrases in the box.

> should be placed is taken will be informed
> are provided ~~was introduced~~ can be collected
> have been increased must be sorted

1 The scheme*was introduced*.... two years ago.
2 Collections to twice a week.
3 Containers for household waste
 by the council.

4 All waste into categories.
5 Paper in the blue boxes.
6 Larger items for recycling if you phone this number.
7 The waste to a recycling plant.
8 Households of any changes to collection days.

2 Complete the second sentence so that it has a similar meaning to the first sentence, using the correct form of the passive.

1 a Nowadays they teach children about environmental issues at school.
 b Nowadays*children are taught*........ about environmental issues at school.

2 a The authorities have started recycling schemes throughout the country.
 b throughout the country.

3 a Governments have discussed international cooperation on environmental issues.
 b by governments.

4 a Experts say that people should do more to solve environmental problems.
 b Experts say that to solve environmental problems.

5 a One idea is that people can use solar power to provide energy.
 b One idea is that to provide energy.

6 a We must find alternatives to existing energy sources soon.
 b soon.

7 a Some countries took steps to deal with environmental problems years ago.
 b by some countries to deal with environmental problems years ago.

8 a Will we solve environmental problems in the future?
 b in the future?

Unit 6 Making money, spending money

Reading Section 1

❶ Read through the article briefly and answer the following question.

What is it about? Circle A, B or C.

A two people who own shops

B various different products

C a chain of shops and a product

❷ Now read the text carefully and answer Questions 1–13.

MOVERS AND SHAKERS

Discover the stories behind two enthusiastic entrepreneurs who are creating major waves in the UK business world

Retailers often declare that customers are their most important asset. But, while some sound as if they are paying lip service to the idea, **Sally Bailey**, chief executive of **White Stuff**, is a true believer. Even the clothing retailer's website reflects her view, declaring: 'Lovely clothes for lovely people'. Ms Bailey says: 'The most important people are those who buy our product. This includes the buyers who select it, and the customers who buy it in our shops. Everything we do is about service to get the product into the customer's hands.'

So when research revealed that customers disliked changing rooms that opened directly onto the shop floor, White Stuff amended its floor plans, introducing a false wall that screened off the changing area. 'It's not rocket science,' explains Ms Bailey. 'You just need to listen to what the customer is saying. We are dedicated to pleasing them. We ask: "What is the best thing we could do?"' Hence, the introduction of one oversized fitting room in each of White Stuff's 54 stores to enable mothers to bring their buggies in while they change.

'When a customer walks into a White Stuff shop, we want them to feel like they are at home,' says Ms Bailey. 'There are chairs to sit down on, water coolers, and staff will come along with colouring books to entertain children while the customer browses.' Even the background music is carefully considered. On Saturdays it has a faster tempo. On Sundays, when customers may prefer a quieter atmosphere, the tone is softer. 'The music is changed by the hour, according to the day,' says Ms Bailey.

White Stuff has eschewed the shop design of a traditional fashion retailer, preferring to model its interiors on a Victorian house where Ms Bailey believes her customers aspire to live. Since her arrival, White Stuff has sought locations away from the beaten track and shopping centres are viewed as anathema. 'To be honest, we do have some stores that are very hard to find,' says Ms Bailey. 'In Exeter, for example, there's the High Street and the shopping centre, but you have to turn left down an alley to find White Stuff, right by an organic butcher and coffee shop.'

Yet White Stuff's customers, whom Ms Bailey describes as 'extremely loyal', are not deterred by these intrepid expeditions. When she took over five years ago, White Stuff had 15 stores and an annual turnover of £14m. Today, turnover is in excess of £55m, with stores generating annual revenues between £500,000 and £2.5m from an average customer spend of £35.

Matt Stockdale, managing director of **HomePride**, which this year will turn over more than £4m, has the mother of former Tesco buyer Fraser McDonald to thank for his success. Desperate to get the supermarket chain to stock his oven cleaning product, Oven Pride, Mr Stockdale bombarded the buyer with calls.

But it was to no avail: 'The response was always "Thanks but no thanks",' he recalls. 'So I said, "Let me send some to your mother, your aunt, your grandmother..." and, I think to make me go away, he gave me his mother's address.' Two weeks later, Mr Stockdale was in the buyer's office signing a deal to supply his product to 30 stores. 'He told me that his mother wanted him to give me a chance but that he didn't give me much hope,' says Mr Stockdale. A year later he was supplying 130 Tesco stores. 'I didn't realise when I first approached Tesco that it was the

UK's biggest supermarket chain,' says Mr Stockdale. 'I just knew that I shopped there.'

The idea for the oven cleaner came in 1999 when, after being made redundant from his job as a sales manager for a telecoms business, Mr Stockdale decided to fulfil a lifelong ambition to run his own company. 'I looked at a catalogue business first because direct sales was what I knew,' he says. 'But I came across chemical companies making products, one of which was an oven cleaner. I was always the one lumbered with cleaning our oven, so I was intrigued.' He tested one product, a bottle of white fluid, which produced such great results that he started to research the oven cleaner marketplace. 'I found the hardest thing was to clean the racks,' says Mr Stockdale.

He decided to create kits to make cleaning racks easy, sourcing packaging, disposable gloves and a bag, into which the racks could be placed with the cleaning fluid. 'I created 5,000 units and sent one each to Kleeneze, Betterware and QVC, and got nowhere,' he recalls. Dejected, Mr Stockdale found another sales job but, 15 months later, a fax arrived with a purchase order from Kleeneze. 'I went to the garage and dusted down the stock,' he says. Kleeneze sold out within weeks, and placed more orders. Then QVC faxed across an order. 'I was suddenly on national television, but in eight weeks QVC had sold out,' he says. 'I didn't realise what I had.' It took a letter from a satisfied customer, asking when the cleaner would be available in shops, to prompt Mr Stockdale to change his strategy and approach high street retailers. Enter Tesco.

In its first year, HomePride turned over £90,000 but soon reached £1.1m. 'Going into retail changed everything for me,' says Mr Stockdale.

Questions 1–3

Label the diagram below.

*Choose **NO MORE THAN TWO WORDS** from the passage for each answer.*

changing rooms (1 oversized, enough space for **1**)

false wall

2 for children

water coolers

background music (**3** on Saturdays)

Questions 4–8

Do the following statements agree with the information given in the reading passage?

Write

TRUE if the statement agrees with the information

FALSE if the statement contradicts the information

NOT GIVEN if there is no information on this

4 Sally Bailey intends to find locations for White Stuff in shopping centres.

5 Sally Bailey started White Stuff.

6 The buyer at Tesco initially rejected Oven Pride.

7 The buyer's mother often gives him advice on products.

8 Matt Stockdale discovered important information about Tesco after contacting the company.

Questions 9–13

Complete the flow chart below.

*Choose **NO MORE THAN TWO WORDS AND/OR A NUMBER** from the passage for each answer.*

The story of HomePride

Matt Stockdale made redundant from job in telecoms

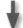

Thought of starting a catalogue business (experience in **9**)

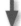

Saw chemical products and became interested in oven cleaners

Tested a white fluid for cleaning ovens and researched the market

Observed that the biggest problem was how to get **10** clean

Made **11** to solve this problem

Sent his product to various companies

First order came after **12**

Product appeared on TV and sold out

A question asked by a **13** gave him the idea of approaching shops

Vocabulary

Verbs + infinitive and verbs + -*ing*

❶ Complete these sentences about money, using the infinitive or –*ing* forms of the verbs in the box.

lose	check	buy	~~pay~~	put
spend	save	borrow		

1 I refuse*to pay*........ such a high price for a ticket.
2 I ended up all my money in that shop because there were so many things I liked.
3 I tried some money but nobody agreed to lend me any.
4 Did you remember some money into your account today?
5 I wanted money, so I bought a cheaper one.
6 If you don't want to risk your money, don't gamble.
7 She failed the price before she bought it and it cost more than she expected.
8 Those phones are not worth , they're not very good.

❷ Complete the second sentence so that it has a similar meaning to the first sentence.

1 a He often gets into trouble with money.
 b He keeps*getting*........ into trouble with money.
2 a I got a job, so I was able to earn some money.
 b Getting a job enabled some money.
3 a I was surprised that prices there were so high.
 b I didn't expect so high.
4 a I don't want to spend a lot of money.
 b I want to avoid a lot of money.
5 a 'Buy this model,' the shop assistant said to me.
 b The shop assistant advised that model.
6 a 'Pay the bill before the end of the week,' she said to me.
 b She reminded the bill before the end of the week.

7 a I think I might get a new computer.

 b I'm considering a new computer.

8 a My parents said that I should save money.

 b My parents encouraged money.

▶ Student's Book unit 6, p61

❸ Complete these sentences about banks and banking with the jumbled words in the box.

TRDEFOAVR	TCERID	SRIETENT
TEIDB	~~CLAEBNA~~	NBAHCR

1 I checked the*balance*..... to see how much money I had in my account.

2 My account was in , so I had some money to spend.

3 The rate on this account has fallen recently.

4 There's always a long queue in the local of my bank.

5 If you pay the bill by direct , it's a bit cheaper.

6 He's got a big at the bank and other money problems too.

Key vocabulary

❹ Choose the correct option, A, B or C, to complete each sentence.

1 If you buy a branded product, it
 A is cheaper than usual.
 B has the maker's name on it.
 C is being specially advertised.

2 If you purchase something, you
 A buy it.
 B look for it.
 C use it.

3 An own-label product is a product that
 A is new on the market.
 B is for sale at a cheaper price.
 C has the shop's name on it.

4 Retailer can be another word for
 A product.
 B shop.
 C customer.

Listening Section 2

❶ You are going to hear a manager talking about new machines in a museum. Look at Questions 5–10. Which of the following are you required to label? Circle A, B or C.

A the kinds of drink in the machine

B how you order a drink from the machine

C how you put drinks into the machine

❷ ⟨07⟩ **Now listen and answer Questions 1–10.**

Questions 1–4

Where will the following machines be?

*Choose **FOUR** answers from the box and write the correct letter, **A–F**, next to questions 1–4.*

1 cash machine **3** games machine

2 ticket machine **4** drinks machine

A visitor centre	**D** entrance hall
B in front of the building	**E** exhibition halls
C next to elevators	**F** reception area

Questions 5–10

Label the diagram below.

*Write **ONE OR TWO WORDS AND/OR A NUMBER** for each answer.*

DRINKS MACHINE FOR STAFF ROOM

5 front

6 receiver

drink delivered by a visible 7 (drink not 8)

put in 9 for drink required

order maximum of 10

Writing Task 2

❶ Read the following Writing task and underline the main points to consider.

Write about the following topic:

The purpose of businesses is to make money and they should concentrate only on this.

Do you agree or disagree?

Give reasons for your answer and include any relevant examples from your knowledge or experience.

❷ Look at these student ideas for paragraphs. Which of these ideas would make suitable paragraphs for an answer? Write *Yes* or *No*.

A businesses and the environment

B the most successful business sectors

C how to start a business

D the need to make profits

E why some businesses fail

F treatment of employees

G why people choose a particular career

H businesses and the local community

❸ The following are phrases that could be used in an answer to this Writing task. Complete them with the correct prepositions.

1 making money is an important part ..*of*.. what companies do

2 businesses play an important role society

3 businesses want to make profits what they produce

4 companies that lose a lot of money can go business

5 companies do business other companies

6 a company's attitude the people who work for it

7 businesses should also make a contribution society

8 companies should pay attention other matters

9 profitable companies may take more workers

10 businesses need to give thought other matters

❹ Now write your answer for the Writing task above.

Grammar

Relative pronouns and relative clauses

❶ Complete these sentences about shopping with relative pronouns.

1 The town*where*........ I live has lots of shops.

2 The shops I like most are all local.

3 The people work in the local shops are all friendly.

4 My favourite shop is the clothes shop I buy most of my clothes.

5 I first went there ten years ago, I was a teenager.

6 It sells clothes by designers clothes I really like.

7 It has assistants are very friendly and helpful.

8 And it sells clothes at prices I can afford!

❷ Complete this description of someone's job with the relative clauses in the box.

where there is a problem	when he left
which is which need	~~whose name is~~
who don't know which describe	which involves

The mystery shopper

I have a friend **(1)** ….*whose name is*…. Graham. He has

a job **(2)** ……………………… very interesting. He started

this job last year, **(3)** ……………………… college. He is a

'mystery shopper', **(4)** ……………………… going to shops

(5) ……………………… and pretending to be a customer.

He talks to staff in shops, **(6)** ……………………… he's

working for the company. He then writes reports

(7) ……………………… his experience in the shops. He

describes aspects of the service **(8)** ………………………

to improve.

❸ Combine the pairs of sentences in *a* about supermarkets in Britain, using a relative clause.

1 a Tesco is one of Britain's biggest supermarket
chains. It employs over 50,000 people.

 b Tesco, ….*which is one of Britain's biggest*….
….*supermarket chains, employs*…. over 50,000
people.

2 a Tesco's profits are very high. It is one of
Britain's most successful companies.

 b Tesco, ……………………………………… one
of one of Britain's most successful companies.

3 a In the 1980s supermarkets began to appear all
over Britain. Tesco was one of the main ones.

 b In the 1980s, ………………………………………

………………………………… was one of the main ones.

4 a British people used to buy their food in small
shops. They quickly changed to shopping in
supermarkets.

 b British people, ………………………………………
to shopping in supermarkets.

5 a In small towns, many small shops have closed.
People go to out-of-town supermarkets instead.

 b In small towns, ………………………………………
go to out-of-town supermarkets instead.

6 a Supermarkets now sell a variety of things.
They are a fundamental part of the British way
of life.

 b Supermarkets, ………………………………………
a fundamental part of the British way of life.

Unit 7 Relationships

Listening Section 3

1 You will hear two students talking about a presentation. Look at the second task, Questions 6–10. What kind of word will be required for all of the questions? Circle A, B or C.

A adverbs **B** verbs **C** nouns

2 (08) Now listen and answer Questions 1–10.

Questions 1–5

Choose the correct letter, A, B or C.

1 Maya chose the topic of lifelong friendships because
 A it was an unusual area of research.
 B she had a particular interest in it.
 C someone suggested it to her.

2 Maya says that the sample of people she used
 A was smaller than she wanted it to be.
 B was typical of the population in general.
 C was the basis for further work.

3 The problem with the questionnaire was that
 A it wasn't well constructed.
 B the subjects couldn't engage with it.
 C too much time was required to complete it.

4 Maya says that when she conducted the interviews,
 A she kept brief notes.
 B the subjects were all very relaxed.
 C they followed a clear structure.

5 What does Maya say about other research in the area?
 A A lot of it contradicted her findings.
 B It wasn't very easy to find.
 C It was carried out in the same way as hers.

Questions 6–10

Complete the flow chart below.

Write **NO MORE THAN TWO WORDS** for each answer.

Lifelong friendships presentation

Origins of friendship (age, where began, circumstances, etc.): 1 table

↓

Effects of change of **6**: 2 tables

↓

Effects of **7**: 1 pie chart

↓

Comparisons between descriptions of
8: patterns of extreme change

↓

Changes in **9**: 1 pie chart

↓

10 (e.g. sports, musical tastes): continuing or changing

Vocabulary

Feelings

▶ Student's Book unit 7, p68

❶ Complete the sentences with the adjectives in the box.

bored	reassuring	upset	~~irritated~~
helpful	concerned	persuasive	
irritating	boring	upsetting	

1 I get very*irritated*.... when people keep asking me stupid questions.

2 She was so that I ended up agreeing to what she wanted.

3 I wasn't at all because I knew nothing bad was going to happen.

4 Donna gets if people criticise her and she often starts crying.

5 I was so at the party that I nearly fell asleep.

6 You've been very and I couldn't have done this without you.

7 It's to know that I'm not the only person with this problem.

8 It was a very experience and I felt bad about it for a long time.

9 The conversation was extremely and I stopped listening.

10 His behaviour was very and I shouted at him.

Age(s) / aged / age group

❷ Complete these results from a survey about social networking sites by circling the correct options in each of these sentences.

1 The highest number of people using the sites was in the 16–24 *ages* / (*age group*).

2 35% of children started using the sites at *the age* / *ages* of 12 or under.

3 45% of users *ages* / *aged* 16–24 checked for messages every day.

4 65% of parents *aged* / *age* below 40 said that they looked at their children's activities on the sites.

5 5% of people over *age* / *the age* of 70 used the sites to keep in touch with family.

6 10% of people between *ages* / *the ages* of 40 and 50 used the sites regularly.

7 People of different *age* / *ages* used the sites for different reasons.

8 The 60+ *ages* / *age group* had the lowest number of users.

9 80% of users were under 30 years of *age* / *aged*.

10 People in the lower *age groups* / *ages* used the sites more than older people.

Key vocabulary

❸ Complete the sentences below, then use the words to complete this crossword.

Across

4 If you can the difference between two things, the difference is clear to you.

5 An is an unusual or bad event that happens.

6 If you to doing something bad, you say that you did it.

8 If you something, you say what will happen in the future.

Down

1 If results are , they are the same over a period of time.

2 If you someone for something, you say they are responsible for something bad.

3 Animals living in the are living in their natural habitat, not in a zoo.

7 A is someone who doesn't tell the truth.

Reading Section 2

❶ Read through the article quickly. Then look at Questions 7–10 and answer the following.

In which sections of the text are there references to the people listed?

❷ Now read the text carefully and answer Questions 1–13.

ESTABLISHING YOUR BIRTHRIGHTS

Position in the family can play a huge role in shaping character, finds Clover Stroud

A Last week I was given a potent reminder of how powerful birth order might be in determining a child's character. My son, Jimmy Joe, nine, and my daughter, Dolly, six, were re-enacting a TV talent show. Jimmy Joe elected himself judge and Dolly was a contestant. Authoritative and unyielding, he wielded a clipboard, delivering harsh criticisms that would make a real talent show judge flinch. Initially Dolly loved the attention, but she soon grew tired of his dominance, instigating a pillow fight, then a fist fight. It ended, inevitably, in tears. A visiting friend, with an older, more successful sister, declared it 'classic first child behaviour of dominance and supposed authority'. Dolly's objection to her brother's self-appointed role as leader was justified, he announced, while Jimmy Joe's superiority was characteristic of the forceful personality of firstborns. Birth order, he said, wasn't something they could just shrug off.

B Debate about the significance of birth order goes right to the heart of the nature versus nurture argument and is, consequently, surrounded by huge controversy. This controversy has raged since the 19th century, when Austrian psychiatrist Alfred Adler argued that birth order can define the way someone deals with life. He identified firstborns as driven and often suffering from a sense of having been 'dethroned' by a second child. Younger children, he stated, were hampered by having been more pampered than older siblings. It's a view reiterated by Professor Frank Sulloway's influential work, *Born to Rebel*. Sulloway, a leading proponent of the birth-order idea, argued it has a definitive effect on the 'Big Five' personality traits of openness, conscientiousness, extroversion, agreeableness and neuroticism.

C According to the birth-order theory, first children are usually well-organised high achievers. However, they can have an overdeveloped sense of entitlement and be unyielding. Second children are sometimes very competitive through rivalry with the older sibling. They're also good mediators and negotiators, keen to keep everyone happy. Middle children, tagged the 'easy' ones, have good diplomacy skills. They suffer from a tendency to feel insignificant beside other siblings and often complain of feeling invisible to their parents. Youngest children are often the most likely to rebel, feeling the need to 'prove' themselves. They're often extroverts and are sometimes accused of being selfish. Twins inevitably find it harder to see themselves as individuals, unless their parents have worked hard to identify them as such. It's not unusual for one twin to have a slightly dominant role over the other and take the lead role.

D But slapping generalised labels on a child is dangerous; they change all the time, often taking turns at being the 'naughty one' or the 'diligent one'. However, as one of five children, I know how hard it is to transcend the tags you earn according to when you were born. It is unsurprising then that my eldest sister is the successful entrepreneur, and that, despite covering all the big bases of adult life like marriage, kids and property, my siblings will probably always regard me as their spoilt younger sister.

E 'As the oldest of three, I've found it hard not to think of my own three children as having the same personality types that the three of us had when I was growing up,' says Lisa Cannan, a teacher. 'I identify with my eldest son, who constantly takes the lead in terms of organisation and responsibility. My daughter, the middle child, is more cerebral than her brothers. She's been easier than them. She avoids confrontation, so has an easy relationship with both boys. My youngest is gorgeous but naughty. I know I'm partly to blame for this, as I forgive him things the elder two wouldn't get away with.'

F As a parent, it's easy to feel guilty about saddling a child with labels according to birth order, but as child psychologist Stephen Bayliss points out, these characteristics might be better attributed to parenting styles, rather than a child's character. He says that if a parent is worried about having encouraged, for example, an overdeveloped sense of dominance in an older sibling or spoiled a younger child, then it's more useful to look at ways this can be addressed than over-analysing why it happened. Bayliss is optimistic that as adults we can overcome any negative connotations around birth order. 'Look at the way you react to certain situations with your siblings. If you're unhappy about being treated as a certain type of personality, try to work out if it's a role that you've willingly accepted. If you're unhappy with the role, being dynamic about focusing on your own reactions, rather than blaming theirs, will help you overcome it. Change isn't easy but nobody need be the victim of their biography.'

The reading passage has six paragraphs, **A–F**.

Choose the correct heading for each paragraph from the list of headings below.

i	Children's views on birth order
ii	Solutions are more important than causes
iii	Characteristics common to all children regardless of birth order
iv	Doubts about birth-order theory but personal experience supporting it
v	A theory that is still supported
vi	Birth-order characteristics continuing as children get older
vii	A typical example of birth-order behaviour in practice
viii	Exceptions to the rule of birth order
ix	A detailed description of each child in families in general

1 Paragraph A
2 Paragraph B
3 Paragraph C
4 Paragraph D
5 Paragraph E
6 Paragraph F

Questions 7–10

Look at the following statements (Questions 7–10) and the list of people below.

Match each statement with the correct person, A–D.

You may use any letter more than once.

7 Experience as a child can affect behaviour as a parent.

8 Birth order may not be the main reason why children have the personalities they have.

9 There is a link between birth and a group of important characteristics.

10 It is possible for people to stop feeling bad about how family members behave with them.

List of people

A Alfred Adler
B Professor Frank Sulloway
C Lisa Cannan
D Stephen Bayliss

Questions 11–13

Complete the sentences below.

*Choose **ONE WORD ONLY** from the passage for each answer.*

11 First-born children have expectations that are too high with regard to

12 Middle children are often considered by their parents.

13 Youngest children may be described as by other people.

Writing Task 1

❶ **Look at the Writing task below. Which is the best title for the two pie charts? Circle A, B or C.**

A Happiness of parents before and after having children

B Happiness of parents compared with happiness of children

C Happiness of parents with children of different ages

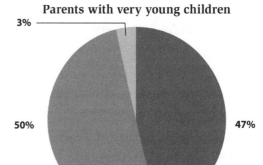

Parents with very young children

3%

50% 47%

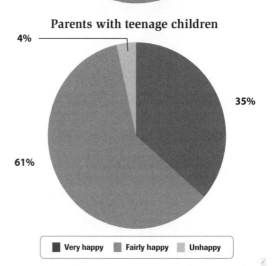

Parents with teenage children

4%

61% 35%

■ Very happy ■ Fairly happy ■ Unhappy

2 Which of the following are main differences between the two charts? Write *Yes* or *No*.

A the categories in the charts

B the percentages of very happy people

C the percentages of fairly happy people

D the percentages of unhappy people

E the ages of children

F the totals of very happy and fairly happy people

3 Which of the following overviews is the best? Circle A, B or C.

A The main conclusion from the pie charts is that parents with very young children were happy but parents with older children were not.

B In general, parents got happier as their children got older.

C To sum up, parents with teenage children were less happy than parents with very young children, but very few of them were unhappy.

4 Look at the Writing task on the right. What are the main features of the charts? Write *Yes* or *No*.

A differences between the two years

B how high certain figures are

C similarities between the two relationships

D how many people couldn't answer

E differences in the two relationships

F how much certain figures fell

G similarities between the two years

H how low certain figures are

The charts below show the results of surveys in 2005 and 2009 asking workers about their relationships with their supervisors and their co-workers.

Summarise the information by reporting the main features, and make comparisons where relevant.

Relationships at work
(survey of workers 2005 & 2009)

Relationships with supervisor

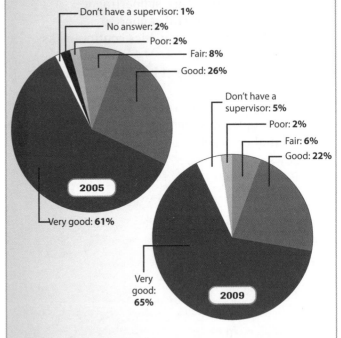

Relationships with co-workers

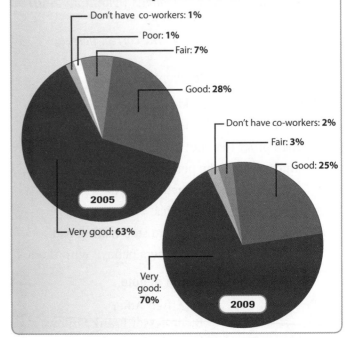

5 Now write your answer for the Writing task above.

Grammar

Reference devices

▶ Student's Book unit 7, p75

❶ Complete this text about self-help books with the correct reference devices, for example, *them, it, this, one, other,* etc.

Self-help books about relationships have been very popular for some years and **(1)** ...*they*... sell in very large quantities. But why do people use **(2)** ? Why are **(3)** books so popular?

(4) kind of book is the kind that tells people how to improve **(5)** relationships with **(6)** people in **(7)** personal lives. According to research, women often buy **(8)** kind of self-help book. **(9)** books give advice about relationships with your boyfriend or husband and a woman might buy **(10)** of them because **(11)** thinks that **(12)** will give her good ideas on how to deal with **(13)** person.

Another kind of self-help book deals with how to be successful in life by having good relationships at work. Some of the most successful **(14)** in this category are about relationships in the workplace, and according to research, **(15)** is a subject that appeals to men more than women. A man might buy a book in **(16)** category because **(17)** believes **(18)** claims that **(19)** will help **(20)** to rise to the top and make lots of money.

Zero, first and second conditionals

❷ Correct the underlined phrases in these sentences if necessary. Put a tick (✓) above them if they are correct.

he'd make
1 If Harry was more pleasant to people, <u>he'll make</u> more friends.

2 If <u>you'll get on</u> well with your boss, work is enjoyable.

3 People don't enjoy life <u>unless they have</u> good relationships with other people.

4 I don't argue with my friends unless <u>they would upset</u> me.

5 If we discuss this calmly, <u>we won't have</u> an argument.

6 If <u>I wouldn't like</u> him, I wouldn't accept his bad behaviour towards me.

7 If you need some help tomorrow, <u>I give</u> it to you.

8 Unless <u>you apologise</u>, he'll be very angry with you.

9 <u>I'll be</u> unhappy if I didn't have my friends to go out with.

10 If I didn't trust Tara, <u>I wouldn't tell</u> her my secrets.

11 We don't go to that restaurant unless it <u>will be</u> my birthday.

12 I'd live in this town forever if I <u>had</u> the choice.

13 If I were you, I <u>won't</u> marry him.

14 If I <u>don't phone</u> my grandmother every Sunday, she gets very upset.

15 I'd be fitter if I <u>exercise</u> more.

Unit 8 Fashion and design

Reading Section 3

❶ **Read through the article about fashion briefly. Then look at Questions 11–14 and answer the following.**

What is the best way of answering these questions? Circle A, B or C.

A by finding the people mentioned in the questions

B by finding the ideas mentioned in the options

C by reading the whole text again

❷ **Now read the text carefully and answer Questions 1–14.**

MAKING A LOSS IS THE HEIGHT OF FASHION

In this topsy-turvy world, selling a dress at an enormous discount turns out to be very good business indeed, says William Langley

Given that a good year in the haute couture business is one where you lose even more money than usual, the prevailing mood in Paris last week was of buoyancy. The big-name designers were falling over themselves to boast of how many outfits they had sold at below cost price, and how this proved that the fashion business was healthier than ever. Jean-Paul Gaultier reported record sales, "but we don't make any money out of it," the designer assured journalists backstage. "No matter how successful you are, you can't make a profit from couture," explained Jean-Jacques Picart, a veteran fashion PR man, and co-founder of the now-bankrupt Lacroix house.

Almost 20 years have passed since the bizarre economics of the couture business were first exposed. Outraged that he was losing money on evening dresses costing tens of thousands of pounds, the couturier Jean-Louis Scherrer – to howls of "treason" from his colleagues – published a detailed summary of his costs. One outfit he described contained over half a mile of gold thread, 18,000 sequins, and had required hundreds of hours of hand-stitching in an atelier. A fair price would have been £50,000, but the couturier could only get £35,000 for it. Rather than riding high on the follies of the super-rich, he and his team could barely feed their hungry families.

The result was an outcry and the first of a series of government- and industry-sponsored inquiries into the surreal world of ultimate fashion. The trade continues to insist that – relatively speaking – couture offers you more than you pay for, but it's not as simple as that. When such a temple of old wealth starts talking about value for money, it isn't to convince anyone that dresses costing as much as houses are a bargain. Rather, it is to preserve the peculiar mystique, lucrative associations and threatened interests that couture represents.

Essentially, the arguments couldn't be simpler. On one side are those who say that the business will die if it doesn't change. On the other are those who say it will die if it does. What's not in doubt is that haute couture – the term translates as "high sewing" – is a spectacular anachronism. Colossal in its costs, tiny in its clientele and questionable in its influence, it still remains one of the great themes of Parisian life. In his book, *The Fashion Conspiracy*, Nicholas Coleridge estimates that the entire couture industry rests on the whims of less than 30 immensely wealthy women, and although the number may have grown in recent years with the new prosperity of Asia, the number of couture customers worldwide is no more than 4,000.

To qualify as couture, a garment must be entirely hand-made by one of the 11 Paris couture houses registered to the Chambre Syndicale de la Haute Couture. Each house must employ at least 20 people, and show a minimum of 75 new designs a year. So far, so traditional, but the Big Four operators – Chanel, Dior, Givenchy and Gaultier – increasingly use couture as a marketing device for their far more profitable ready-to-wear, fragrance and accessory lines.

It isn't hard to see how this works in practice. "Haute couture is what gives our business its essential essence of luxury," says Bernard Arnault, the head of LVMH, which

owns both Dior and Givenchy. "The cash it soaks up is largely irrelevant. Set against the money we lose has to be the value of the image couture gives us. Look at the attention the collections attract. It is where you get noticed. You have to be there. It's where we set our ideas in motion."

The big idea being the one known in the trade as "name association". Couture outfits may be unaffordable, even unwearable, but the whiff of glamour and exclusivity is hard to resist. The time-starved modern woman who doesn't make enough in a year to afford a single piece of couture can still buy a share of the dream for the price of a Chanel lipstick or a Givenchy scarf.

For all this, couture has been in decline – the optimists would say readjusting to changed conditions – for years. The number of houses registered to the Syndicale has halved in the last two decades. Pierre Cardin once had almost 500 people working full time on couture, but by the 1980s the number had fallen to 50, and today the house is no longer registered.

Modern life tells the story. Younger women, even the seriously wealthy ones, find ready-to-wear clothes invariably more practical and usually more fun. Couture's market has dwindled. "Haute couture is a joke," scoffs Pierre Bergé, the former head of Yves St Laurent – another house that no longer creates it. "Anyone who tells you it still matters is fantasising. You can see it dropping dead all around you. Nobody buys it any more. The prices are ridiculous. The rules for making it are nonsensical. It belongs to another age. Where are today's couturiers? A real couturier is someone who founds and runs their own house. No one does that any more."

Why, then, are the surviving couture houses smiling? Because they trade in fantasy, and, in these times, more people want to fantasise. "We've received so many orders we may not be able to deliver them all," says Sidney Toledano, head of Dior. So, the clothes are rolled out and the couture losses roll in, and everyone agrees that it's good business.

Questions 1–5

Choose the correct letter, A, B, C or D.

1 What is the main topic of the first paragraph?
 A the difference between haute couture and other areas of the fashion industry
 B contrasting views on haute couture
 C the losses made on haute couture
 D the negative attitude towards haute couture of people in the fashion industry

2 The writer says that Jean-Louis Scherrer
 A upset other couturiers.
 B was in a worse financial position than other couturiers.
 C was one of the best-known couturiers.
 D stopped producing haute couture dresses.

3 The writer says that the outfit Jean-Louis Scherrer described
 A was worth the price that was paid for it.
 B cost more to make than it should have.
 C was never sold to anyone.
 D should have cost more to buy than it did.

4 In the third paragraph, the writer states that haute couture makers
 A think that the term 'value for money' has a particular meaning for them.
 B prefer to keep quiet about the financial aspects of the business.
 C have changed because of inquiries into how they operate.
 D want to expand their activities to attract new customers.

5 The writer says in the fourth paragraph that there is disagreement over
 A the popularity of haute couture.
 B the future of haute couture.
 C the real costs of haute couture.
 D the changes that need to be made in haute couture.

Questions 6–10

Do the following statements agree with the views of the writer in the reading passage?

Write

YES *if the statement agrees with the views of the writer*

NO *if the statement contradicts the views of the writer*

NOT GIVEN *if it is impossible to say what the writer thinks about this*

6 The way that companies use haute couture as a marketing device is clear.

7 Only wealthy people are attracted by the idea of 'name association'.

8 Pierre Cardin is likely to return to producing haute couture.

9 Some women who can afford haute couture clothes buy other clothes instead.

10 It is hard to understand why some haute couture companies are doing well.

Questions 11–14

Complete each sentence with the correct ending, A–F, below.

11 In his book, Nicholas Coleridge claims that

12 The head of LVMH believes that

13 The former head of Yves St Laurent feels that

14 The head of Dior states that

A there is great demand for haute couture.

B people who defend haute couture are wrong.

C the cost of haute couture is likely to come down.

D haute couture is dependent on a very small number of customers.

E more companies will start producing haute couture.

F it is important to continue with haute couture.

Listening Section 4

❶ **You will hear part of a lecture about jeans. Look at Questions 1–10. What is the main focus of the task? Circle A, B or C.**

A developments connected with jeans

B the different uses of jeans

C attitudes towards jeans

❷ 09 **Now listen and answer Questions 1–10.**

Questions 1–10

Complete the sentences below.

*Write **NO MORE THAN TWO WORDS** for each answer.*

1 The word jeans may have originated in a material used in clothes worn by from Italy.

2 One difference between jean and denim material concerned the used to create them.

3 Denim was used in the clothes worn by people whose place of work was

4 Strauss's first name was originally

5 The miners' problem concerned the on their clothes.

6 Strauss's clothes solved the problem because they used fasteners.

7 The label Strauss added showed his waist overalls connected to

8 In the 1930s, the clothes became more popular because people saw characters in wearing them.

9 In the 1940s, people in other countries saw the clothes being worn by from the U.S.

10 In the 1950s, teenagers called the clothes

Vocabulary

Dress (uncountable) / *dresses* (countable) / *clothes* / *cloth*

❶ Circle the correct option in each of these sentences.

1 My grandmother made my *clothes / cloth* when I was a child.
 She always cut the *clothes / cloth* very carefully.

2 *Dress / Dresses* for this event will be informal.

3 She doesn't have great interest in *clothes / dress* and fashion in
 general.

4 She didn't take enough *dress / dresses* on the trip with her.

5 The teacher got some *cloth / dress* and showed the children how
 to make a rabbit from it.

6 The weather isn't warm enough for summer *cloth / dresses*.

Key vocabulary

**❷ Complete the sentences below, then use the words to complete
this crossword.**

Across

4 A is a kind of material or cloth.

5 A is an item of clothing.

6 clothes are informal.

7 If something is , it is very very old.

8 A is a kind of cloth made by weaving.

Down

1 The of something are how it started.

2 If something is , there is nothing like it.

3 A is a picture of a person, especially the person's
 head/face.

4 If something is , it might easily break and must be
 treated carefully.

**❸ Complete the sentences below
with the words in the box. There
are two words which do not fit
into any of the gaps.**

celebrity	functional
conservation	performance
decorative	~~repair~~
contemporary	retire
produced	preserve

1 This jumper has a very big hole
 in it and you won't be able to
 *repair*.... it.

2 During her fashion course, she
 compared clothes
 with clothes from the past.

3 The best way to
 these clothes is to keep them
 out of the light.

4 These clothes are all
 by hand and that's
 why they take a long time to
 make.

5 She always wanted to be
 famous and attract attention
 from the media, so she was
 very happy when she became
 a

6 These clothes are very
 and can be worn
 both for work and social
 occasions.

7 He gave a wonderful
 in the film and
 the critics said he was a
 brilliant actor.

8 The clothes made by this
 company have a
 design on the front of them.

Writing Task 2

❶ Read the following Writing task.

> Write about the following topic:
>
> *Some people say that the clothes people wear are the most important indication of what they are like. Others, however, say that people should not be judged by the clothes they wear.*
>
> *Discuss both these views and give your own opinion.*
>
> Give reasons for your answer and include any relevant examples from your knowledge or experience.

Below are three essay plans that candidates made for this question. Which two of the essay plans are suitable? Why are they suitable and why is the other essay plan not suitable?

A

Paragraph 1:	introduction – importance of the latest fashions to people today, especially the young
Paragraph 2:	why people want to follow the latest fashions – celebrities, advertising, etc.
Paragraph 3:	result – people all over the world wearing the same clothes, loss of national identity through wearing of different clothes
Paragraph 4:	conclusion – people shouldn't copy each other's clothes, should express their own individuality through what they wear

B

Paragraph 1:	introduction – people often judge others by the clothes they wear + example
Paragraph 2:	examples of when it is right to judge people by the clothes they wear, e.g. at work
Paragraph 3:	other things that indicate what people are like – not clothes but behaviour, the way they speak, etc.
Paragraph 4:	conclusion – why it's not always right to judge people by the clothes they wear

C

Paragraph 1:	introduction – people who wear clothes to impress others / people who don't do this
Paragraph 2:	importance of clothes worn for work – the impression they give
Paragraph 3:	clothes not worn at work – fashions among the young and the impression they want to give
Paragraph 4:	my opinion: clothes for work and impression they give important, outside work not important and can't judge people from what they wear

❷ What *must* you mention in your answer? Write *Yes* or *No*.

A a contrast between past and present attitudes to clothes

B the connection between clothes and opinions of people

C current fashions in clothes

D contrasting views on the importance of clothes

E clothes worn by famous people

F a personal view on the importance of clothes

G clothes worn in different parts of the world

H the kind of clothes you like to wear

❸ Which of these candidate's notes about topic areas for the answer are relevant to the task and which are not? Write *Yes* or *No*.

A more important things than clothes

B clothes and advertising

C teenage fashions

D when clothes are important

E cost of fashionable clothes

F clothes and image

G work clothes

H how fashions start

❹ Now write your answer for the Writing task above.

Grammar

Time conjunctions: *until/before/when/after*

❶ Make sentences by matching 1–6 with A–F.

1 I want to buy a new coat
2 I can't wear that shirt again
3 I'm going to get changed
4 I'll decide whether to buy this or not
5 I can wear this jumper again
6 I'm not going to buy a new suit

A until I really need one.
B before I go out.
C when I find one I really like.
D when I've repaired it.
E after I've tried it on.
F until I've washed it.

❷ Correct the <u>underlined</u> words if necessary. Put a tick (✓) above the words if they are correct.

1 Make sure it suits you before <u>you'll buy</u> it. *you buy*

2 She won't be happy until <u>she's found</u> something new to wear.

3 When <u>I go</u> shopping I don't like trying on lots of clothes.

4 When <u>people will get</u> a bit older, they change the kind of clothes they wear.

5 After <u>I've bought</u> some new trousers, I'm going to go home.

6 When <u>I've paid</u> for these clothes, I won't have any money left.

7 I'm going to keep looking until <u>I'm finding</u> something I like.

8 You should repair the jumper before that hole <u>will get</u> bigger.

9 When <u>I've got</u> changed, I'll be ready to go out.

10 I won't buy any clothes until <u>I tried</u> them on.

❸ Complete the sentences below with the words in the box.

I get	I've worn	I've chosen	I wash	I've had
I've found	I'm	~~I've saved~~	I leave	I throw

1 I won't be able to buy that dress until ...*I've saved*... some money.
2 When college, I'll have to buy some smart clothes for work.
3 After which shirt to wear, I'll get ready to go out.
4 When a shower, I'll put on my new clothes.
5 I'll buy some new swimming trunks when on holiday.
6 These new shoes will feel more comfortable when them a few times.
7 Before these jeans away, I'll try to repair them.
8 When the receipt, I'll take these clothes back to the shop.
9 I won't wear this suit again until married next month.
10 I'll check the instructions before this jumper in the machine.

Recording script

Unit 1

Track 2

You will hear an interviewer asking a member of the public for his views on the city.

First you have some time to look at Questions 1–5. You will see that there is an example that has been done for you. On this occasion only, the conversation relating to this will be played first.

Interviewer Hello, we're conducting a survey about what people think of this city. I wonder, would you mind answering a few questions?

Man I'm in a bit of a hurry.

I Well, it won't take long, just a couple of minutes of your time …

M Well, OK, but I haven't been living here for long, so I might not be able to answer some of your questions.

I That's not a problem, we're looking for views from a range of people. Could I just get a few details first?

M OK, I guess.

I Well, first of all, which age group do you fit into? 18 to 24, 25 to 34, 35 to 50?

M I'm 28, so that's the middle one of those, what was it, 25 to 34?

I Yes.

M OK, that's me.

The man is aged 28 and in the 25 to 34 age group, so 25 to 34 has been written in the space.

Now we shall begin. You should answer the questions as you listen as you will not hear the recording a second time.

I Hello, we're conducting a survey about what people think of this city. I wonder, would you mind answering a few questions?

M I'm in a bit of a hurry.

I Well, it won't take long, just a couple of minutes of your time …

M Well, OK, but I haven't been living here for long, so I might not be able to answer some of your questions.

I That's not a problem, we're looking for views from a range of people. Could I just get a few details first?

M OK, I guess.

I Well, first of all, which age group do you fit into? 18 to 24, 25 to 34, 35 to 50.

M I'm 28, so that's the middle one of those, what was it, 25 to 34?

I Yes.

M OK, that's me.

I And how long have you been living in this city?

M I've only been here for three weeks and it's my first experience of this country at all. I've come here to work on a six-month contract.

I Right, so it's all pretty new for you?

M Yes, I'm still getting used to it.

I Right. So, where did you live previously?

M I'm from New Zealand. I lived there all my life before I came to Britain.

I Oh, really? I haven't met anybody else from your country before.

M No? Well, there are a few of us here.

I OK, perhaps I'll meet some more while I'm doing this. Now, the next question is 'occupation' – did you say you came here for work?

M Yes, that's right. I'm a lawyer. My firm has sent me here to gain some experience of practising law in an international context. So, I'm here to learn really.

I Sounds very interesting.

M Yes, I'm already learning a lot. Things are very different here from back at home.

I Now, what area of the city are you living in?

M I'm in an apartment in Waterfall Road, that's in Coundon.

I Oh, OK, let's see, how's that spelt, C-O-U-N-D-O-N, that's right, isn't it? It's O-N at the end, not E-N, isn't it?

M Yes, that's right.

I And your postcode, if you can remember it. Just the first part will do.

M That's CV26.

I OK, thanks.

Pause

I Now I want to ask you for your views on various aspects of living here. First of all, public transport. Is the public transport system adequate for you?

M Mm, well, it's hard to say. When I've used it, it's been fine, but I don't use it all that often. I cycle to work every day and that's usually how I get around in my free time, too. So, I'm not sure I can comment really on that particular issue.

I No improvements to suggest then?

M No, I don't have enough experience to do that.

I OK, now sports facilities. Do you do much sport?

M Yes, I do, it's my main interest outside work and I've got no criticisms there. As soon as I arrived I joined a cricket club – a friend back home who'd lived here for a while told me about it – and I've made lots of friends there already.

I Apart from that, do you think there are enough facilities?

M Yes, as far as I can see. I use the public swimming pool regularly, I've found some very good tennis courts and the fitness centre is fine, too. I've been able to carry on doing all the sports I'm used to doing at home.

I What about entertainment? Is this adequately provided or is the city lacking in something?

M Well, coming from a pretty small town, I've been amazed at what's on offer here. There are so many things to choose from in the evenings and at weekends. I don't think I'll have time to go everywhere I'd like to while I'm here. I've already been to some excellent restaurants, I've been to the cinema a few times, I've been to all sorts of places. There seem to be loads of things to do.

I What about cleanliness and litter? Do you have any views on that?

M Well, to be honest, I've been pretty surprised about that. Before I came, for some reason I'd had the impression that it would be a pretty dirty place, certainly compared with where I'm from. You know, I was expecting a crowded city with litter and rubbish all over the place, and sure there is some litter and it could all be a bit cleaner, but actually it's not at all bad in that respect.

I OK, now, what about crime and the police force? What are your views on that aspect of life in this city?

M Well, I haven't been here long enough to form much of a view. A colleague at work had her car broken into and some things stolen, and she reported it to the police but there wasn't much they could do about it, apart from give her a crime number so that she could claim on her insurance. I don't know how common that sort of thing is here. Nothing's happened to me so far, that's all I can say. Perhaps I've just been lucky or perhaps crime isn't a major problem, I don't know. But there's crime everywhere, isn't there, all over the world and in the countryside as well as cities.

I OK, well I've got all the information I need for the survey and I've ticked the right boxes. Thanks for taking the time to answer the questions.

M No problem.

Unit 2

Track 3

You will hear a speaker introducing a conference. First, you have some time to look at Questions 1–10.

Pause

Now listen and answer Questions 1–10.

Hello, and welcome to the conference. As you know, it's called Health & Fitness in the Workplace, and the name speaks for itself. We're here to discuss issues that can affect employees and of course therefore, the companies and organisations they work for. In planning the programme for this conference, we've taken into account the answers that you gave us in our questionnaires. Of course, some of the issues we cover will be more relevant to some of you than to others, but we think we've included all the main ones that you indicated are important to you.

Now, the whole subject of health and fitness in the workplace is something that didn't get much attention not that many years ago. Companies and organisations focused purely on the jobs that people were doing, and any assessment of them concerned how well they were doing their jobs, and how their work fitted into the overall operations of the organisation. Anything that might be regarded as a personal issue wasn't part of the company's relationship with its people – it was 'none of their business'. Well, of course, that's all changed and companies and organisations have come to realise that its people's health and fitness are very much their business. And that's not just in the obvious ways, such as the number of days off sick that employees have. There are also

psychological factors, and there is considerable evidence that a fit and healthy person does their job better than someone who doesn't maintain a good level of health and fitness. If you're emphasising these things at your workplace, you're creating an atmosphere that enables you to get the very best out of your people.

We're very much hoping that our programme here at the conference will be both informative and entertaining. The emphasis here is going to be not so much on the theory but on the practical side. What can you do in your roles to promote health and fitness in your workplace? Now, some of you may think you're already doing as much as you can, but I promise you that you're all going to learn something new. We've got speakers here who are going to tell you things you've never heard before and you should leave here at the end of the conference with all kinds of ideas for things you can introduce at your workplace.

But we're not going to be just talking to you and telling you things. One of the great things about an event like this is that it's a great opportunity to share information, so in every session there will be a slot for people to talk about their own practices and experiences. What initiatives have worked for you and which ones haven't been so successful? We can all learn from each other, and that's one of the aims of this conference.

Pause

OK, now let's move on to some details about the conference and what will be happening where. Let me just briefly take you through the map that you've all got in your welcome pack. Right, here on the map, we've marked all the sessions that are taking place this morning, and you've already indicated which ones you'll each be attending. For those of you going to the session on Setting Up a Fitness Centre at work, you go out of the Main Hall here through those doors, turn right at reception and go along the corridor to the Taylor Room, which is on your left. You'll get lots of good advice there on the possibilities and costs of a workplace fitness centre.

The talk on Healthy Eating Schemes is in the Martin Suite. For that, you need to go out of this hall the other way, through the doors at that end, and that takes you straight through to the Martin Suite. If you're keen to introduce healthy eating schemes in your canteens and restaurants, or to improve ones you've already got, you'll get lots of really good ideas from that session.

Now, those of you attending the session on Transport Initiatives, you're in the Fender Room. To get there, you need to go out of those doors that bring you out opposite reception, turn left and left again into a corridor. The Fender Room is the third door on your right. The session will cover everything from how to encourage people to walk or cycle to work to car-sharing schemes.

For those of you who have signed up for the workshop on Running Sports Teams, that will take place in the Gibson Suite. The whole issue of organising company teams, recruiting people for them, encouraging people to take part in them whatever their sporting ability, taking part in competitions – all that will get covered in the workshop. You'll find that if you go out of here, turn right at reception and then right again. The first door you come to on the left is the Gibson Suite.

Finally, if you need any more information or have any queries while the conference is going on, you'll find me in the Conference Coordinator's Office. From here, that's to the left of Reception and along the corridor past the Entrance Hall. If you keep going along the corridor, you'll find my door at the end on your right. Please come and see me if there's anything you want to ask or find out.

OK, let's get started. I hope that you all enjoy ...

Unit 3

Track 4

You will hear a student talking to her tutor about a piece of work she has done. First, you have some time to look at Questions 1–10.

Pause

Now listen and answer Questions 1–10.

Tutor Right, Beth, let's have a look at your dissertation. Well, I think it's a pretty good piece of work.

Beth Thanks.

T Communication Skills in the Workplace. Good choice of topic.

B Thanks.

T Now, I see that you decided to focus on certain sectors ...

B Yes, I felt that jobs involving interaction with the public would be my main area. So obviously, the retail sector had to be in there ...

T Sure. But you didn't just focus on the obvious ones like that, did you?

B No, I wanted to look at a variety of sectors. I felt, for example, that banking would probably lead to the same sort of results as retail.

T And what about call centres?

B Yes, of course that seemed like an obvious place to go initially. But I decided to spread the focus away from interactions involving customers and the goods and services they buy.

T Seems sensible. So, that led you to the idea of tourist guides ...

B Yes, that's a very specific area of communication, dealing with different nationalities ...

T The skills involved in that are very interesting, as you describe them ...

B Yes, and that led me to think about the work of translators and interpreters ...

T Well, that might be the starting point for a whole other piece of work.

B Yes.

T Now, the research you did for this was generally very impressive ...

B Thanks.

T ... though a bit more on the academic research that's been done into this area would have been good.

B Well, I went more for a 'personal' approach here, rather than rehashing other people's work or focusing mainly on the theories about how people communicate.

T Yes, and it worked well. It would have been good if you could have filmed people in action and then analysed the videos.

B I know, but there were practical issues there. So I settled for watching people in action and making notes on what they were doing, and of course there were the interviews too.

T Yes, it's very interesting to compare what people think they're doing with the way they're actually communicating. I was very struck by that aspect. And your analysis from watching people in action was very effective, too.

B I found it fascinating to do that.

T Yes, that comes across. It would be fascinating to get data on the outcomes of these interactions too, whether the desired outcomes were achieved.

B I know and that would be something I'd love to look at if I knew how to go about it.

Pause

T Now, looking at the content of your dissertation, I felt your division into sections was the right one, focusing on specific types of interaction in these contexts.

B Thanks.

T Now, your first section is on Dealing with Complaints. This is an obvious area for something on this subject, but I felt that this section had some really original thinking on your part.

B Yes, I tried to ignore the standard points that are usually made and come up with something fresh, and my research led me in those directions.

T The Collaborating with Colleagues section made for interesting reading too, but I didn't feel that your conclusions there were really backed up by the research you did.

B Oh? I felt that they were. I tried to illustrate everything with examples. Perhaps some weren't as relevant as others ...

T Yes, I think that's right. You made some pretty strong assertions but I wasn't sure they could be justified by the examples.

B Oh, OK. But the evidence for my conclusions in the Interacting with Managers section was pretty powerful, wasn't it?

T Yes, and most of the research in this general area doesn't focus on this particular issue. I think your conclusions there point to something that causes all sorts of trouble in organisations and companies but that isn't given enough attention.

B I agree. It's something that training programmes should be covering, but they don't.

T Now the Giving Instructions section was very well put together, I thought ...

B Yes, this is one where language accuracy and coherence are the main issues ...

T ... and you came to very clear conclusions on that. This is a really effective section, with general points illustrated by lots of examples and a conclusion that made logical sense.

Pause

T Now, finally, let's have a quick look at your overall conclusions.

B OK.

T Now, you've included quite a bit in the main body about Writing Skills but in fact you see Listening Skills as being a much bigger issue.

B Yes, as I say there, people don't pay enough attention to what other people say to them and this leads to all kinds of communication problems.

T And the other big issue is Grammatical Accuracy, isn't it?

B Well, up to a point, but as I say, there are lots of instances where this is less of an issue than Formal Language. When people are in situations where this is required, they're often at a loss and end up not making much sense.

T Yes, as you make clear. Well, Beth, this is a good piece of work. Well done.

B Thanks.

Unit 4

Track 5

You will hear an expert giving a talk about blogs and blogging. First, you have some time to look at Questions 1–10.

Pause

Now listen and answer Questions 1–10.

OK, I'm going to talk today about blogs and blogging. Though I'm assuming you're all familiar with what a blog is, let's just start with a definition. Perhaps the simplest definition is that a blog is a type of website in the form of a journal of one sort or another.

at are arranged
at the top of the

g? Well, blogs
y updated
s always, about
ger's own life, as
ogs on just about
logs, news blogs,

ey allow readers
the blog, or to
e get into contact
g ideas, perhaps
other, wherever

e and there are
of blogging is a
er what the first
e diary started
as called *Justin's*
Underground.

ebsites like
pdated online
ebsites and
inions.

e term 'web log' to
d his own website,
erholz jokingly
vented the term
s' and the people

OK, now let's move on to how to run a blog, and what I'm going to do now is to tell you what I think is the best approach to workflow with a blog. First of all, you need to decide on the frequency of your blog posts. Some people do several a day, which is great if you can keep it up, others one a day. Once a week might be enough, but the key question is what the readers of your blog expect. They need to know when they can expect to see a new post on the blog, so whatever schedule you decide on, it's important to stick to it.

When you're going to do a post, start by reading material to find out what's being discussed in friends' blogs, or in other blogs related to the topic of yours. That way you can take these things into account to ensure that your blog is bang up to date.

Then start composing your blog post. If you're doing one that involves research and links, open a file for storing the sources of your information and the links you're going to put in the post. Also consider using pictures. These can make your blog much more attractive than one that's just text. If you use photos from the web, make sure you cite the source in your blog.

When you've completed the post, add some tags. If you don't have the kind of software that enables you to build them into the post, add them at the bottom. Tags are really important for searchability – they can get you new readers who find your blog via the tags.

If you think this is a particularly good post and you're really proud of it, announce it by sending links to it on social networking sites, together with a very brief summary of what it's about.

Then check your blog statistics to see how many people are reading and responding to your blog. Find out who's blogged about your post and reply to them, and give them a proper reply rather than just saying thanks.

After you've done all that, get off your own blog and comment elsewhere. Remember that you're not the only person blogging and putting out new material – there are lots of others doing the same and you should show them some respect by giving them comments and feedback on their posts where you feel it's appropriate.

Well, that's just some advice on being a good blogger. Blogging's obviously a major thing now in the world of electronic media and it's anybody's guess how it will develop in the future.

Unit 5

Track 6

You will hear a man who is interested in doing voluntary work connected with the environment talking to a woman who works for an organisation that runs environmental projects. First, you have some time to look at Questions 1–10.

Pause

Now listen and answer Questions 1–10.

Hannah Hello, how can I help you?

Ryan Well, I've come in because I want to volunteer for one of your environmental projects. I read something about your organisation in the paper a few days ago and I thought I'd like to get involved.

H OK, that sounds good. What's your name?

R Ryan.

H OK, Ryan, thanks for coming in. I'm Hannah. Now, let me start by telling you something about our organisation and then we can have a look at a few projects that might interest you, after I've found out a bit about you.

R Fine.

H Right, well as you know, we're called *The Volunteer Agency* and that pretty well explains what we do. We recruit people for a wide range of projects. A lot of our work concerns environmental projects and at the moment we've got 130,000 volunteers working on these projects.

R What sort of environmental projects are they?

H Well, for example, if you wanted to go abroad, one of our big projects involves gathering information that is used for the protection of marine and forest environments. Volunteers on that do diving or collect biodiversity data on tropical rainforest species.

R Sounds exciting. But I think I'd rather stay here, at least to start off with.

H OK. Well, here in our own country we've got a big project aimed at clearing up litter in rural areas. The aim of this is to get everyone involved in making sure their local environment is clean and tidy.

R Yes, I've seen adverts for that.

H Another project involves looking after the National Cycle network, keeping the routes safe and attractive for cyclists. This is part of a bigger scheme concerned with developing sustainable transport systems all across the country.

R Interesting ...

H Now, if you want to do something in the city, rather than the countryside, within cities we also have the City Farms projects, which involve working with people, plants and animals.

R Oh, what are those? Are they real farms? How do they work?

H Well, yes, they're real farms and they're an example of a project that relies almost entirely on volunteers. On other projects, you might be working alongside salaried people, but with these, almost everyone is unpaid. In fact, many of our projects have very few, if any, paid staff.

R Yes, that's what I thought.

H Well, do any of these things sound particularly appealing to you?

R Well, as I say, I wasn't thinking of going abroad, and I'm not sure that any of those is exactly the sort of thing I'm really looking for. Sorry!

H That's OK, there are lots more things I can tell you about. I'm sure we'll find a project that's right up your street.

R Yes, I hope so.

H OK, well, let's have a look at a few other possibilities.

Pause

H Right, well one thing that might suit you is a scheme called *Wildlife Link.* There are 47 branches of this around the country, with over 24,000 active volunteers, and it's involved in all aspects of nature conservation. Its aim is to protect wildlife in all habitats across the country. Things you can do there include looking after nature reserves, taking part in community gardening and carrying out surveys of wildlife species. Tell me, are you keen to be outdoors?

R Yes, I am, and that does sound like the sort of thing I might be really interested in.

H OK. Well, here's another project that you might like the sound of. This one's aimed at young people.

R Right, tell me about that one.

H It's called *Wildlife Watch*, and involves organising groups for young people, getting them to explore and learn about their local environment. There are over 300 groups and around 150,000 members of those groups. As well as running those groups and going out with them, there is a need for volunteers with administrative skills. Is that the sort of thing you might fancy?

R Maybe, but I think I'd probably prefer to be more hands-on, doing physical work.

H OK. Well, then the organisation called *Action Earth* might be the one for you. They've got a total of 908 projects, involving over 18,000 volunteers. They do all sorts of things, from planting trees to constructing fences and walls and collecting litter, their aim being to improve the local environment in all sorts of ways. How does that sound?

R I might well be interested in that.

H OK, look, I'll give you some leaflets and contact information, and you can have a think about it all.

R That sounds like a good idea. Thanks.

Unit 6

Track 7

You will hear a manager in a museum talking to the staff about machines that are going to be put into the building. First, you have some time to look at Questions 1–10.

Pause

Now listen and answer Questions 1–10.

OK, now what we need to discuss next is vending machines. Now that the building has been completely refurbished, and we're going to be reopening, we should think of what kind of machines we need. These have two functions, of course – they provide services for visitors and they raise money. Every time someone buys something from the machine, we raise a little more money.

Well, first of all a cash machine seems like a good idea, so that people can get some money to spend while they're in the building, and this will help to keep down queues in the gift shop if everyone is paying with cards. That can go in the entrance hall – we thought about putting it in on the front wall outside the building but decided against that.

Now, we've also decided to install a ticket machine for the individual exhibitions in the various parts of the building. This will take some pressure off the ticket office and reduce the number of people hanging about in the entrance hall. It'll be a simple device – you select the exhibition and then pay for it in cash or by card and it'll be right next to the reception desk, with a sign above it so that people can clearly see it when they arrive.

Now the next machine lots of people might not approve of – a games machine for children to use. I know that this might not seem like the right sort of thing to have in a museum, but a constant complaint we get from visitors is that their visit is spoiled by the sound of bored children running around the corridors and shouting and generally disturbing the atmosphere. If we put a couple of these in the Visitor Centre, well away from the Exhibition Halls, it'll keep some of them occupied.

Then there's the question of a drinks machine. Well, we want as many people as possible to buy our own food and drink in the cafeteria and restaurant, but at the same time visitors will want something to drink when they're going round the museum and are not near to either of those places. We thought a good place for this would be by the lifts on the first floor as people go up and down from one exhibition to another and, of course, that's also right at the top of the stairs.

Pause

Now, the last thing is the drinks machine that we're putting in the staff room. As you'll be using this brand new state-of-the-art machine pretty frequently, I thought I'd just run through with you how it works. So, here on the screen I've put up a picture of it and I'll just tell you all how it works. Well, it's pretty big and you may be surprised to hear that it can store as many as 495 drinks products, so there'll be plenty to choose from and it won't need refilling too regularly.

Right, well, it's got a glass front here and behind it all the drinks, of course. The drinks come in bottles and cans and they're, of course, refrigerated. Now this machine has an interesting feature that I'm sure will entertain you all. When you've chosen and paid for your drink, there's a special rapid pick-up mechanism that grabs your drink and places it into the receiver, here, which is illuminated. So you can see your drink even if it's dark in here. And that's not all.

Through the glass front you can actually see the mechanism working – there's a visible moving arm that gets and delivers the drink and you can see that happening. Now, that's not just to make the machine interesting to look at while you're buying a drink, it's got a serious advantage too. What it does is to quickly and safely move the drink without it being shaken at all. So it won't bubble up or spill when you open it.

Now to the business of how you buy a drink. How it works is that you choose the drink you want from the menu here and then type in the code for that drink – you'll see the code in front of each drink. Then the price of the drink will be displayed here and you pay for it. You can do that with coins or by card. And you can order up to ten products at a time, for example, if you're getting drinks for a group of visitors or colleagues.

So, as I say, it's the very latest in drinks machine technology and I hope you'll all be pleased to have it.

Right, next I'm going to move on to talk about …

Unit 7

Track 8

You will hear two students talking about a presentation that one of them is going to give. First, you have some time to look at Questions 1–10.

Pause

Now listen and answer Questions 1–10.

Jack Hi Maya, how are you getting on with your presentation?

Maya Oh, hi Jack. It's going really well after a slow start.

J What's it about again?

M Well, the general topic area is Human Relationships and we had to choose a specific area within that.

J So, what have you chosen?

M Lifelong Friendships.

J Interesting. What led you to choose that?

M Well, it occurred to me that there's been a lot of research on how people form friendships, and even more on marriage and partnerships, but there's not much on this particular topic. So, I thought I could do something a bit different by focusing on this particular aspect.

J Sounds like a good idea. How have you been doing your research?

M Well, mainly by personal contact. I realised that my parents have a number of lifelong friends, and of course, I've known them for years, so I thought I'd start off by seeing what they had to say.

J Sounds reasonable, but that's only a very small sample, isn't it?

M Yes, but I thought I'd collate the results from that small sample so that I could compare them with more general conclusions from research in the area.

J Good idea. How did you get on when you tried to get information from your subjects?

M Well, I started off by giving them a questionnaire. I spent quite some time working that out, deciding what aspects of their friendships I wanted them to focus on and then I handed it out to them.

J And?

M Well, it didn't work out too well. I kept asking for them back and they kept saying they hadn't had time to do them or hadn't quite finished them, and eventually one or two of them admitted that they were having trouble knowing what to put.

J Oh, why's that?

M They just couldn't analyse their friendships in that 'cold' way, on paper, in nice, neat little paragraphs or by ticking boxes. I realised then that they all felt that way, so I had to abandon that approach.

J What did you do instead?

M Personal interviews. I adapted my questionnaire and sat down with each person and talked to them. I got them to agree to my recording these interviews – that way I could focus on the way the interview went rather than having to write notes all the time – and then I went through the recordings.

J And that worked out well?

M Yes, I got all the information I needed. It was a small sample, as I say, but it was possible to get some general conclusions from them about their lifelong friendships.

J And then you compared this with research data?

M Yes, there's not a lot of that, but I managed to locate some academic research in the area.

J And how did that compare with your findings?

M Remarkably similar actually, so my sample proved to be pretty representative. There were one or two disparities here and there, but in general the research I was able to locate pretty much confirmed what I found myself.

Pause

J Now, when you do your presentation, how have you organised it?

M Well, obviously I've given that a lot of thought, and the various stages of the presentation are linked to the aspects I focused on when I was talking to my subjects. So, obviously, I start with how the friendship was first formed, for example, how old the people were, where they met, how they met, that kind of thing.

J How will you present that?

M I've created a table, with the various headings and the percentages of my subjects whose friendships started in the various ways.

J OK, what comes next?

M Well, I've looked at the effects on the friendship of various developments in the friends' lives. The first category I've called 'Change of Location', and that deals with what happens in the friendship if one or other of the friends goes to live somewhere else.

J What about if they don't change the place where they live but go to work or study somewhere else?

M Well, that's included in my data in that category, in a couple of separate tables.

J What then?

M OK, well then, I've looked at what happens to the friendship when one or both of the friends get married. I got the subjects to say simply whether marriage meant that friendships got less close, closer or stayed much the same.

J How have you presented that data?

M That's a pie chart.

J OK. What other aspects of the friendship have you focused on?

M Well, the next one concerns 'Personality'. I asked people to tick boxes for their friend's personality when they first met, and then how they would describe the same person now.

J How did you compare the answers there?

M Yea, that was tricky to work out. I looked for patterns of change. One finding from that was that many people who were described as 'relaxed' at the beginning of the friendship got categorised as 'stressed' right now. So, for the presentation, I picked out the most extreme changes that I found, not every single change.

J Sounds interesting. Any other categories?

M Yes, two more. I thought it would be interesting to compare how much people had in common in terms of political opinions as their friendship progressed over the years. Did they both change them, or did one person change and if so, did this cause tension or disagreement between them? I've constructed another pie chart for that.

J And the other category?

M Yes, I thought another key area concerned what the people have in common and whether they continue to have those things in common. I've categorised this as 'Shared Interests', and I've looked at any changes that tend to happen over the years. One thing I found, for example, was that men's shared passion for certain sports doesn't change at all over the years, whereas their musical tastes do.

J All sounds great. I'm sure it'll go well when you do the presentation.

M Thanks. I hope so.

Unit 8

Track 9

You will hear part of a lecture about the history of jeans. First, you have some time to look at Questions 1–10.

Pause

Now listen and answer Questions 1–10.

OK, today we're looking at contemporary fashion 'icons' as part of the module on the history and development of fashion. And perhaps the best place to start with this is with a garment that everybody in the world knows about and either wears or has worn – jeans.

Now, of course, jeans are often synonymous with the word 'denim', for the material they're made from. Where do both these terms come from? Well, there isn't universal agreement on either of these things, but the story begins in Europe in the 1500s. The general belief is that the word 'jeans' comes from Genoa in Italy, where sailors wore clothes made from a material called jean.

The word 'denim' is generally considered to come from France at roughly the same time. It is thought to have evolved from 'serge de Nîmes', a kind of material produced in the French town of Nîmes. These two fabrics were different in important ways. Denim was stronger and more expensive than jean. And denim was woven with one coloured thread and one white thread, while jean was woven with two coloured threads.

To start with, the cloth for both of them was a mixture of things. By the 18th century, however, it was made completely from cotton. And it was dark blue because it was dyed with indigo, which was taken from plants in the Americas and India. Denim and jean remained two very different fabrics and by the late 19th century it was denim that had emerged as the most popular and widely worn. Denim was used for workers' clothes, for example, those worn by workers on plantations, because it was very strong and it lasted for a long time. Jean was used for lighter clothes. Eventually of course, the word 'jeans' would come to be used for clothes made from denim, but that's much later.

A key event in the history of jeans was the 1848 Gold Rush, when gold was found in California and thousands of gold miners rushed there to find it and make their fortunes. They wanted clothes that were strong and didn't tear easily. Enter a man called Strauss. He moved to California from New York and started a business supplying work clothes. His first name was Leob, that's L-E-O-B. Later, he changed it to Levi.

Now, the miners in California were experiencing a problem with their work clothes. The pockets tore away from them very easily; they just weren't strong enough or well enough attached. In 1872, a man called Jacob Davis wrote to Strauss about an idea he'd had.

This was for metal rivets to hold the pockets and the rest of the garment together, and he offered Strauss a deal to use this idea in the clothes he was supplying. Strauss accepted the offer and started to make work clothes with these metal fasteners, made of copper. They weren't called jeans at this time, that term didn't come into being until the 1960s – they were sold as 'waist overalls' and made with denim.

In 1886, Strauss added another feature to these clothes, a leather label. To emphasize how strong the garments were, this showed a pair of these trousers being pulled between two horses. The message was that they were so strong that even this could not cause them to tear. By the 1920s, because of their reputation for toughness, Strauss's waist overalls were the most widely used workers' trousers in the U.S.

Now, up until the 1930s, jeans were purely and simply work clothes. But Hollywood changed all that and they made the journey to being fashion items. The roots of this lie in the cowboy movies of the 1930s. Cowboys often wore jeans in these movies, and American men wanted to dress like them in their free time. At this point, jeans are a wholly American thing.

The Second World War in the 1940s took them abroad, as American soldiers wore them when they were off duty. This introduced them to the wider world. But their real popularity as a fashion item really starts in the 1950s, when they caught on with young people. This was because they became the symbol of the teenage rebel. This completely new type of young person emerged in American films and TV programmes that were enormously popular with teenagers. Teenagers didn't call the clothes 'waist overalls', they gave them a new name – 'jean pants'. And pretty soon, this got abbreviated to jeans.

In the 1960s, jeans were the standard kind of trousers worn by students in Western countries and they were the top fashion item. Young people adapted them in all sorts of ways, turning them into embroidered jeans by sewing brightly coloured designs on to them, and all sorts of styles emerged, one of the main ones being flared jeans, with bottoms that got wider and wider as they went down.

Right, now I'm going to move on to look at what jeans symbolised both in Western countries and in non-Western countries at that time. But first of all, does anyone have any questions?

Answer key

Unit 1

Listening

❶ B

Exam tasks

1 three / 3 weeks 2 New Zealand 3 lawyer 4 Coundon
5 CV26 6 B 7 C 8 B 9 A 10 C

Vocabulary

❶ 1 problem 2 trouble 3 problem 4 trouble 5 problem

❷ 1 effect 2 affect 3 affected 4 effects 5 affects / has affected

❸ 2 percentage 3 percentage 4 percent 5 percent 6 percent

❹ 2 Adjusting 3 process 4 stages 5 matters 6 accustomed 7 evidence 8 customs 9 sense 10 seek

Reading

❶ B

Exam tasks

1 T 2 NG 3 F 4 F 5 NG 6 T
7 see life 8 fear 9 (a) cultural clash 10 mobility
11 cross-cultural kids / CCKs 12 diversity and identity
13 shared experience

Writing

❶ B: The chart shows what Bulgarians intended to do in 2001 and 2006. It shows how many did not intend to leave Bulgaria and the intentions of the people who were planning to leave.

Not A: only some of the statistics concern emigration and so emigration is not the main topic.

Not C: most of the people in the chart were not planning to leave Bulgaria and so the main topic is not differences in the reasons why people left in those two years.

❷ 1 stay in Bulgaria

2 No intention to travel/stay abroad; Live abroad for a short time

3 Live abroad for a short time

4 It stayed the same.

5 Tourists/guests/visitors; Work abroad then return

❸ 1 No 2 Yes 3 Yes 4 No 5 Yes 6 No

❹ MODEL ANSWER

> The chart shows that there were changes in the level of education of Bulgarians who planned to leave their country over the period 2002 to 2008.

> The highest category of people in all three years was those with secondary education. This figure fell slightly over the three years, from 65% in 2002 to 61% in 2006 and 59% in 2008.

> However, the figures in the other categories changed significantly. There was a sharp rise in the percentage of people with primary or lower education, from 18% in 2002 to 32% in 2008. This figure only rose by 1% in 2006 but in 2008 it rose considerably.

> The opposite happened with the figures for people who had received higher education, which rose slightly in 2006 but then fell very sharply to 9% in 2008.

> The general trend, therefore, was that the proportion of people with higher education who planned to leave the country fell sharply, while the proportion of people with primary and lower education rose sharply. The percentage of people with secondary education remained much the same and it remained by far the highest percentage.

Grammar

❶ 2 more demanding 3 harder 4 The most difficult 5 the most tiring 6 the friendliest 7 less stressed 8 further 9 more expensive 10 worse 11 bigger 12 faster 13 busier 14 the most exciting 15 more regularly

❷ 2 more expensive; less expensive / cheaper 3 the oldest; younger 4 better; worse 5 more slowly; faster / more quickly 6 the most difficult; more difficult

Unit 2

Reading

❶ B

Exam tasks

2 iv 3 ix 4 i 5 viii 6 v 7 ii
8 A / E 9 E / A 10 B / E 11 E / B 12 C / E 13 E / C

Listening

❶ A

Exam tasks

1 A 2 B 3 B 4 A 5 C
6 D 7 H 8 F 9 A 10 C

Vocabulary

❶ 2 criticised 3 irregular 4 sunny 5 Daily 6 appearance 7 happiness 8 inactive

❷ 2 dramatically 3 simplify 4 runners 5 surprising 6 unexpected

❸ Across: 3 avoid **4** techniques **5** stall **8** locally

Down: 1 likely **2** artificial **6** luxury **7** yields

Writing

❶ A: both views are discussed and a firm conclusion is given

Not B: only one view is discussed (being healthy and fit)

Not C: only one view is discussed (being unhealthy and unfit)

❷ 2 lead **3** stay **4** do **5** work **6** take **7** cut
8 make **9** go **10** lose

❸ 2 As a result **3** On the other hand
4 Another **5** also **6** In fact **7** in particular

❹ MODEL ANSWER

> One of the big issues in some parts of the world today is that of unhealthy lifestyles and the effects that unhealthy lifestyles have on people and society. This is not just a personal issue, it's also a social and medical one.
>
> For a lot of people, it's easy to have an unhealthy lifestyle. They spend most of their time sitting at desks at work. In fact, this has become more and more true of people over time, because jobs that involved physical movement have been replaced by jobs involving computers.
>
> Another reason is that they use their cars for every journey instead of walking sometimes. So they get very little exercise, and this is very bad for them. And many people, in particular young people, spend a lot of their free time sitting down and looking at screens. They watch movies or play computer games all the time, instead of going out and doing sport and taking exercise. Food is another issue. Nowadays, many people eat junk food all the time and this is very bad for you.
>
> People are very aware of this issue and they want to stay fit and healthy. In most places, it's not difficult to do this. There are gyms and fitness centres where people can go, and lots of people do this. In addition, there is a lot of information about what to eat and it's not difficult or expensive to eat healthy food. The whole subject gets a lot of publicity in the media. As a result of all this, many people find it easy to stay fit and healthy.
>
> In conclusion, it's very easy for a lot of people to have unhealthy lifestyles and this can cause medical problems because they can eventually require some kind of medical treatment, which puts more pressure on the medical profession. On the other hand, it's not at all difficult for people to avoid these problems by taking regular exercise and eating healthy food.

Grammar

❶ 2 information **3** jobs **4** research **5** suggestions
6 groups **7** equipment **8** knowledge **9** ways
10 work

❷ 2 great **3** a lot of **4** a wide **5** number **6** Few
7 amount **8** much **9** few **10** a little

❸ 2 equipment; ✓ **3** advice; ✓ **4** damage; health **5** ✓; ✓
6 software; ✓ **7** ✓; ways **8** ✓; problems

Unit 3

Listening

❶ C

Exam tasks

1 A / D **2** D / A **3** C / D **4** D / C **5** F **6** A **7** C **8** D
9 L/listening S/skills **10** F/formal L/language

Vocabulary

❶ 2 extracts **3** findings **4** structure **5** weaknesses
6 assessment **7** evaluation **8** features

❷ 2 ✓ **3** ✓ **4** find out **5** know **6** study **7** ✓ **8** ✓; ✓

❸ 2 native **3** less **4** find **5** longer **6** diet **7** inclusion
8 matters

Reading

❶ The fourth and fifth paragraphs

Exam tasks

1 NG **2** Yes **3** No **4** Yes
5 D **6** E **7** B **8** H **9** C
10 C **11** A **12** D **13** C **14** B

Grammar

❶ 2 has given **3** 've / have been looking; haven't found
4 haven't studied **5** was; left; didn't have
6 've / have been working **7** made; wrote
8 've / have put

❷ 2 from; to **3** In; to **4** by **5** Over; in **6** Between; of; in
7 from; to; during / over / in **8** at; in

Writing

❶ A

❷ 1 higher-talking **2** 45 million **3** 36 months **4** 500; 1100
5 22 months **6** lowest-talking

❸ A

❹ MODEL ANSWER

> The table shows changes in the percentages of people who considered that various communication skills were essential in their jobs between 1997 and 2006. The skills were divided into two categories: external (with people outside the company) and internal.
>
> The most common skill required was dealing with people and the highest percentage of people in both years said that this was essential. This was the only skill considered essential by more than half of the people in both years.

The next most essential external skill in 2006 was communicating knowledge of particular products and services, which was essential for 35% of people in 1997 and 41% of people in 2006. The highest figure for communication with people within the company or organisation was listening carefully to colleagues, which nearly half of people in 2006 said was essential. This figure was 9% higher than the one for 1997.

Other important skills were advising or caring for customers or clients, instructing or training people and analysing problems together with others. The least required skills involved making speeches or presentations and planning the activities of others.

For all skills except selling a product or service, the percentage increased between 1997 and 2006, meaning that more people saw these skills as essential in 2006. So, the requirement for almost all these skills grew over the period, the biggest rise being in listening to colleagues.

Unit 4

Reading

❶ The first, second, third and fifth paragraphs

Exam tasks

1 F 2 NG 3 T 4 T 5 F 6 NG
7 100,000 children 8 test scores 9 positive
10 parents
11 the newspaper 12 4 / four hours 13 children's books

Listening

❶ Questions 6, 7 and 9

Exam tasks

1 monologues 2 business 3 H/home P/page 4 forums
5 we blog
6 frequency 7 sources 8 announce 9 statistics
10 thanks

Vocabulary

❶ 1 causes 2 reasons 3 factors 4 reasons 5 causes
6 factors

❷ 2 networking 3 date 4 research 5 download
6 browse 7 visit 8 touch

❸ 2 transform 3 lack 4 attract 5 do 6 reveal
7 restrict 8 launch 9 experiment 10 evolve

Writing

❶ electronic media; negative effect on personal relationships;
agree or disagree; reasons; relevant examples

❷ A Yes B Yes C No D Yes E No F No G Yes H No

❸ A Yes B Yes C No D Yes E No F Yes G Yes H No

❹ MODEL ANSWER

People use electronic media to communicate with each other more and more these days, rather than having face-to-face contact or speaking to each other. This can have an effect on their relationships with other people. But is the effect necessarily a negative one?

It is easy to see many positive effects of the use of electronic media on relationships. For example, email enables people who might otherwise not have any contact with each other to communicate regularly. People with friends and family in other countries, for example, can keep in touch much more easily and regularly than if they only contacted each other by letter. It can take a lot of effort and time to write a letter but it's easy to send a quick email.

Social networking sites are another example of positive effects. These enable people to make new friends and to keep their friends up to date with everything they're doing. People can extend their group of friends very quickly and easily.

On the other hand, there can be negative effects too. Some people don't bother to respond to communications via text messages or emails and this can upset and annoy the people who have sent them. Also, people sometimes don't take care when they communicate via electronic media – sometimes their messages don't make sense to the people receiving them or they can seem rude.

Communicating through electronic media can therefore cause some problems between people, and it cannot replace meeting and talking face to face. But in general, it has more positive than negative effects.

Grammar

❶ 1 B 2 A; C 3 A; B 4 C

❷ 1 a 2 The; the 3 an 4 - 5 -; the 6 a; the 7 -
8 The 9 The; - 10 The

❸ 2 an 3 - 4 - 5 - 6 a 7 the 8 a 9 a 10 - 11 a
12 a 13 an 14 - 15 - 16 - 17 the 18 the

Unit 5

Listening

❶ Questions 1 and 5

Exam tasks

1 130,000 2 diving 3 litter 4 cyclists 5 City Farms
6 paid staff 7 species 8 groups 9 Action 10 fences

Vocabulary

❶ 1 Tourism 2 tourist; environment 3 nature; countryside
4 countryside 5 tourism

❷ 2 infrastructure 3 plant 4 source 5 drawback 6 step

❸

C	L	C	H	A	N	G	E	S	S	I	E
D	E	S	A	T	O	V	A	T	I	N	M
E	L	S	B	M	T	U	R	O	N	B	I
S	A	Y	I	O	I	P	E	P	F	E	S
T	O	U	T	S	W	I	N	C	O	T	S
R	L	H	A	P	H	L	E	A	S	I	I
U	N	C	T	H	I	E	W	A	S	P	O
C	O	N	S	E	R	V	A	T	I	O	N
T	U	Y	R	R	O	E	B	A	L	K	S
I	N	T	E	E	V	L	L	S	S	I	P
O	L	R	I	N	G	S	E	M	I	D	S
N	E	N	D	A	N	G	E	R	E	D	O

2 fossil **3** renewable **4** destruction **5** change
6 atmosphere **7** habitats **8** emissions **9** conservation
10 levels

Reading

❶ Sections A, B and C

Exam tasks

1 E **2** A **3** B **4** E **5** B **6** D **7** B **8** A **9** C
10 agricultural lands **11** ethanol **12** coal-fuelled
13 (clean) electricity

Writing

❶ yes = A, B, D, G, H

❷ **1** 56% **2** transmission cables **3** 4% **4** 40%
5 electrical energy **6** LNG terminal **7** pipeline
8 30–60% **9** thermal **10** (natural gas-fired) cogeneration
11 40% **12** 70 and 90%

❸

> The diagram compares two different ways of producing energy. //
> The conventional system involves a thermal power plant. At the first
> stage, at the plant, 56% of the energy put into the system is not
> used and becomes waste heat. At the next stage, power goes from
> the plant through transmission cables and at this stage another 4%
> of the energy is lost. This means that only 40% of the power is used
> at the end of the process and this is used as electrical energy. // In
> the other system, natural gas is used as the source of power. Power
> comes from the LNG terminal through a pipeline to a gas engine.
> At this stage, between 10% and 30% of the energy that has been
> produced is lost. Of the power that is not lost, 30-60% of it is then
> used for thermal energy and 20-45% is used as electrical energy.
> // The comparison shows that the conventional system is less
> energy efficient than the other system, called a natural gas-fired
> cogeneration system. The overall energy efficiency of the

> conventional system is only 40%, meaning that only 40% of the
> power it produces can be used. In contrast, the system based on
> natural gas is much more efficient, as between 70% and 90% of the
> energy produced is used.

❹ B

❺ MODEL ANSWER

> The diagram shows where air leaks into and out of a house, causing
> loss of heat and waste of energy.
>
> A lot of air escapes from the house through the ceiling on the
> first floor and goes up into the space in the roof. This air escapes
> through recessed lights in the ceilings of upstairs rooms and also
> through the attic hatch that leads to the roof space.
>
> Air gets into the house in several different parts of it. It comes
> through windows and doors and into rooms in the house. It comes
> through the vents that have been installed for various electrical
> appliances, such as the dryer and the kitchen fan and it also comes
> through the outdoor faucet and into the crawl space.
>
> The diagram shows that there is a lot of air getting into and out of
> the house, with air either coming in or getting out in a great many
> places. This must mean that a lot of heat is lost and that a lot of
> energy is wasted.

Grammar

❶ **2** have been increased **3** are provided **4** must be sorted
5 should be placed **6** can be collected **7** is taken
8 will be informed

❷ **2** Recycling schemes have been started **3** International
cooperation on environmental issues has been discussed
4 more should be done **5** solar power can be used
6 Alternatives to existing energy sources must be found
7 Steps were taken **8** Will environmental problems be
solved

Unit 6

Reading

❶ C

Exam tasks

1 buggies **2** colouring books **3** faster (tempo)
4 F **5** F **6** T **7** NG **8** T
9 direct sales **10** (the) racks **11** kits
12 15/fifteen months **13** (satisfied) customer

Vocabulary

❶ **2** spending **3** to borrow **4** to put **5** to save **6** losing
7 to check **8** buying

❷ **2** me to earn **3** prices (there) to be **4** spending
5 me to buy **6** me to pay **7** getting **8** me to save

❸ **2** credit **3** interest **4** branch **5** debit **6** overdraft

4 1 B 2 A 3 C 4 B

Listening

1 B

Exam tasks

1 D 2 F 3 A 4 C
5 glass 6 illuminated 7 moving arm 8 shaken
9 code 10 10/ten products/drinks

Writing

1 purpose of business; make money–only this; agree or disagree; reasons and relevant examples

2 yes = A, D, F, H

3 2 in 3 on/from 4 out of 5 with 6 towards/to
7 to 8 to 9 on 10 to

4 MODEL ANSWER

> It is obvious that businesses exist to make money and if they don't make money they can't continue. Profits must be the most important thing for any business, and if a business makes profits, it can grow, which is good not only for the business but also for other people, because it will require more employees. If, on the other hand, a business is losing money, it will have to get rid of some of its employees.
>
> But is making money the only thing that businesses should focus on? I think that in the modern world, there are other considerations. First of all, businesses should think about the effects they have on the environment. For many years, businesses in the developed world have had 'green' policies and tried to make sure that they do as little damage as possible to the environment. This is a very important issue and it should be part of every company's operations.
>
> Businesses should also pay attention to the people who work for them. They shouldn't treat employees as simply numbers, anonymous people whose only function is to help the business make money. They should make sure that they have reasonable working conditions and they shouldn't exploit them.
>
> Another important role for businesses is in the local community. They can sponsor local events, giving money so that these events can take place. Some of their profits can be spent helping to make life in the local area better for everyone, for example, by giving money to schools.
>
> In my view, therefore, the primary purpose of businesses is to make money but this is not the only thing they should concentrate on. There are other important considerations for them too.

Grammar

1 2 that / which 3 who / that 4 where 5 when
6 whose 7 who / that 8 which / that

2 2 which is 3 when he left 4 which involves
5 where there is a problem 6 who don't know
7 which describe 8 which need

3 2 whose profits are very high, is 3 when supermarkets began to appear all over Britain, Tesco 4 who used to buy their food in small shops, quickly changed 5 where many small shops have closed, people 6 which now sell a variety of things, are

Unit 7

Listening

1 C

Exam tasks

1 A 2 C 3 B 4 C 5 B
6 location 7 marriage 8 personality
9 political opinions 10 shared interests

Vocabulary

1 2 persuasive 3 concerned 4 upset 5 bored 6 helpful
7 reassuring 8 upsetting 9 boring 10 irritating

2 2 the age 3 aged 4 aged 5 the age 6 the ages
7 ages 8 age group 9 age 10 age groups

3 Across: 4 tell 5 incident 6 confess 8 predict
Down: 1 consistent 2 blame 3 wild 7 liar

Reading

1 Sections B, E and F

Exam tasks

1 vii 2 v 3 ix 4 iv 5 vi 6 ii
7 C 8 D 9 B 10 D
11 entitlement 12 easy 13 selfish

Writing

1 C

2 yes = B, C, E

3 C

4 yes = B, C, G, H

5 MODEL ANSWER

> The pie charts show what people said about their relationships with their supervisors and their co-workers in 2005 and 2009.
>
> On the subject of their relationships with supervisors, many people said that they had a very good relationship. This figure went up from 61% in 2005 to 65% in 2009. The next highest percentage was people who said they had a good relationship – this fell from 26% in 2005 to 22% in 2009. Not many people said the relationship was only fair or that it was poor, and not many didn't have a supervisor. So, the vast majority of people had a good or very good relationship in both years.

Concerning relationships with co-workers, again most people in both years said the relationships were either very good or good, the figure for very good rising from 63% to 70%. The figure for people saying the relationships were fair fell from 7% to 3% and in 2009 nobody said the relationship was poor. So for almost everybody, relationships with co-workers were very good or good.

Overall, slightly more people said their relationships with co-workers were very good or good in both years but the difference was not great and in general both relationships were described as very good or good by most people. The responses did not change much over the two years, though in both categories the percentage of people saying relationships were very good rose a bit.

Grammar

❶ 2 them 3 these 4 One 5 their 6 other 7 their
8 this / that 9 These 10 one 11 she 12 it 13 this / that 14 ones 15 this / that 16 this / that 17 he
18 its 19 it 20 him

❷ 2 you get on 3 ✓ 4 they upset 5 ✓ 6 I didn't like
7 I'll give 8 ✓ 9 I'd/I would be 10 ✓ 11 is 12 ✓
13 wouldn't 14 ✓ 15 exercised

Unit 8

Reading

❶ A

Exam tasks

1 C 2 A 3 D 4 A 5 B
6 YES 7 NO 8 NG 9 YES 10 NO
11 D 12 F 13 B 14 A

Listening

❶ A

Exam task

1 sailors 2 thread(s) 3 plantations 4 Leob 5 pockets
6 metal / copper 7 two horses 8 cowboy movies / films
9 soldiers 10 jean pants

Vocabulary

❶ 1 clothes; cloth 2 Dress 3 clothes 4 dresses
5 cloth 6 dresses

❷ **Across:** 4 fabric 5 garment 6 casual 7 ancient
8 textile
Down: 1 origins 2 unique 3 portrait 4 fragile

❸ 2 contemporary 3 preserve 4 handmade 5 celebrity
6 functional 7 performance 8 decorative

Writing

❶ B: The general issue is addressed in the introduction, paragraph 2 supports the first view, paragraph 3 supports the second view and brings in other ideas to address the issue in general, the last paragraph provides

a firm conclusion, and views are illustrated by examples in the first three paragraphs.

C: Ways of looking at the issue in general are discussed in the introduction, something supporting the first view is given in paragraph 2, something in support of the second view is given in paragraph 3 and a personal opinion on the two views is given in the last paragraph.

Not A: This is a plan for a very well-organised answer but it does not deal with the two contrasting views in the question. It is about people following fashions and wearing the same clothes, it is not about clothes giving an indication of what people are like or about opinions people have of others because of the clothes they wear.

❷ yes = B, D, F

❸ yes = A, C, D, F, G

❹ MODEL ANSWER

Clothes are an important issue for many people these days and many people like to dress fashionably and to make a strong impression on others with the clothes they wear. Other people, on the other hand, don't care much about fashion and just wear whatever they feel like wearing. They aren't interested in the impression their clothes give to other people. Who's right? Do the clothes you wear really say a lot about you as a person?

First of all, we must consider the circumstances. When someone is at work, the clothes they wear are more important than how they dress in their free time. If someone is dealing with the public, for example, it is important that they look smart and professional. If you are dealing with someone in an office or a bank, you are unlikely to think that they are good at their job if they look scruffy. In the professional world, clothes say a lot about the person.

Their clothes are a reflection of their personality. People become members of groups of friends because they share the same style of clothes. Their clothes are a symbol of themselves as people and they judge others according to the way they dress.

In my view, the way people dress at work can be very important, and it does have a big effect on the way other people see them. But I agree with people who think that what you wear in the rest of your life is unimportant. It is unwise to judge people according to what fashion they follow because this does not tell you anything about their personality. It is much more important to find out what a person is really like than to make a decision about them because of what they are wearing. Personality, beliefs and attitudes are much more important than clothes.

Grammar

❶ 2 F 3 B 4 E 5 D 6 A

❷ 2 ✓ 3 ✓ 4 people get 5 ✓ 6 ✓ 7 I find / have found 8 gets 9 ✓ 10 I try / I've tried

❸ 2 I leave 3 I've chosen 4 I've had 5 I'm 6 I've worn
7 I throw 8 I've found 9 I get 10 I wash

Acknowledgements

Development of this publication has made use of the Cambridge International Corpus (CIC). The CIC is a computerised database of contemporary spoken and written English which currently stands at over one billion words. It includes British English, American English and other varieties of English. It also includes the Cambridge Learner Corpus, developed in collaboration with the University of Cambridge ESOL Examinations. Cambridge University Press has built up the CIC to provide evidence about language use that helps to produce better language teaching materials.

The authors and publishers acknowledge the following sources of copyright material and are grateful for the permissions granted. While every effort has been made, it has not always been possible to identify the sources of all the material used, or to trace all copyright holders. If any omissions are brought to our notice, we will be happy to include the appropriate acknowledgements on reprinting.

Text

Telegraph Media Group Limited for the text on p. 8 'Third Culture Kids' from 'Third Culture Kids' by Ruth E Van Reken, *The Telegraph*, 13.11.09, for the text on pp. 12–13 'What do you know about the food you eat?' adapted from 'Food Science and food myths: Bond may have been onto something' by Mick O'Hare, *The Telegraph*, 5.10.10, pp. 20–21 'Strictly English' adapted from 'Simon Heffer: The Corrections' by Simon Heffer, *The Telegraph*, 20.8.10 and 'Strictly English: Part Two' by Simon Heffer, *The Telegraph*, 27.8.10, pp. 24–25 'Is constant use of electronic media changing our minds?' from 'Are Twitter and Facebook affecting how we think?' by Neil Tweedie, The Telegraph, 28.6.10, pp. 32–33 'Russia's boreal forests and wild grasses could combat climate change' from 'Russia's boreal forests may help to combat climate change' by Kristofar Ivanovich, *The Telegraph*, 29.4.10, pp. 36–37 'Movers and Shakers' from 'Clothes retailer White Stuff listens to the customer' by Helen Dunne, *The Telegraph* 27.1.09 and 'HomePride MD proud to see oven cleaning kits rack up fine profits' by Helen Dunne, *The Telegraph*, 9.6.09, p. 44 'Establishing your birthrights' from 'Establishing your birthrights' by Clover Stroud, *The Telegraph Weekend*, 16.1.10, pp. 48–49 'Making a loss is the height of fashion' from 'Haute couture: Making a loss is the height of fashion' by William Langley, *The Sunday Telegraph*, 11.7.10. Copyright © Telegraph Media Group Limited;

European Foundation for the Improvement of Living and Working Conditions for the two graphs on p.10 adapted from the European Working Conditions Observatory (http://www.eurofound.europa.eu/ewco). Reproduced by permission;

Paul H Brookes Publishing Co Inc., for the charts on p. 21 adapted from *Meaningful Differences in the Everyday Experience of Young Children* written by Hart & Risley.

Copyright © 1995, Paul H Brookes Publishing Co., Inc, Baltimore. Adapted by permission;

Futurelab Education for the table on p. 23 adapted from 'Which communication skills are essential in your job?' Survey 1997 and 2006 http://www.beyondcurrenthorizons.org.uk/. Reproduced with permission;

Osaka Gas Group for the diagram on p. 34 from the *Osaka Gas Group CSR Report 2009*. Reproduced with permission;

Diagram on p. 35 from The Energy Star Program (www.energystar.gov);

Your Workplace for the pie charts on p. 46 originally published in the July/August 2009, volume 11-4, issue of *Your Workplace magazine, Live Healthy. Work Smart*. Reprinted with permission. www.yourworkplace.ca

Photos

Key: TL = top left TR = top right

p. 8: Thinkstock; p. 16 (TR): Thinkstock/Comstock; p. 16 (TL) and 17: Shutterstock/Monkey Business Images; p. 19: iStock/© Jennifer Sharp; p. 24: Thinkstock/Jupiterimages; p. 27: Thinkstock/Stockbyte; p. 29: Thinkstock/Goodshoot; p. 32: Shutterstock/shalunishka; p. 37 (TR): ©Phil Weedon/White Stuff/www.prshots.com; p. 37 (TL): Photograph of Terence Leahy from Newscast; p. 39: Photolibrary Group/Age fotostock/Stuart Pearce; p. 40: Thinkstock; p. 44: Thinkstock/Jack Hollingsworth; pp. 48–49: © MAYA VIDON/epa/Corbis; p. 50: Shutterstock/crystalfoto; p. 53: Thinkstock/Brand X Pictures.

Commissioned photo on p. 20: Sophie Clarke/Cambridge University Press

Illustrations

Kveta pp. 6, 12, 18, 28, 30, 39, 41, 42, 47, 52; Peter Marriage pp. 10, 14, 22, 23, 45, 46; Andrew Painter pp. 35, 37; Martin Saunders pp. 34; David Whamond p. 11; Gary Wing pp. 7, 26

The publishers are grateful to the following contributors:

Judith Greet: editorial work

Kevin Doherty: proofreader

John Green: audio producer

Tim Woolf: audio editor

Cover design and page layout: Wild Apple Design Ltd

Audio recorded at: I.D. Audio Studios, London